A Lonely Trek
© Wooster Scott

Jane Wooster Scott

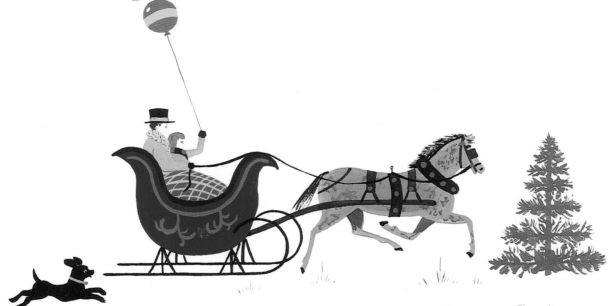

An American Jubilee
The Art of
Jane Wooster Scott

CROSS RIVER PRESS

A DIVISION OF ABBEVILLE PUBLISHING GROUP

NEW YORK LONDON PARIS

To my children,

Vernon IV and

Ashley,

my greatest gifts from God.

You have filled every day with love, beauty,

hope, and challenge.

The Mother's Day Picnic

Motherhood, the glorious blessing of womankind, warrants a special celebratory day in such pleasant surroundings as provided by artist Jane Wooster Scott.

The painting abounds with joy and beauty, ringing with the laughter of free spirits. The bandstand's lacy latticework, the profusion of spring flowers and placid water join harmoniously with the music in a serenade to the gentle, wiser gender as grandmothers, mothers and mothers-to-be revel in the spirit of maternity.

THE MOTHER'S DAY PICNIC
Original oil on canvas 24 x 30 in (60.9 x 76.2 cm), 1993

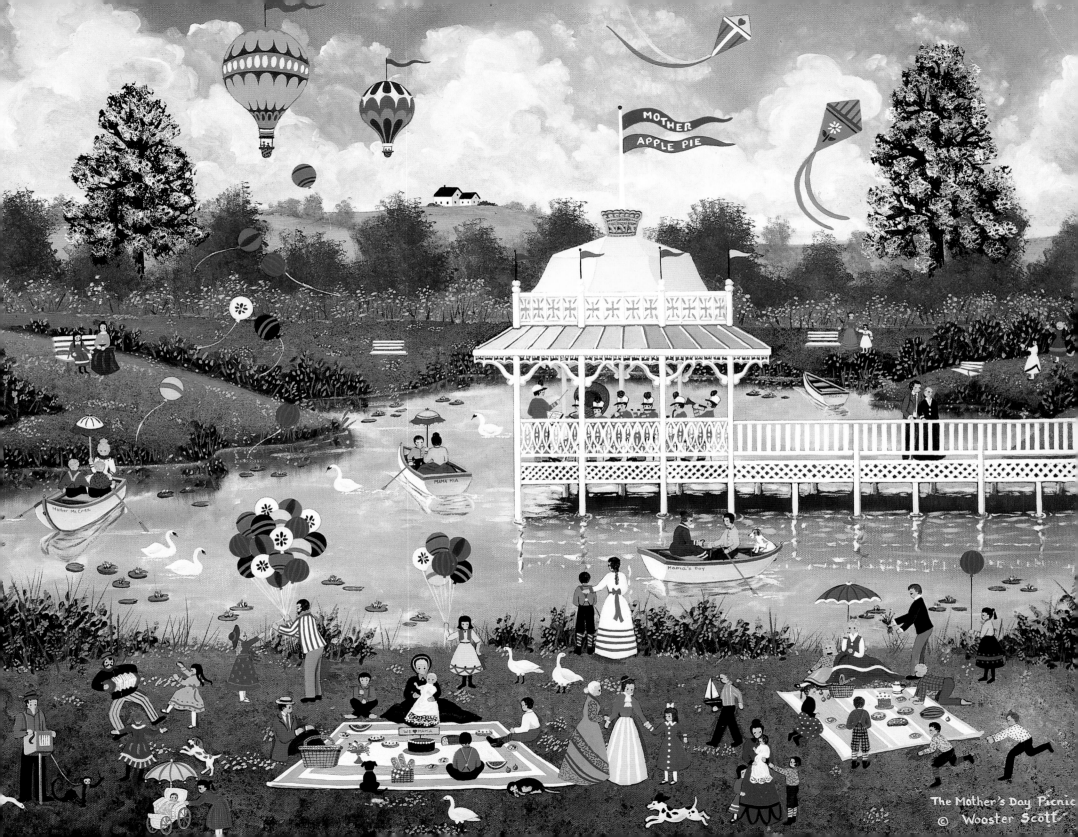

The Mother's Day Picnic
© Wooster Scott

In the Heart of Dixie

One glance at this exciting moment in time and place and no matter how much a Damned Yankee you may be, it is difficult not to feel the pride and passion when, even in jest, a Southerner cries, "The South will rise again!"

IN THE HEART OF DIXIE
Original oil on canvas 30 x 40 in (76.2 x 101.6 cm), 1992
Silkscreen serigraph, 22 x 29 in (55.8 x 73.6 cm), 1993

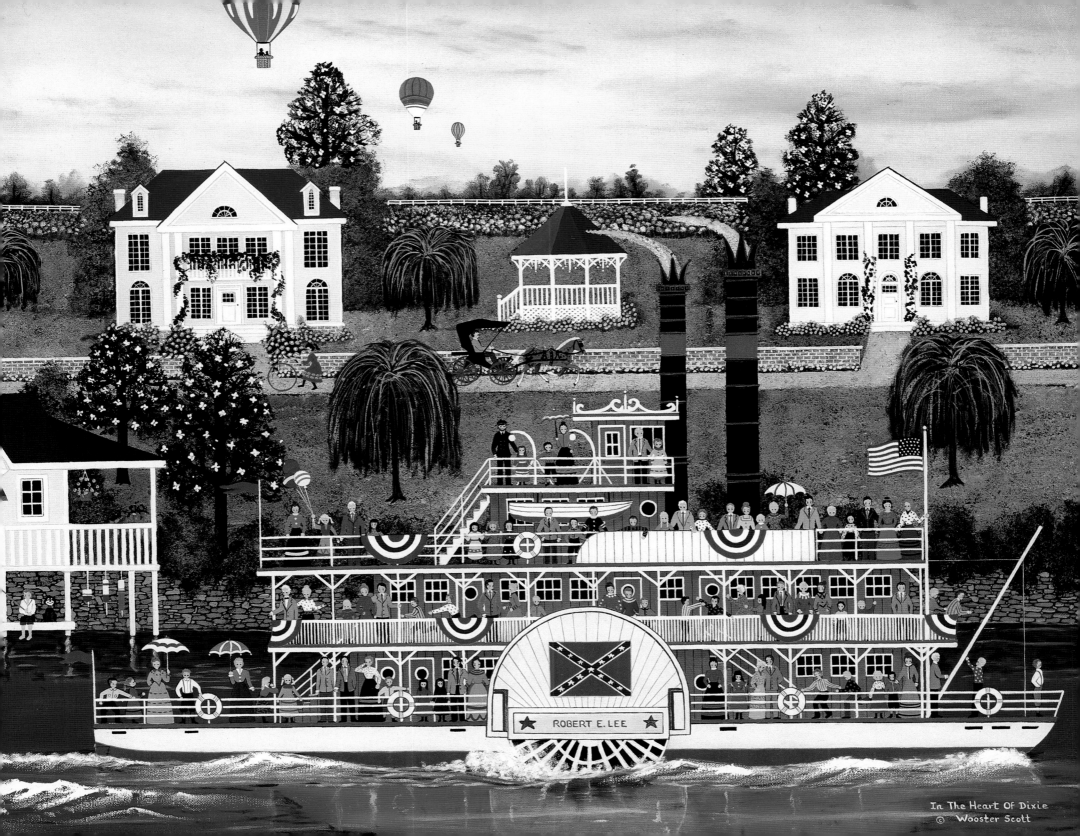

In The Heart Of Dixie
© Wooster Scott

The Party's Over

Oh, how proud we were in the '20s when we owned our first automobiles. Those early horseless carriages were more than simple transportation or a matter of convenience.

The revelers chugging home after a festive party were pleased to see that no one still drove a horse and buggy.

Some things never change in this ever-changing society of ours. Automobiles were a grand status symbol for our grandparents in the wake of the industrial revolution.

They still are!

THE PARTY'S OVER
Original oil on canvas 24 x 30 in (60.9 x 76.2 cm), 1992
From the collection of Rusty Staub

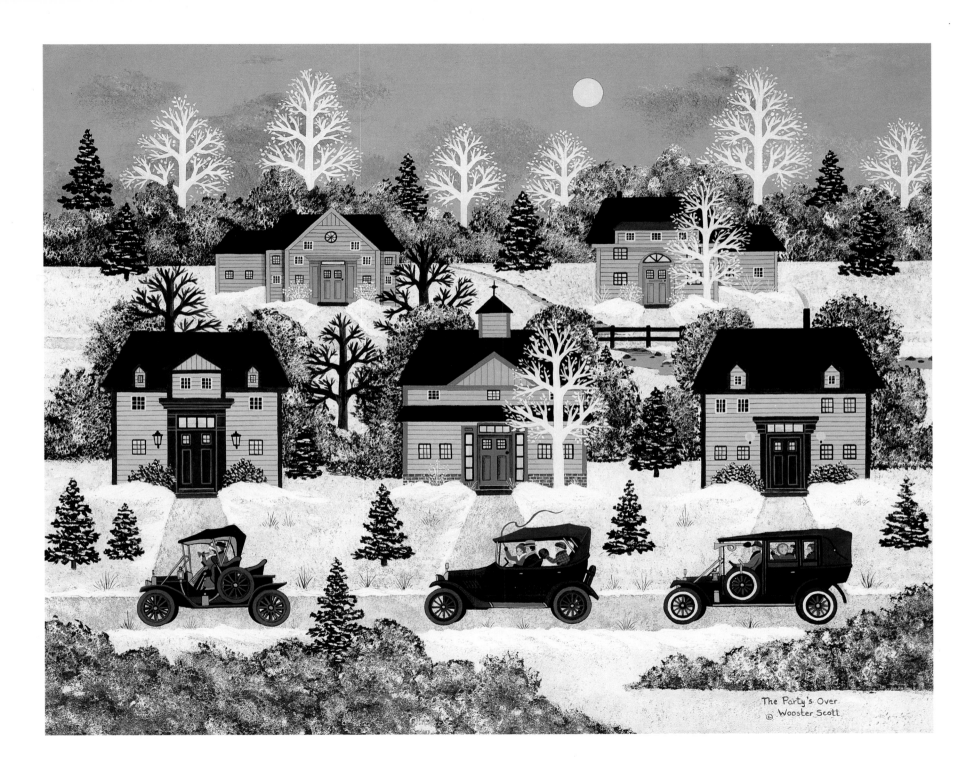

The Party's Over
© Wooster Scott

A Kids' World

Toys are fun and boys are dandy,

And so's confectioner's candy.

We think puppies are nice,

We love skating on ice.

But of all winter thrills,

None beats sledding the hills.

A KIDS' WORLD
Original oil on canvas 20 x 24 in (50.8 x 60.9 cm), 1992
Silkscreen serigraph 16 x 19⅓ in (40.6 x 48.7 cm), 1992

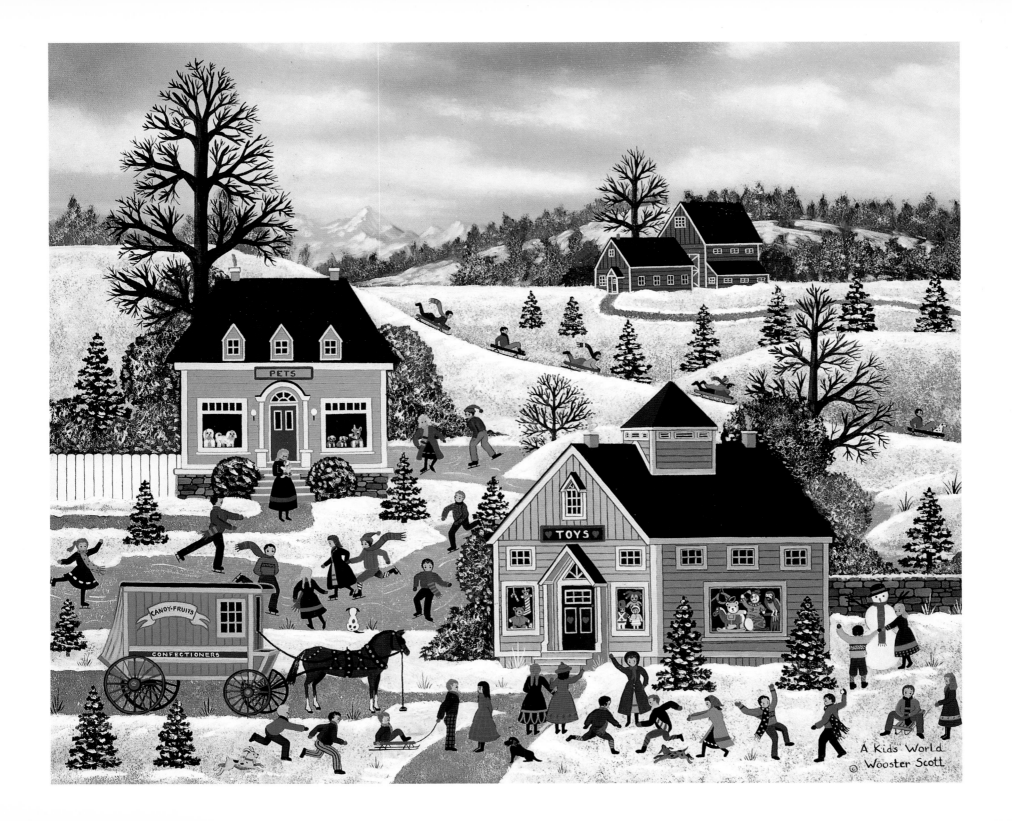

Mid Winter Night's Dream

This fanciful panorama never existed. Nor could it have. But we are asked to suspend credulity—and happily comply—to see a village of quaint 19th Century shops and homes on the snowy banks of a mountain lake. And what's that towering over the happy burghers? Why, a modern ski mountain, of course, just to make sure the viewer is paying attention.

MID WINTER NIGHT'S DREAM
Original oil on canvas 40 x 30 in (101.6 x 76.2 cm), 1993
From the collection of Mr. and Mrs. James Nelson

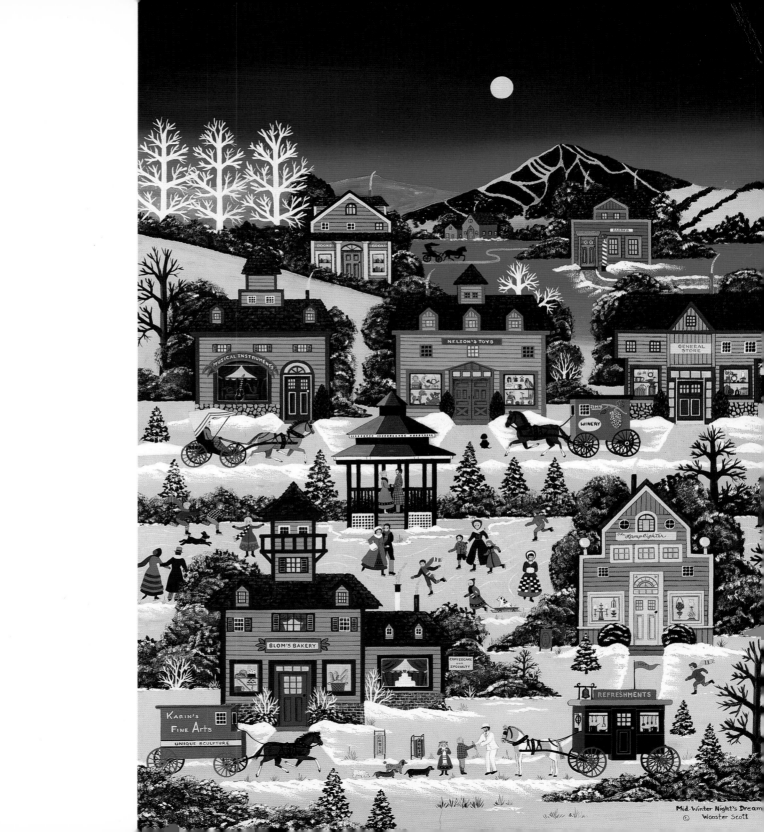

Going for the Brass Ring

Did you ever catch the brass ring on a merry-go-round, then turn it in for a free ride?

It was a once-in-a-lifetime thrill, a good luck omen. Especially for girls.

I'll share a secret if you promise not to tell. I caught the brass ring when I was seven years old in Perkiomenville, Pennsylvania, visiting Aunt Sarah. The carousel looked just like this one. But I didn't exchange that ring for another ride. I tried it on my finger. It *was* lucky, too, and is a treasured trophy in my jewel box of memories.

GOING FOR THE BRASS RING
Original oil on canvas 20 x 24 in (50.8 x 60.9 cm), 1989
Silkscreen serigraph 23½ x 28 in (59.6 x 71.1 cm), 1990

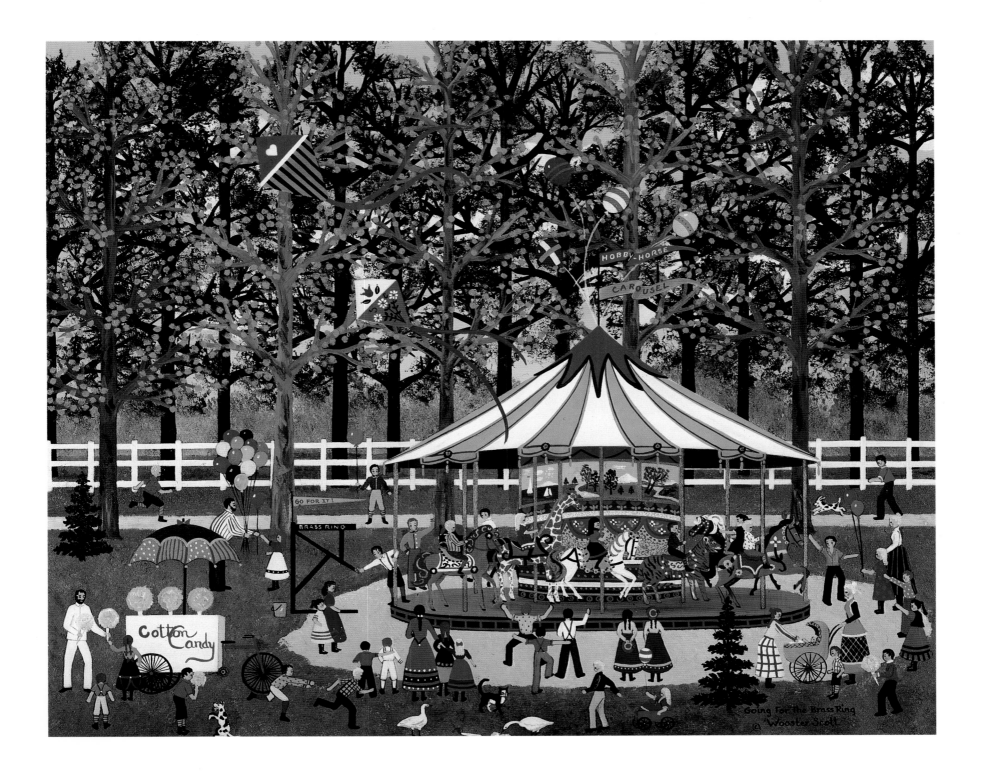

A Different Place Entirely

Stop! Wait.

Hold it right there!

Something's wrong here.

Where are we?

Hello?

Yes, that's Planet Earth out there. At least it looks like the Big Blue Marble floating serenely in space. But if that's Earth, then what place is this and how did we get here?

It can't be the moon. Astronauts say there aren't any trees and barns, or houses, fences and harvesters on the moon. Just rocks.

What magic has this artist conjured? Another Earth in a parallel universe? What?

It's eerie and spooky and utterly fascinating.

Don't you wish you were there?

A DIFFERENT PLACE ENTIRELY
Original oil on canvas 16 x 20 in (40.6 x 50.8 cm), 1985
From the collection of Larry Niven
Offset lithograph 11¼ x 14 in (28.5 x 35.5 cm), 1989

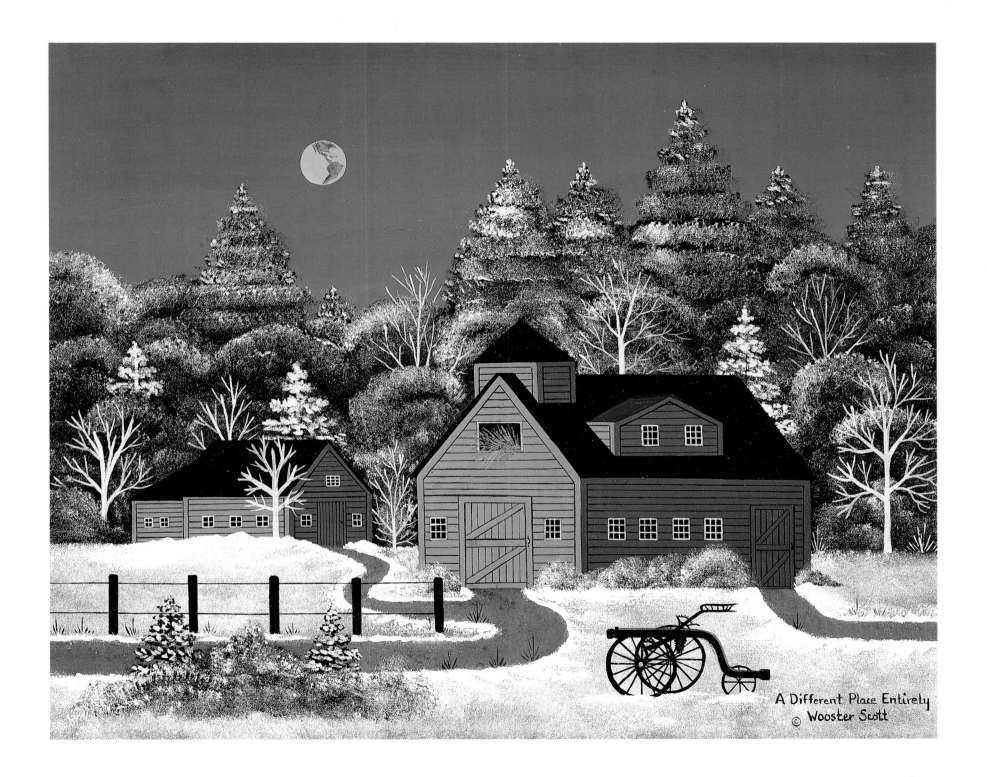

A Different Place Entirely
© Wooster Scott

Town Square

The vast American prairie stretches to every horizon, as far as the eye can see, framing this small outpost of civilization in the middle of nowhere. A hundred town squares like it have disappeared, swallowed up by *progress* and *development*, or abandoned to weeds and decay as inhabitants answered the siren call of big city lights. Even as the artist painted the fading yellow light of a gathering autumn afternoon, she sadly predicts a twilight time for this little town that once aspired to cityhood.

TOWN SQUARE
Original oil on canvas 30 x 30 in (76.2 x 76.2 cm), 1992

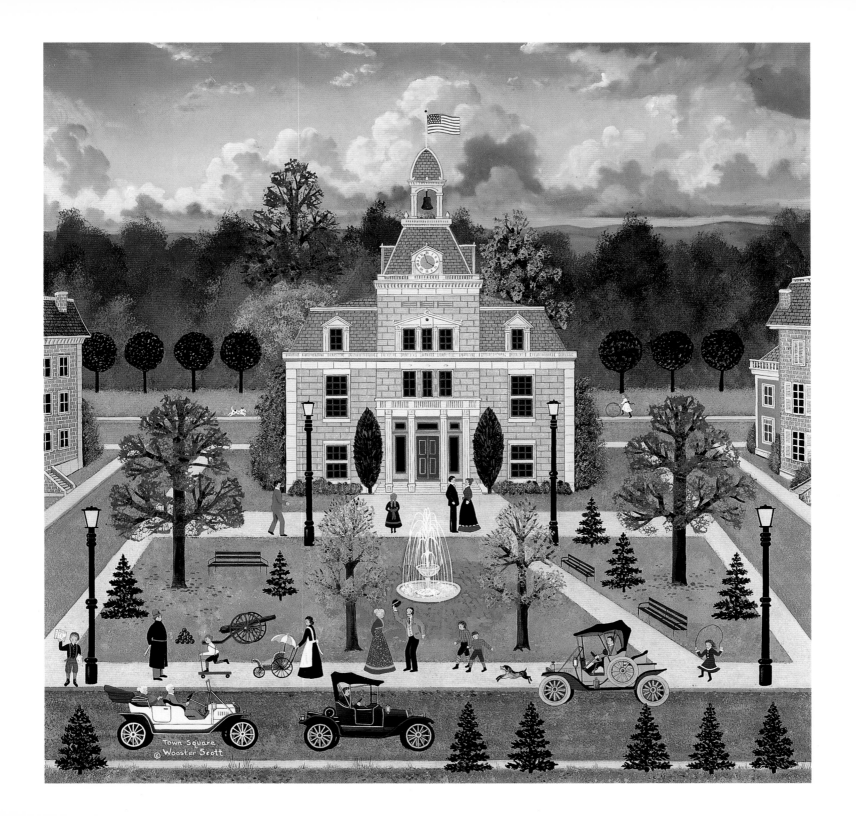

Town Square
© Wooster Scott

Venice Beach Vibes – The '80's

Charged vibrations shriek from frenetic Venice Beach all year.

Artist Scott visited the surreal scene where sights and sounds and action defy analysis but attract a million tourists. Craziness swirls and eddies to the beat of rap and rock. Costumes, nudity, rollerblades, diving kites, street performers, homeless pushing shopping carts, drugs, mystics, psychics, fast food, vulgar signs, zonked zonkers, trinkets, T-shirts, any old (or new) thing for sale. "Shades, man?"

Bedlam?

People pulsate to a cacophony of dissonance, magnifying the prevailing urgency. Hurry, scurry, make no progress.

Oldsters, youngsters, natives, visitors stare at each other vacantly. Aliens from a remote galaxy?

All eyes ask, "Whither go we from here?"

VENICE BEACH VIBES—THE '80's
Original oil on canvas 22 x 28 in (55.8 x 71.1 cm), 1985
From the collection of Ron Sunderland
Offset lithograph 16 x 20 in (40.6 x 50.8 cm), 1985

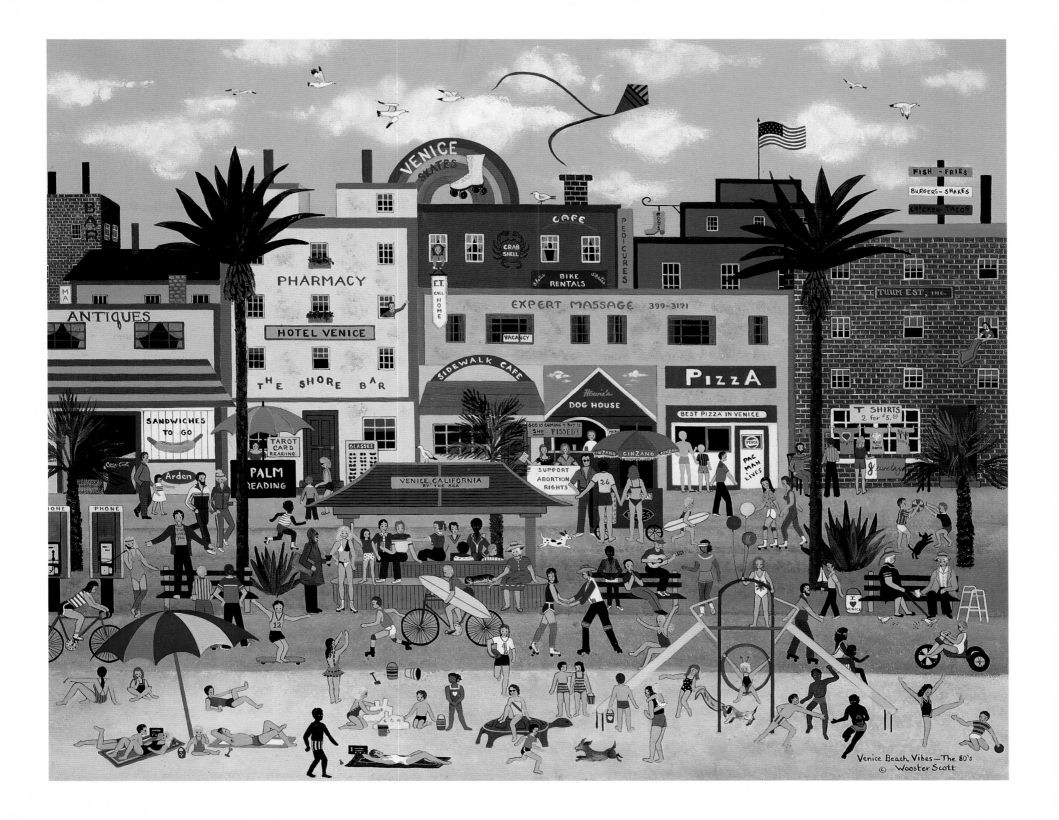

Venice Beach Vibes—The 80's
© Wooster Scott

Mountain Majesty

Mankind's incursions too often disfigure nature, wounding our planet's natural dignity. This majestic mountain, noble in its altitude and mass, is enhanced by human adornment, perhaps in celebration of its proximity to the heavens. It is a temporary alliance. When man is gone, the mountain will remain in solitary splendor.

MOUNTAIN MAJESTY
Original oil on canvas 40 x 50 in (101.6 x 127 cm), 1993
From the collection of the Sun Valley Co.
Offset lithograph 21¾ x 27¼ in (55.2 x 69.2 cm), 1993

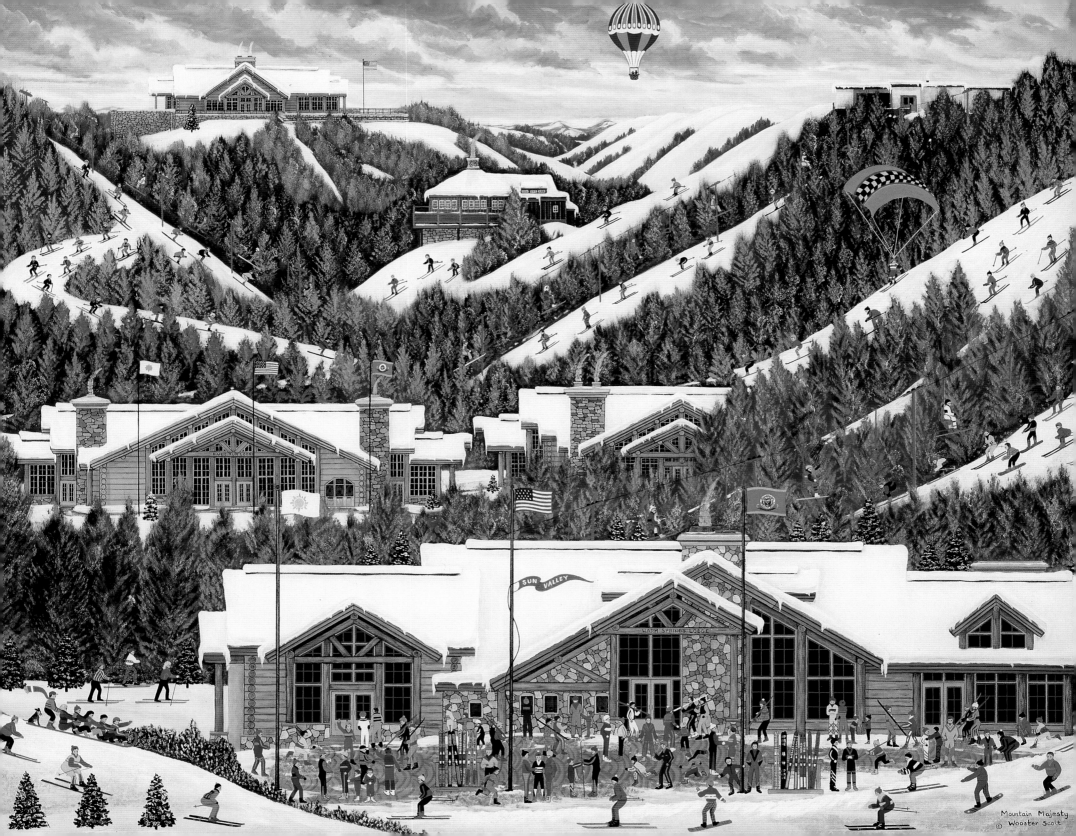

Mountain Majesty
© Wooster Scott

The News Room

The News Room is among the artist's earliest paintings, based on the old city room of the long-defunct *Los Angeles Herald-Express*. It is one of a very few Scott works on canvas board. A limited edition sepia etching is a great favorite of newsmen nationwide.

A handful of oldtimers today recall when reporters wore suits and neckties and were the envy of copyboys who watched their heroes clack away at manual typewriters. Newspapers printed *extras*, special editions hawked on the streets to announce world-shaking events: Lindbergh's transatlantic flight and the sinking of the Titanic.

Old photographs provided much of the detail, augmented by recollections of gaffers who as young men worked at the newspaper and others like it. This news room did exist: the planked floor, open windows, the roar of the presses, the pungency of ink and an unremitting sense of urgency.

Scott miraculously brings to life a rich era of the American heritage that should not fade away.

THE NEWS ROOM
Original oil on canvas board 16 x 20 in (40.6 x 50.8 cm), 1969
From the collection of Vernon Scott IV
Original Etching 16 x 20 in (40.6 x 50.8 cm), 1978

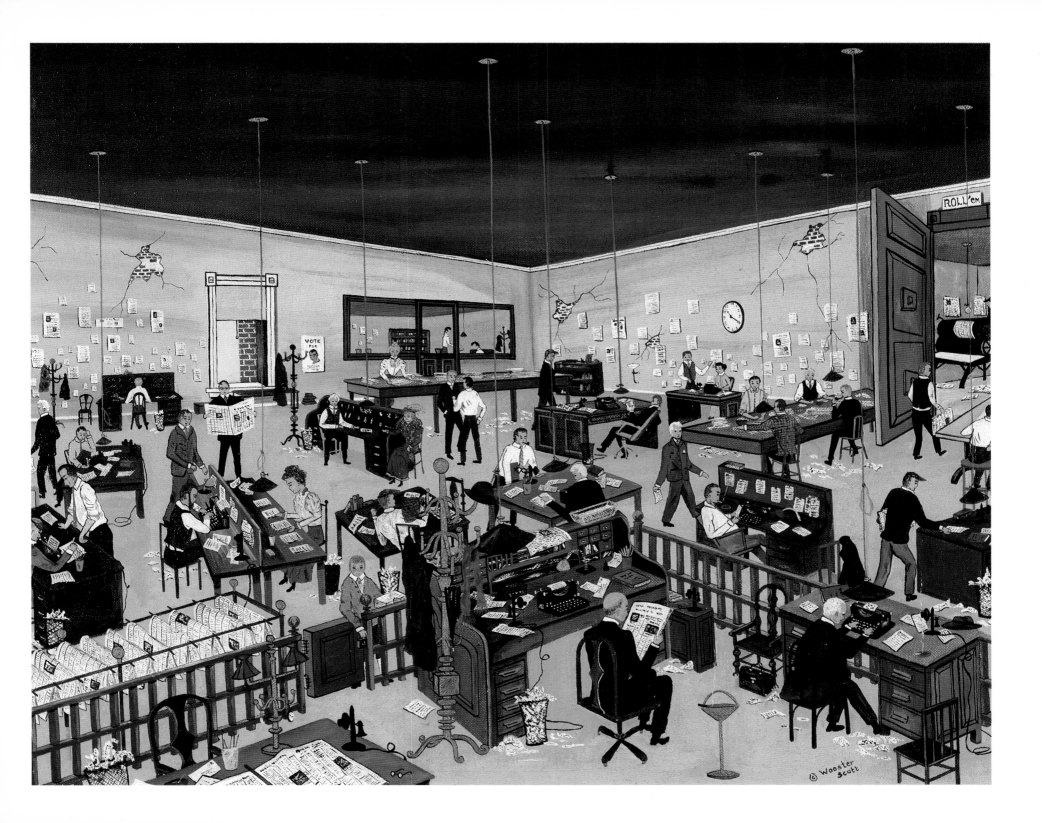

On the Summer Wind

Darting kites and silvery light

Make a summer's day

An artist's delight.

ON THE SUMMER WIND
Original oil on canvas 30 x 40 in (76.2 x 101.6 cm), 1990
Silkscreen serigraph 24 x 32 in (60.9 x 81.2 cm), 1991

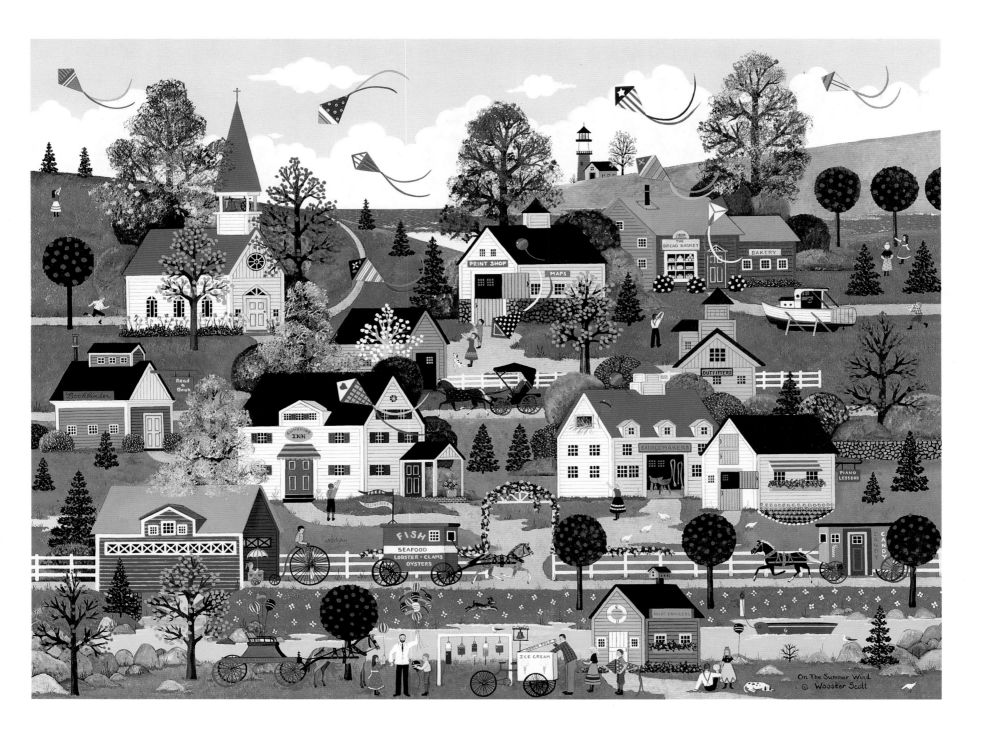

On The Summer Wind
© Wooster Scott

Southern Serendipity

Antebellum Dixie was a gentle and poetic time. Womenfolk were as fragile and sweet as magnolia blossoms and menfolk were mannerly and amusing. This serendipitous lifestyle ended almost one-hundred and fifty years ago with the *War Between The States*, as they call it down South.

Its like has not been seen again.

SOUTHERN SERENDIPITY
Original oil on canvas 24 x 24 in (60.9 x 60.9 cm), 1993

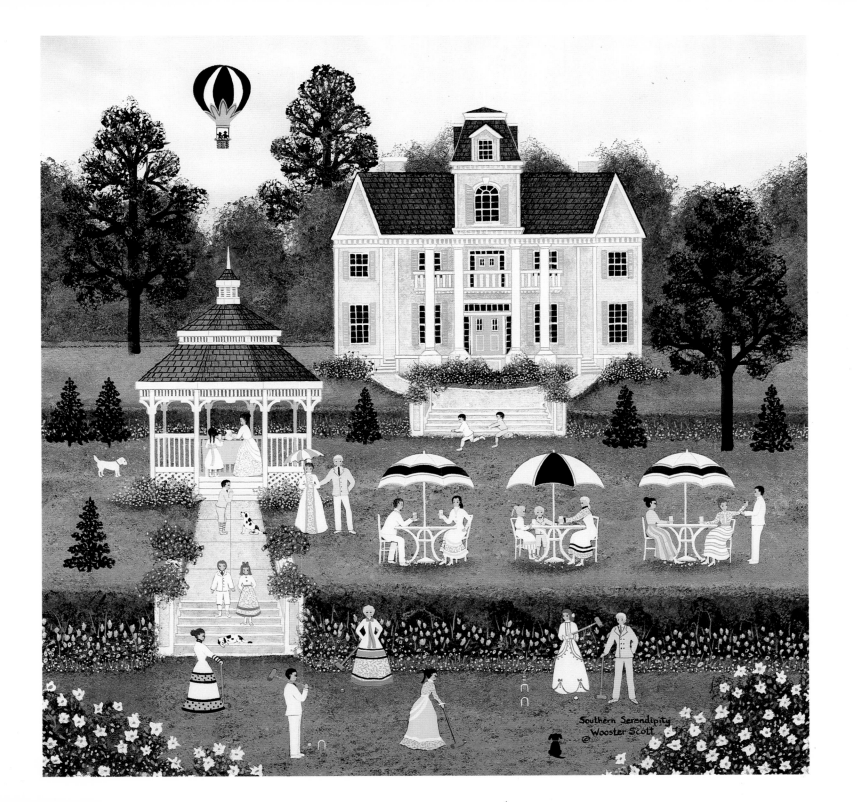

Southern Serendipity
Wooster Scott
©

Keeper of the Light

Jane Wooster Scott's paintings of an earlier, less sophisticated America often elicit long forgotten vocations. One such was lighthouse keeping, men whose lonely vigils in isolated, whitewashed towers along rocky coasts saved countless ships from foundering on shoals and uncharted rocks. These hardy individualists were revered by small boys, as were railroad engineers in their striped blue caps and red-checkered bandanas. On this spanking New England morning the artist depicts a pair of young fishermen taking time to greet a local hero.

KEEPER OF THE LIGHT
Original oil on canvas 16 x 20 in (40.6 x 50.8 cm), 1988
From the collection of Cynthia Klapper
Offset Lithograph 9 x 11¼ in (22.8 x 28.5 cm), 1989

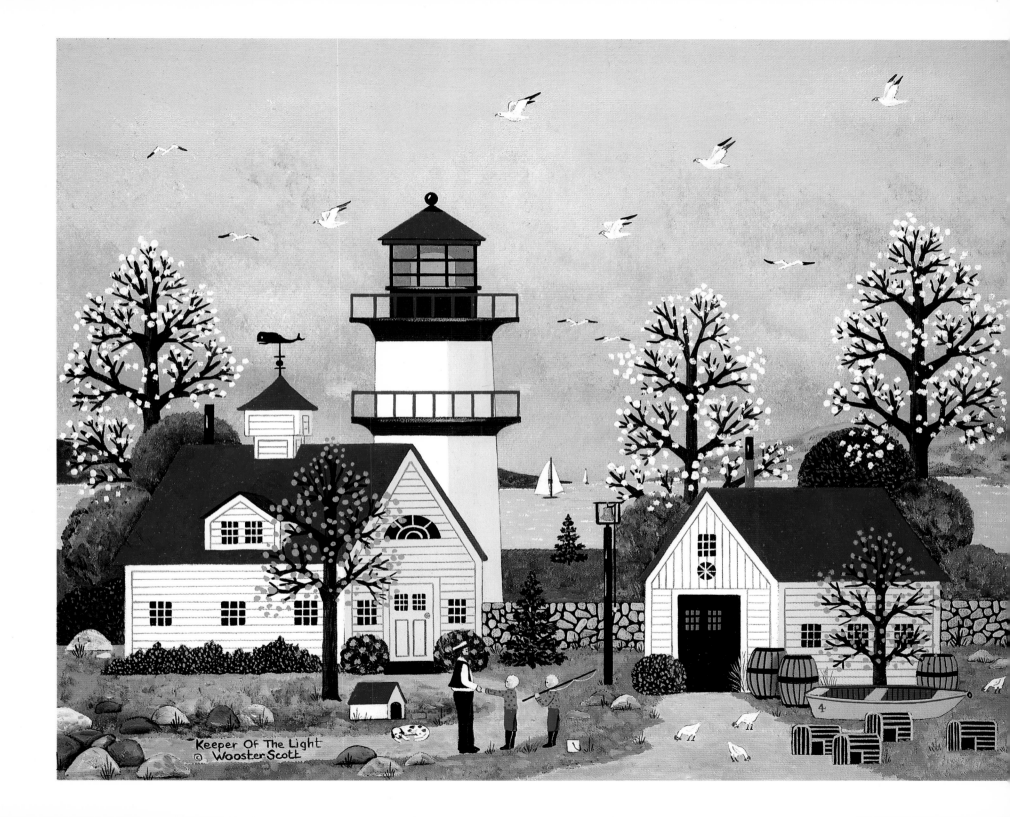

"Keeper Of The Light
© Wooster Scott

Indian Summer in Nantucket

History clings to Nantucket Island, its farms, cranberry bogs, lighthouses, harbors and fishing fleets as tenaciously as it does to Cape Cod, reminding Americans of their roots.

To this day, a hardy breed of Yankees continue to wrest a livelihood from the bounty of land and sea through old-fashioned dedication to the New England work ethic.

INDIAN SUMMER IN NANTUCKET
Original oil on canvas 40 x 30 in (101.6 x 76.2 cm), 1985
Offset lithograph 27 x 20 in (68.5 x 50.8 cm), 1988

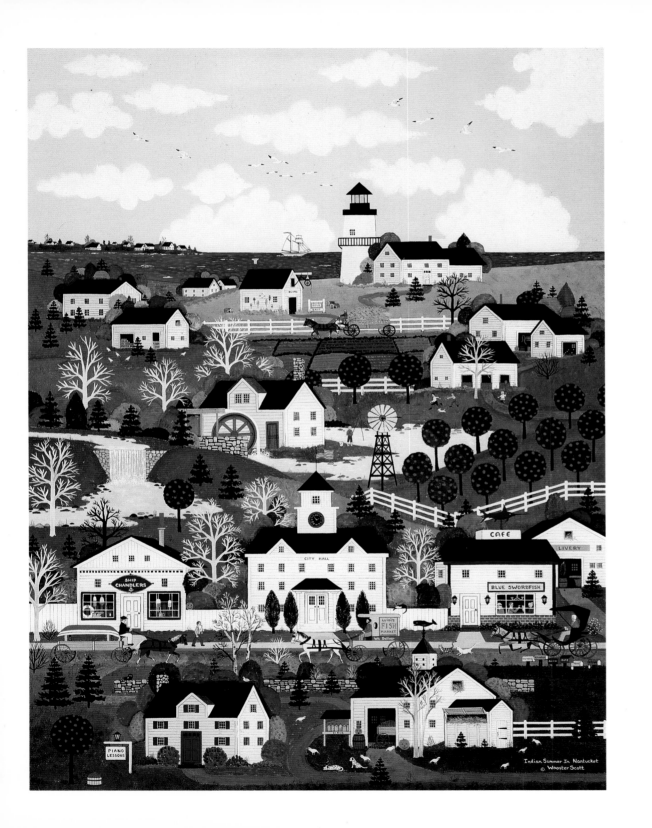

Indian Summer In Nantucket
© Wooster Scott

Memories Past

Recollections most often improve with the time span between fact and memory. Traveling through the Pennsylvania Dutch countryside long ago, the mind's eye stored away snapshots of barns and silos, covered bridges and millponds, wagons and pastures, kids and swans.

Years later, the images in your mind's eye often become a kaleidoscopic jumble of indistinct impressions. But if you're lucky, sometimes they coalesce into a single enchanting vista. Artist Jane Wooster Scott has done that for us here.

MEMORIES PAST
Original oil on canvas 30 x 40 in (76.2 x 101.6 cm), 1992
From the collection of Mr. and Mrs. Michael Kazanjian
Offset lithograph 19 x 25⅜ in (48.2 x 64.4 cm), 1992

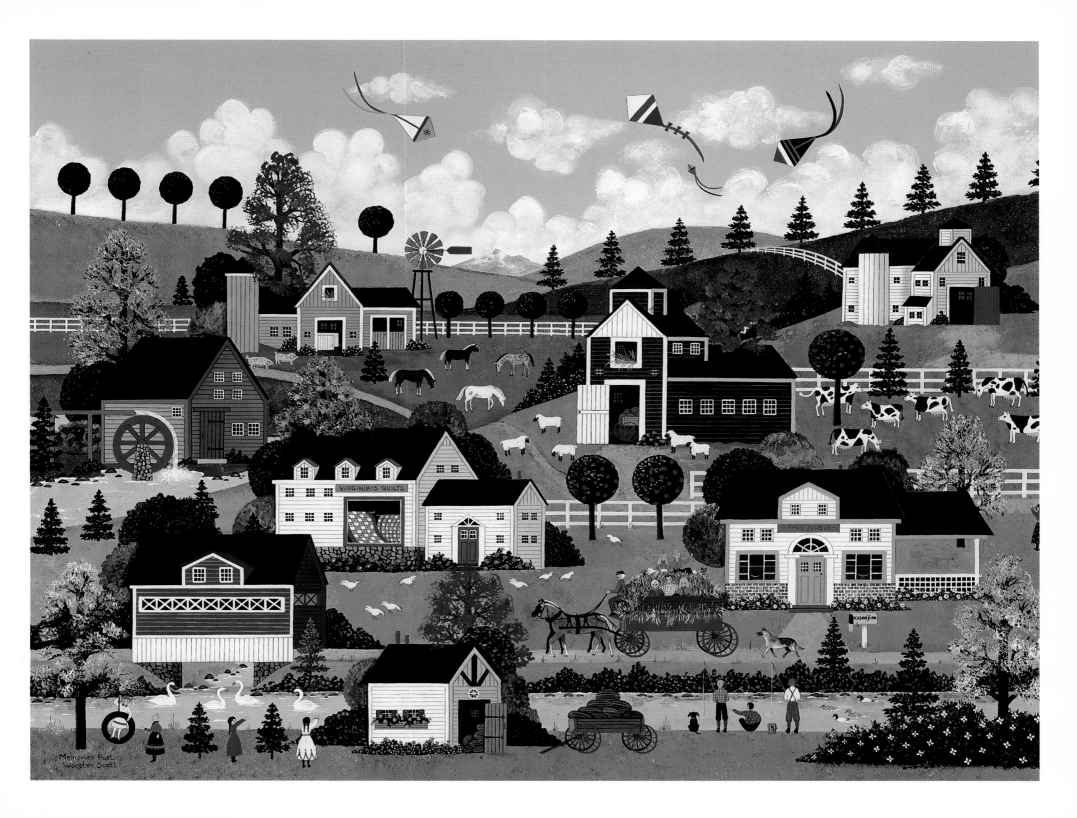

Memories Past
© Wooster Scott

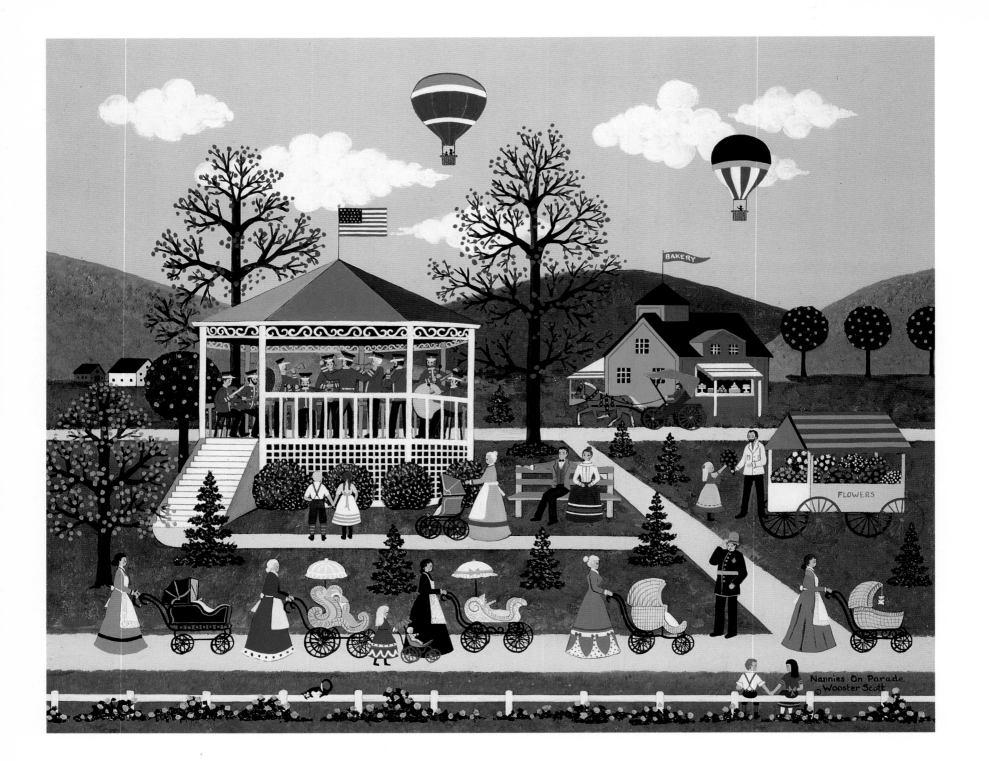

Nannies On Parade
© Wooster Scott

Nannies on Parade

Indeed, a passing parade of faded traditions.

Gone are Saturday afternoon band concerts in the park.

Gone too are handcrafted perambulators, whose tiny passengers

were cherished by loving nannies. Alas, the nanny herself has

almost become obsolete. But all will endure,

despite plastic strollers and jeans-clad babysitters with boomboxes,

thanks to this fanciful depiction of a bygone day.

NANNIES ON PARADE
Original oil on canvas 20 x 24 in (50.8 x 60.9 cm), 1989

Neptune's Fantasy

Neptune's Fantasy was an experiment, the artist's venture into an unfamiliar realm that became one of her most popular works. Like many Scott paintings, the canvas is pure fantasy, unique in its timelessness and universality. In a mystical, softly filtered landscape beneath the sea, she envisions a sunken ghost ship, a brilliant array of fishes and aquatic plants, frolicking orcas, a comical dancing octopus and, happily, a charming Lorelei.

NEPTUNE'S FANTASY
Original oil on canvas 24 x 24 in (60.9 x 60.9 cm), 1991
Silkscreen serigraph 26 x 26 in (66.0 x 66.0 cm), 1991

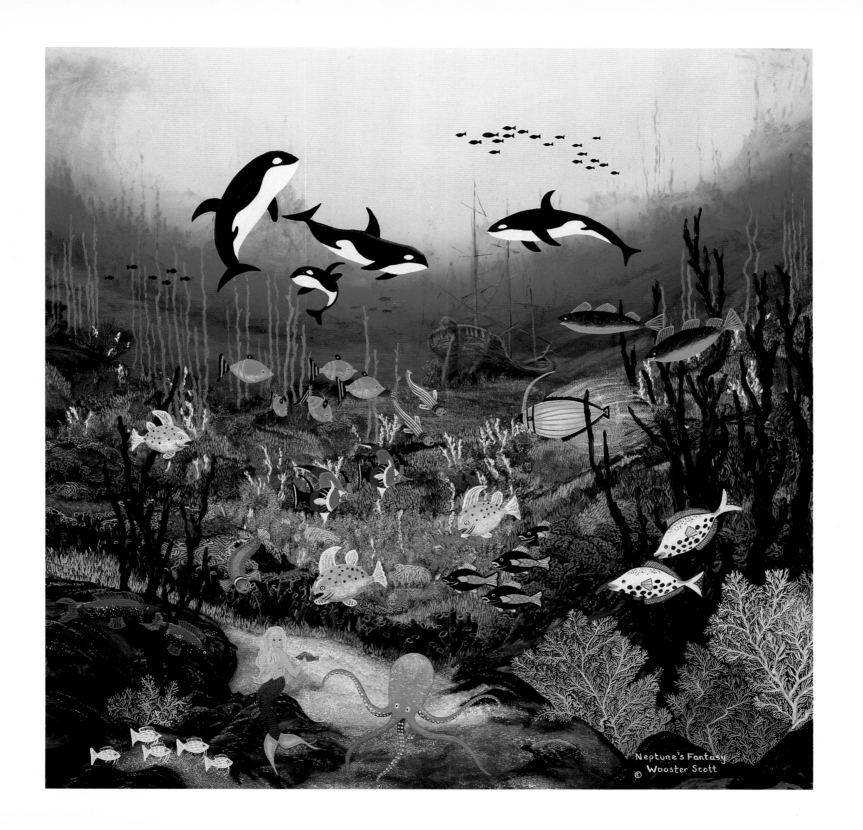

Neptune's Fantasy
© Wooster Scott

A Whoop and a Holler on Independence Day

FREEDOM is what the Fourth of July is all about, as these happy celebrants attest. Freedom is a philosophic concept that cannot be fully appreciated until it is lost. The United States of America has been vigilant in its preservation for more than two-hundred years, guarding this precious gift from tyrants and despots abroad who would take it from us.

In the next two-hundred years Americans must be ever more vigilant not to allow our own government to steal our freedom from us.

A WHOOP AND A HOLLER ON INDEPENDENCE DAY
Original oil on canvas 20 x 24 in (50.8 x 60.96 cm), 1980
From the collection of Governor & Mrs. John Y. Brown (Phyllis George)

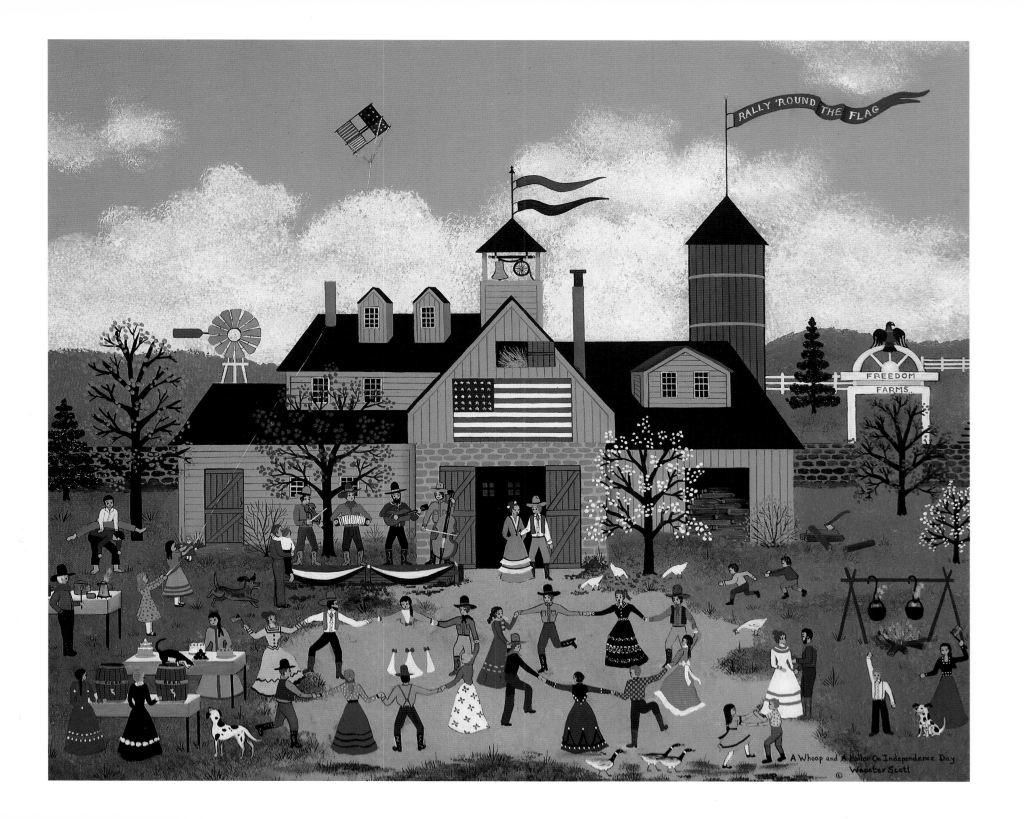

The American Train Suite

The romance of the rails lingers in America's heart, although the railroad train has lost its popularity to the Johnny-come-lately automobile and upstart airplane.

Ah, but there was a time when faraway steam whistles sang their forlorn song across prairie, mountain pass and field as trains chugged coast to coast, binding ever closer our union. Mile-long freights (always with a red caboose) and sleek silver passenger Pullmans alike left signature trails of billowing coal smoke.

Locomotives were marvels of wheels, boilers, pipes and cowcatchers, live white steam clouds, bells and whistles, black cast iron and shiny brass. They were monsters of power and speed as they stormed by on parallel ribbons of steel.

Their names were as romantic as love ballads:

Chesapeake & Ohio, Burlington Northern, Wabash, Lackawanna, Penn Central, Southern Pacific, Chicago & Northwestern, Norfolk & Western, Allegheny, Seaboard Coast Line, Baltimore & Ohio, Lehigh Valley, and the Chicago, Milwaukee, St. Paul & Pacific. All emblazoned with individual logos on yellow, brown or rust-colored wooden freight cars.

Remember *I've Been Working On The Railroad, The Atchison, Topeka And The Santa Fe, Casey Jones, John Henry and The Gandy Dancer's Ball?*

Now there are diesel locomotives, flat cars piled with truck rigs. Horns instead of steam whistles. Gone is the aromatic magic and the chuffa-chuffa of the Iron Horse.

One hopes recording technology has captured the diminishing, plaintive wail, the whooo-whooo-whooooooo, of a distant train lumbering along its lonely way.

And why does *Amtrak* lack the poetry of *Union Pacific?*

(Bottom Right)
SPANNING GRAND GORGE
Original oil on canvas 30 x 24 in (76.2 x 60.9 cm), 1992
Offset lithograph 21¼ x 16⅞ in (53.9 x 42.8 cm), 1992

(Top Left)
WHISTLE STOP AT ASHFIELD JUNCTION
Original oil on canvas 20 x 24 in (50.8 x 60.9 cm), 1984
Offset lithograph 16¾ x 20⅛ in (42.5 x 51.1 cm), 1992

Whistle Stop At Ashfield Junction
© Wooster Scott

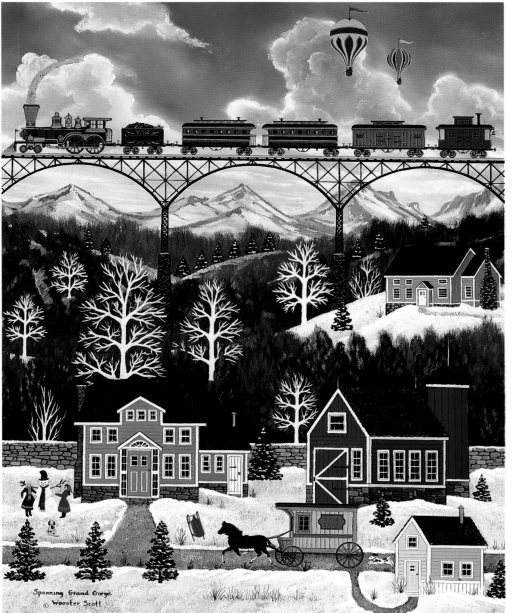

Spanning Grand Gorge
© Wooster Scott

Christmas Traffic Jam

You wouldn't think four horse-drawn rigs clopping down a snowy road in a quiet New Jersey backwater would constitute a traffic jam. But that's what it is all right, considering sometimes four rigs don't pass this way in a month of Sundays.

'Course the Rainbow Inn yonder does a spot of business come summertime with city dudes looking to get close to nature. But with the holidays upon us, one could expect this frenzied activity, especially among the young folk carrying on in the haywagon.

Things aren't like they used to be. Silas, the scoundrel, is commercializing the Yuletide selling chowder from a cart. Next thing you know half a dozen rigs will be clogging up the road.

Believe me, the good old days are gone forever.

CHRISTMAS TRAFFIC JAM
Original oil on canvas 24 x 30 in (60.9 x 76.2 cm), 1990
Silkscreen serigraph 24 x 30 in (60.9 x 76.2 cm), 1990

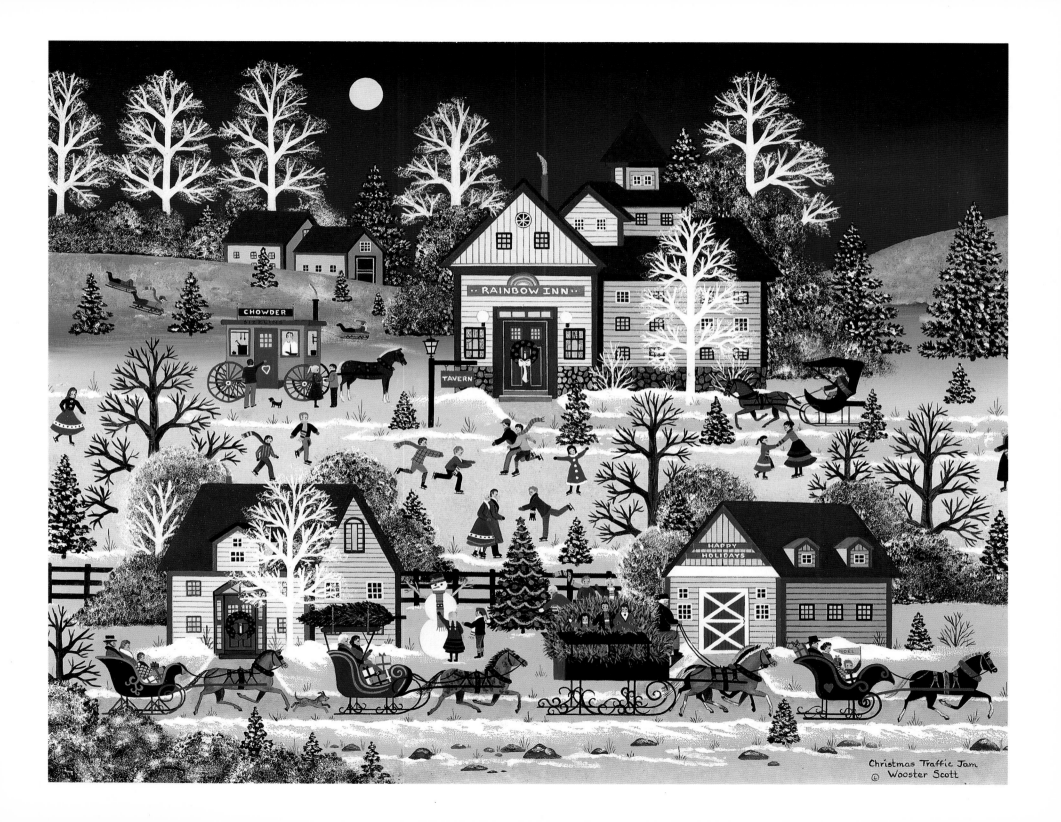

Christmas Traffic Jam
© Wooster Scott

Peaceful Harbor

Why do you suppose humans are drawn to bobbing vessels in quaint harbors to inhale tangy brine, marvel at the tapestry of drying nets, to hear lapping wavelets against hulls and jetties?

We are told that eons ago our species originated in primordial seas on a planet without land. Now the sea is alien and uninhabitable for our kind. Perhaps a profoundly existential genetic code beckons us to pay respect to the mother who nurtured all life when the world was young.

PEACEFUL HARBOR
Original oil on canvas 24 x 30 in (60.9 x 76.2 cm), 1993

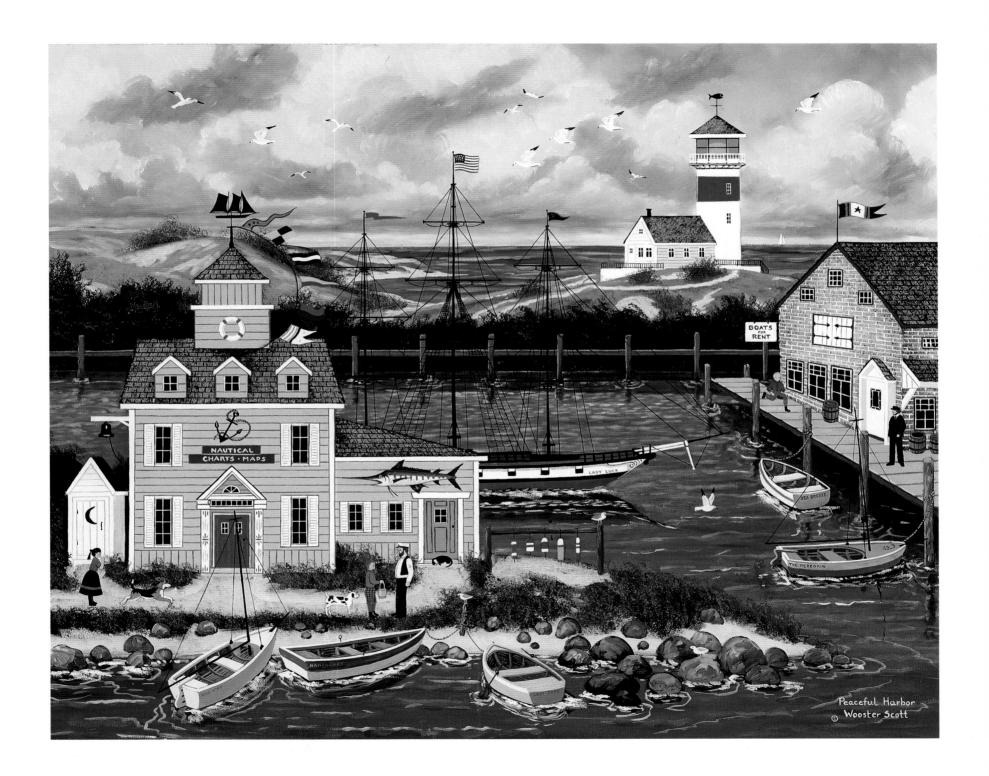

NAUTICAL
CHARTS · MAPS

BOATS
FOR
RENT

LADY LUCK

SEA BREEZE

THE PEREGRIN

NANTUCKET

Peaceful Harbor
Wooster Scott
©

Winter's Eve

Whoops!

The sign was supposed to read *Bedside Manor*. But the sign-painter was a lady patient who knew the doctor well.

WINTER'S EVE
Original oil on canvas 16 x 20 in (40.6 x 50.8 cm), 1990
From the collection of Dr. Sidney Garber
Offset lithograph 14⅜ x 18 in (36.5 x 45.7 cm), 1990

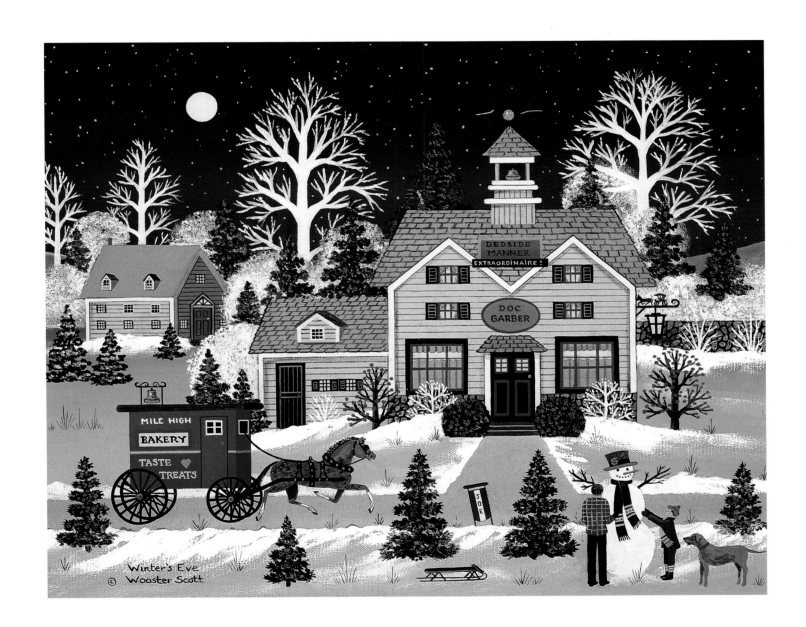

Winter's Eve
© Wooster Scott

Little Girls' Delight

Almost every woman had a favorite doll baby that she passed along to her own daughter. The artist saved her first such treasure for her daughter Ashley, who frequently pops up in Scott's paintings, suspiciously like the petite brunette with long hair pushing a pram past a lovely Victorian doll shoppe.

LITTLE GIRLS' DELIGHT
Original oil on canvas 20 x 16 in (50.8 x 40.6 cm), 1988
Offset lithograph 28 x 14 in (71.1 x 35.5 cm), 1988

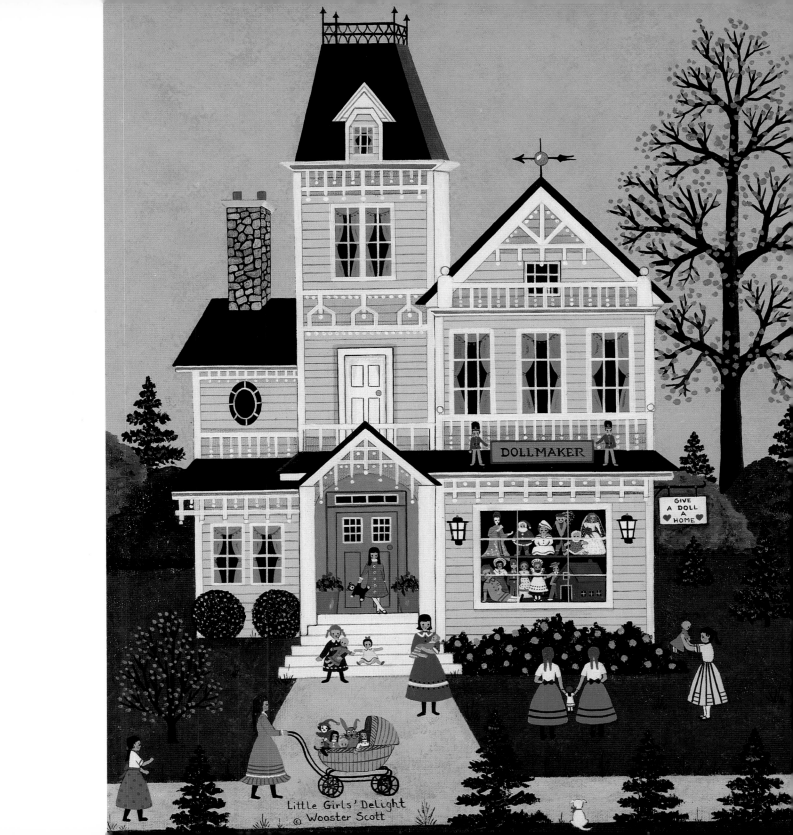

Little Girls' Delight
© Wooster Scott

At Attention!

The hallowed plains of West Point echo the names of heroic men and the glory they achieved in the nation's battles to preserve freedom.

Peacemakers bewail our military traditions, invoking celestial intercession to the tenent of strength in defense of the Constitution. If there be peace, let there be preparedness.

AT ATTENTION!
Original oil on canvas 24 x 30 in (60.9 x 76.2 cm), 1992
Offset lithograph 18 x 22½ in (45.7 x 57.1 cm), 1992

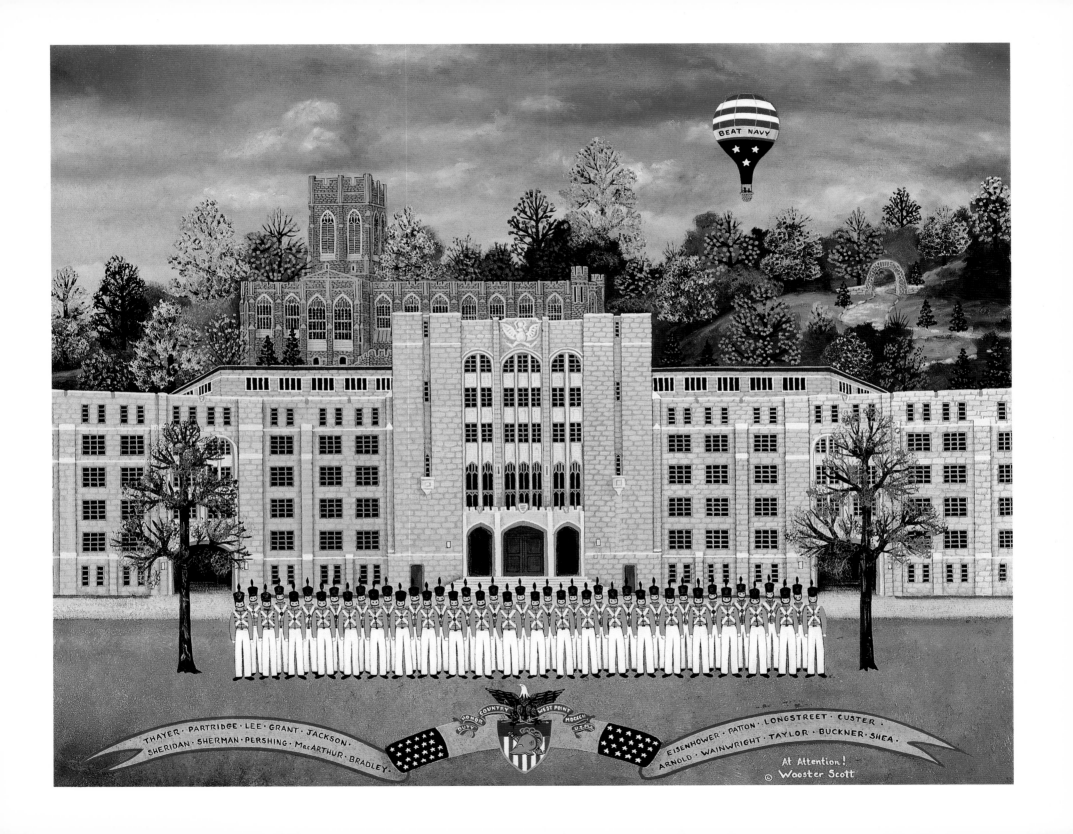

Aromas of the Gods

Lives there man, woman or child able to pass a bakery unassailed by the aromatic treasures of the ovens?

Pause, then, gentle art lover. Allow your olfactory senses to inhale the heavenly exudations of berry pie, chocolate layer cake, apple strudel, ginger snaps, coffee cake and a plump loaf of freshly-baked bread.

You can do it! Fasten your attention on the inviting Breadwinner Bakery. Inhale deeply. Presto! Cinnamon, vanilla, burnt-sugar, nutmeg and honey.

Oh, yes. Now the gods envy *you!*

AROMAS OF THE GODS
Original oil on canvas 24 x 30 in (60.9 x 76.2 cm), 1992
Offset lithograph 15¼ x 19 in (38.7 x 48.2 cm), 1993

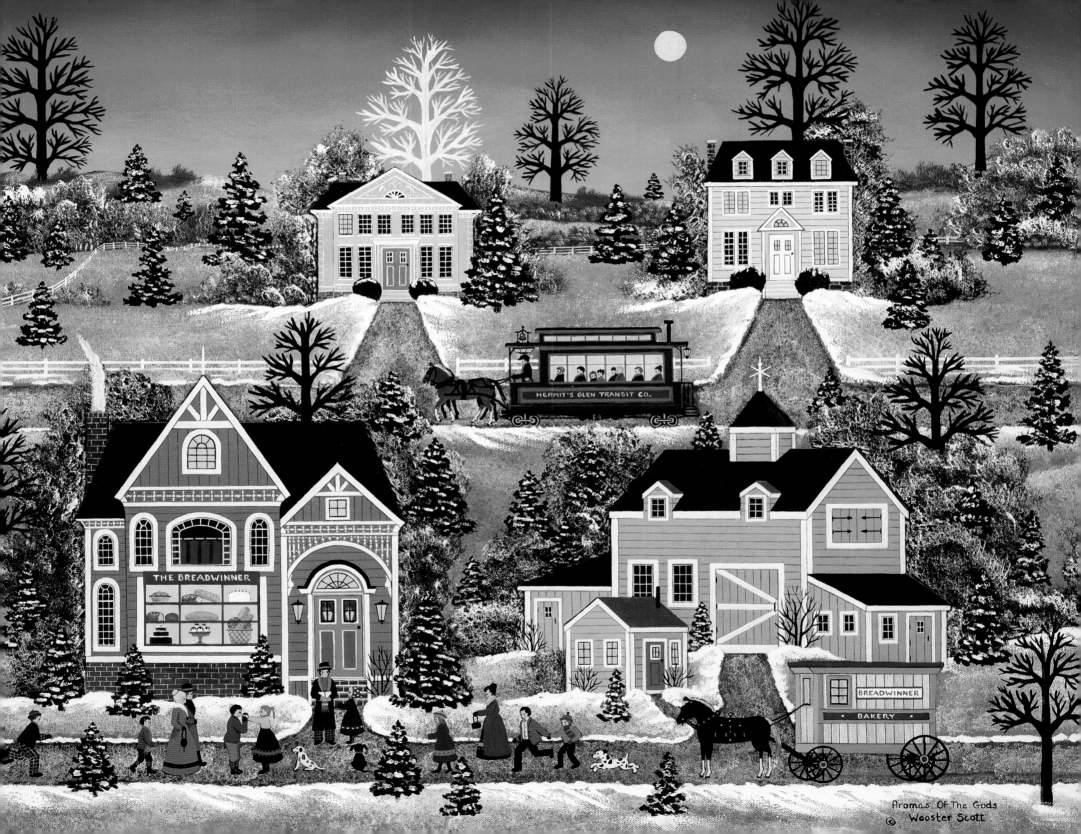

Aquatic Playmates

Parallel spheres of mammalian species.

So far apart, yet so close; so alike, yet dissimilar. They breathe the same air in different media. They almost communicate, but not quite. They frolic in fun. In the sun.

They share the planet but inhabit different worlds.

Or do they?

AQUATIC PLAYMATES
Original oil on canvas 16 x 20 in (40.6 x 50.8 cm), 1991

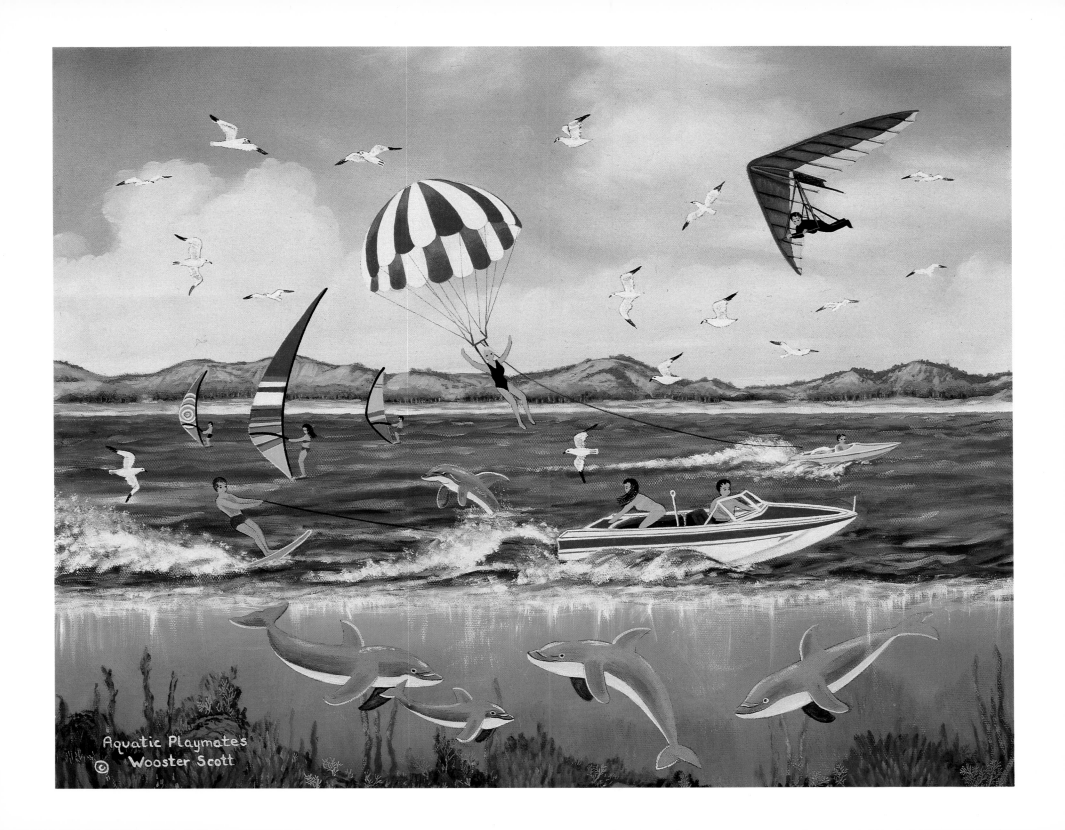

Aquatic Playmates
© Wooster Scott

Tossing the Wedding Bouquet

Would you believe every one of these bridesmaids is a spinster lady?

Some as old as twenty-four. Poor dears.

I'd sooner fight John L. Sullivan than touch those posies. Fate being sort of tricky, that little flower girl in the yellow dress is going to nab that nosegay and then wish she hadn't.

The spinsters know good and well she's the bride's kid sister.

TOSSING THE WEDDING BOUQUET
Original oil on canvas 20 x 24 in (50.8 x 60.9 cm), 1985
Offset lithograph 20 x 24 in (50.8 x 60.9 cm), 1985

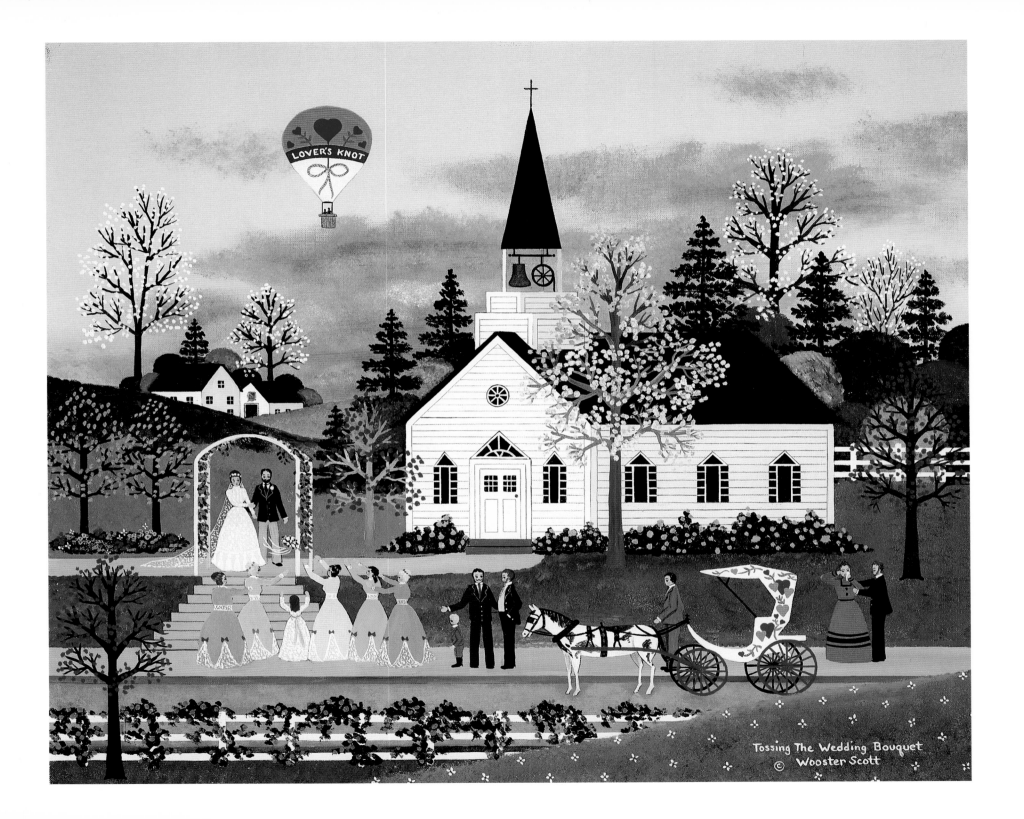

Tossing The Wedding Bouquet
© Wooster Scott

Birthday Mayhem

On this special day little Rollo turned ten.

His parents decided some money they'd spend.

So they hired two ponies and a red-faced clown,

And then they invited every wild kid in town.

They called on their neighbors to help with the fun,

There were unscheduled pranks and before it was done

The kiddies took over and got out of hand.

Next year little Rollo goes to Disneyland.

BIRTHDAY MAYHEM
Original oil on canvas 30 x 24 in (76.2 x 60.9 cm), 1991
Silkscreen serigraph 30 x 24 in (76.2 x 60.9 cm), 1991

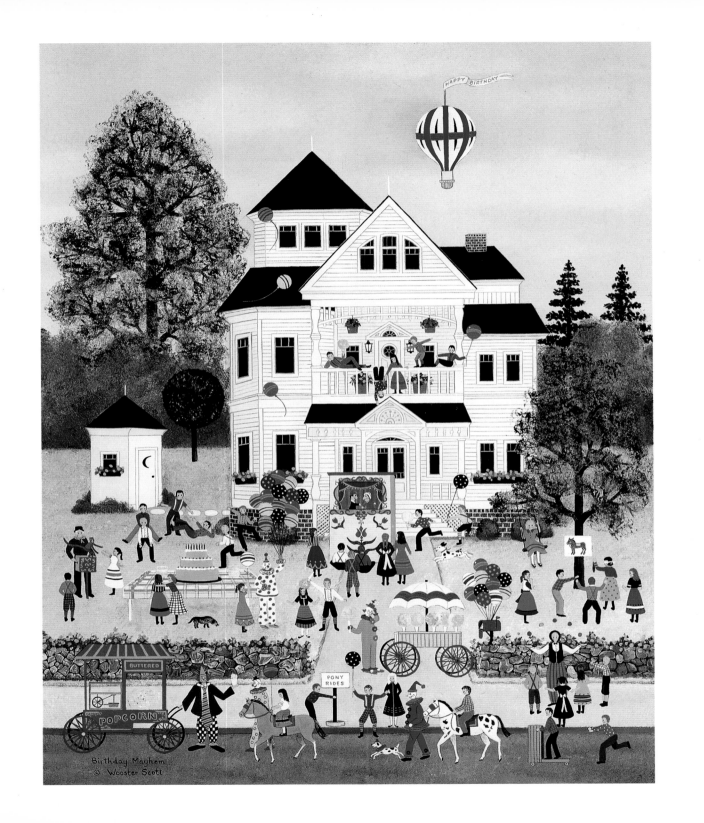

Birthday Mayhem
© Wooster Scott

High Flyers at Stormy Point

Kids are funny. These boys learned Benjamin Franklin discovered 'lectricity flying a kite in a lightning storm.

Well now, it worked for old Ben, but lighthouse keeper Thaddeus Throckmorton got all worked up when these scalawags flew their confounded kites too close to his light.

If you want to know the truth, Thaddeus nodded off. When he woke up that big black and white kite was right beside his window. Mistaking it for a runaway freighter, he bellowed, "Man the lifeboats!"

He tongue-lashed those boys good and proper. But there's some in these parts say Thaddeus ain't been right in the head since the Maine got sunk off Narragansett Bay. Or was that down in Havana?

(Left)
HIGH FLYERS AT STORMY POINT
Original oil on canvas 20 x 24 in (50.8 x 60.9 cm), 1991

Burton's Barnstormers

Like rare butterflies, this colorful flight of dancing, darting, soaring birds inspired children whose offspring would live to see supersonic jets savage the skies with thunder, contrails and bombs. Today thousands of sleek liners ply the commercial sky and go unnoticed on the ground.

But there was a time when aircraft gracefully adorned the heavens, filling us with awe and wonder. What fun it was to run outdoors at the purring sound of a skyborne engine, to point aloft and shout, "Lucky Lindy, throw us down a piece of cheese!"

Once airplanes were more beautiful than practical, more exciting and mysterious than anything man had made before.

Now it is difficult even to imagine there was such a time, such a place, such magical man-made birds.

(Right)
BURTON'S BARNSTORMERS
Original oil on canvas 16 x 20 in (40.6 x 50.8 cm), 1991

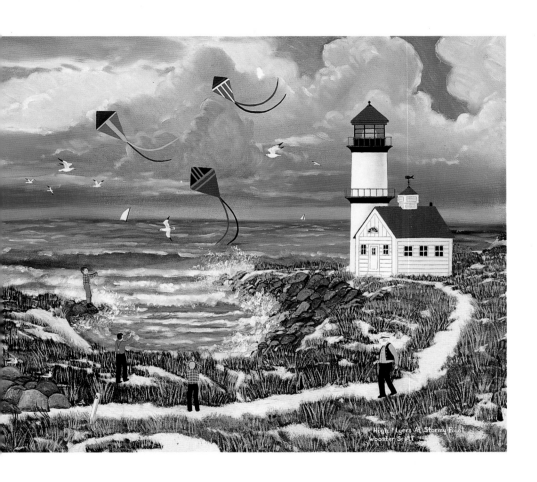

High Flyers At Stormy Point
Wooster Scott

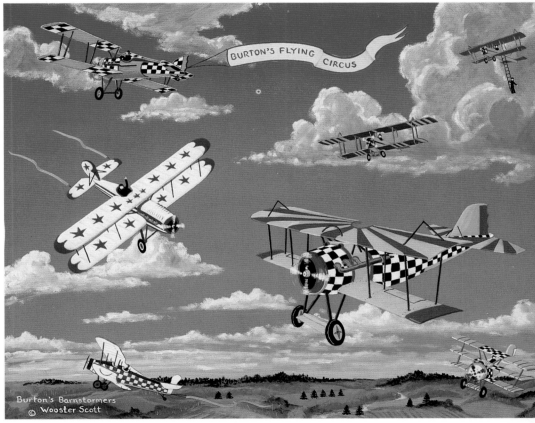

BURTON'S FLYING CIRCUS

Burton's Barnstormers
© Wooster Scott

Cape Cod Harbor

This painting makes you want to buy a boat and sail smack dab for this Down East inlet, tie up at the jetty and head for a pint at the Captain's Pub. Listen to the locals spin scuttlebutt yarns while an old salt plays a chanty on his concertina for the price of an ale. It sounds like an anthem in this time and place. Then to the Fish Shanty for a bowl of chowder with salty little oyster crackers. No rock 'n' roll, no automobiles or water pollution, or graffiti or television.

The good old days?

You bet your barnacles, matey.

CAPE COD HARBOR
Original oil on canvas 16 x 20 in (40.6 x 50.8 cm), 1987

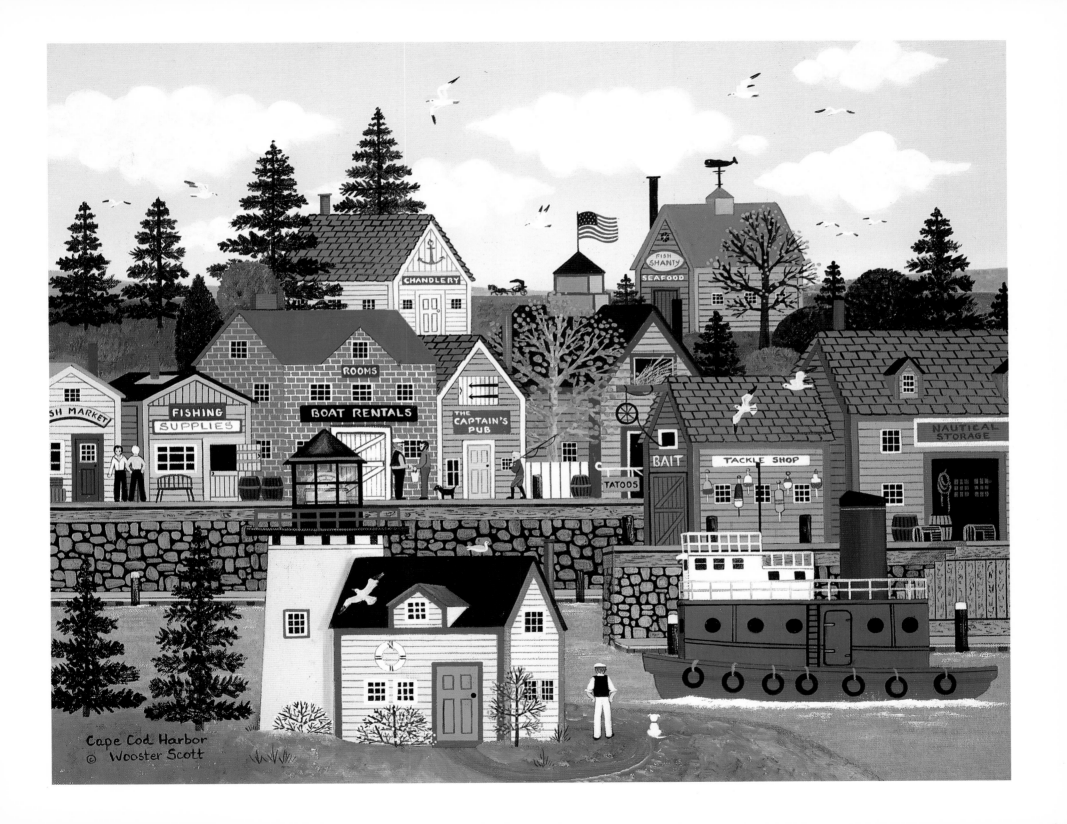

Cape Cod Harbor
© Wooster Scott

Carefree Days

Carefree is not one of the Four Freedoms. It isn't in the United States Constitution. It cannot be found in the Bill of Rights. Nor did our forefathers declare carefree an inalienable right.

Yet as civilizations go, America is the most carefree country on earth. To be sure, there are taxes, recessions, national debt and civil and personal strife enough to go around. But if a poll were taken in this wide land, who among us would prefer to live elsewhere?

Yes, there is room for improvement. But it would seem nobody has more fun than Americans. If not, then what's happening here?

CAREFREE DAYS
Original oil on canvas 24 x 30 in (60.9 x 76.2 cm), 1991
Offset lithograph 20 x 25 in (50.8 x 63.5 cm), 1992

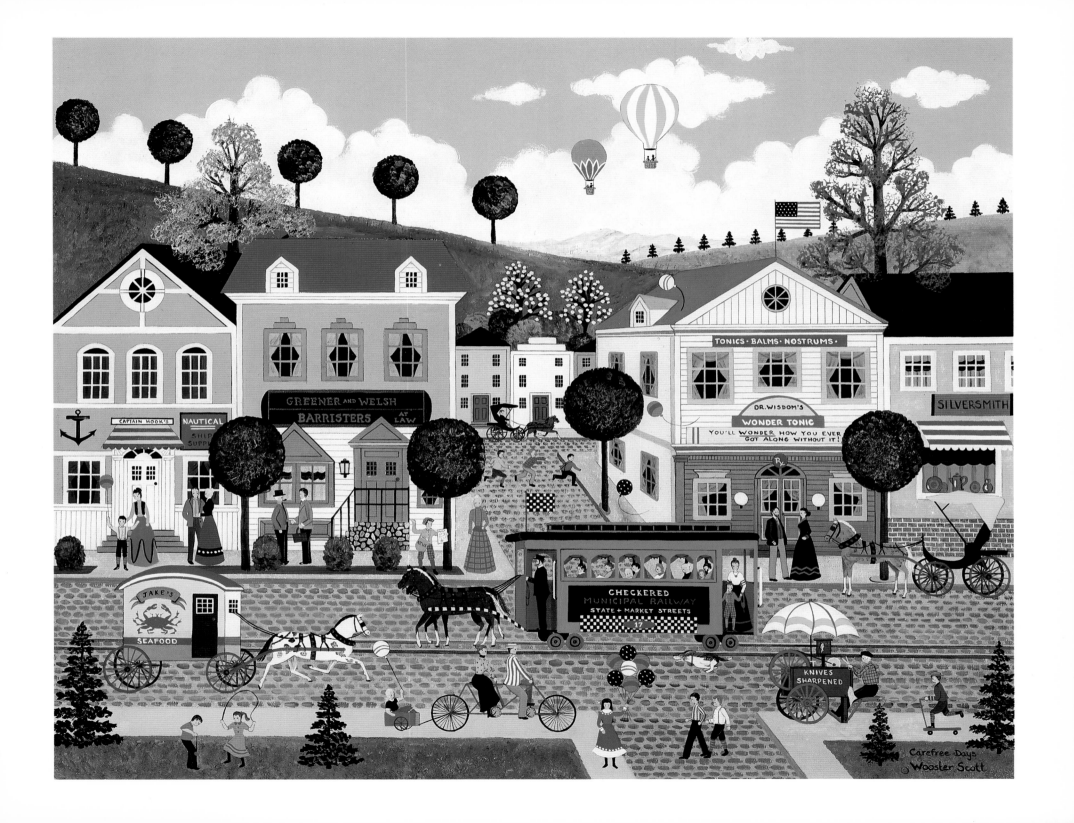

Head 'Em Off at the Pass

Jane Wooster Scott captures the magic of moviemaking on location with a horse opera somewhere in the not-so-wild west at a time when Native Americans and cowboys squared off.

Historically, of course, the tales were pure fiction. The cavalry and native tribes were adversaries, not cowpokes and Indians. When such films are made today, Indians are the good guys and soldiers the bad guys for the sake of political correctness, or perhaps simple historic accuracy.

Hollywood makes few Westerns now. But this one must have been a doozey. See that tall jasper in the black ten-gallon hat kibitzing the checker game in the foreground? Well, that canvas camp chair has his name inscribed on it. Everyone who ever worked with John Wayne loved him and called him *Duke*.

HEAD 'EM OFF AT THE PASS
Original oil on canvas 24 x 30 in (60.9 x 76.2 cm), 1992

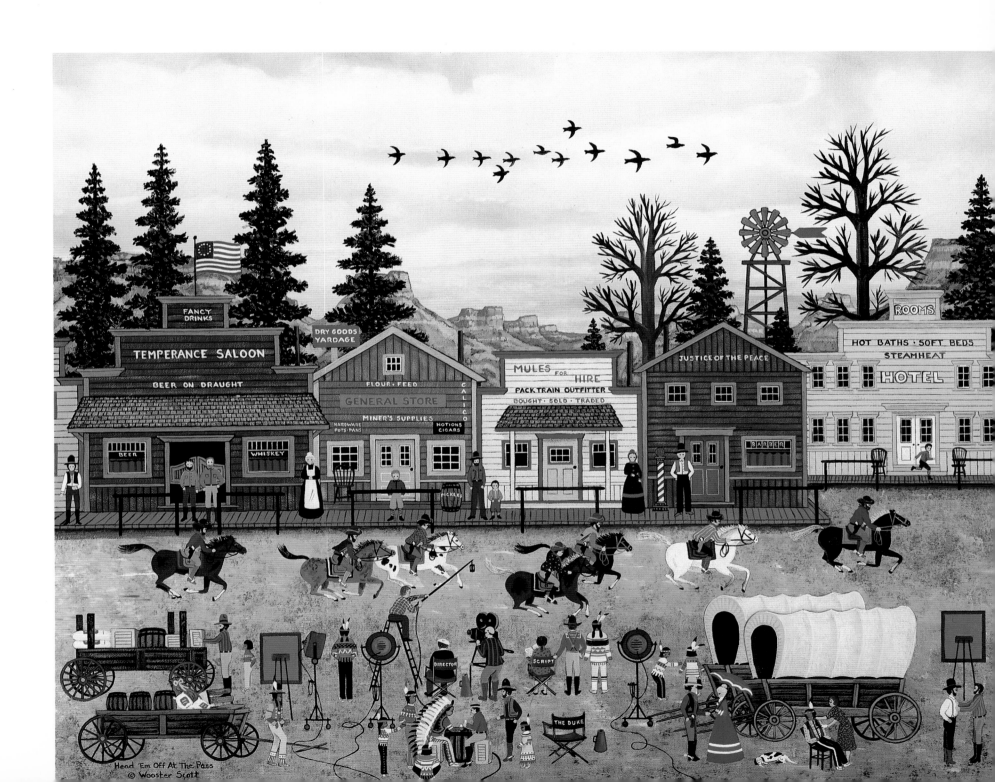

Head 'Em Off At The Pass
© Wooster Scott

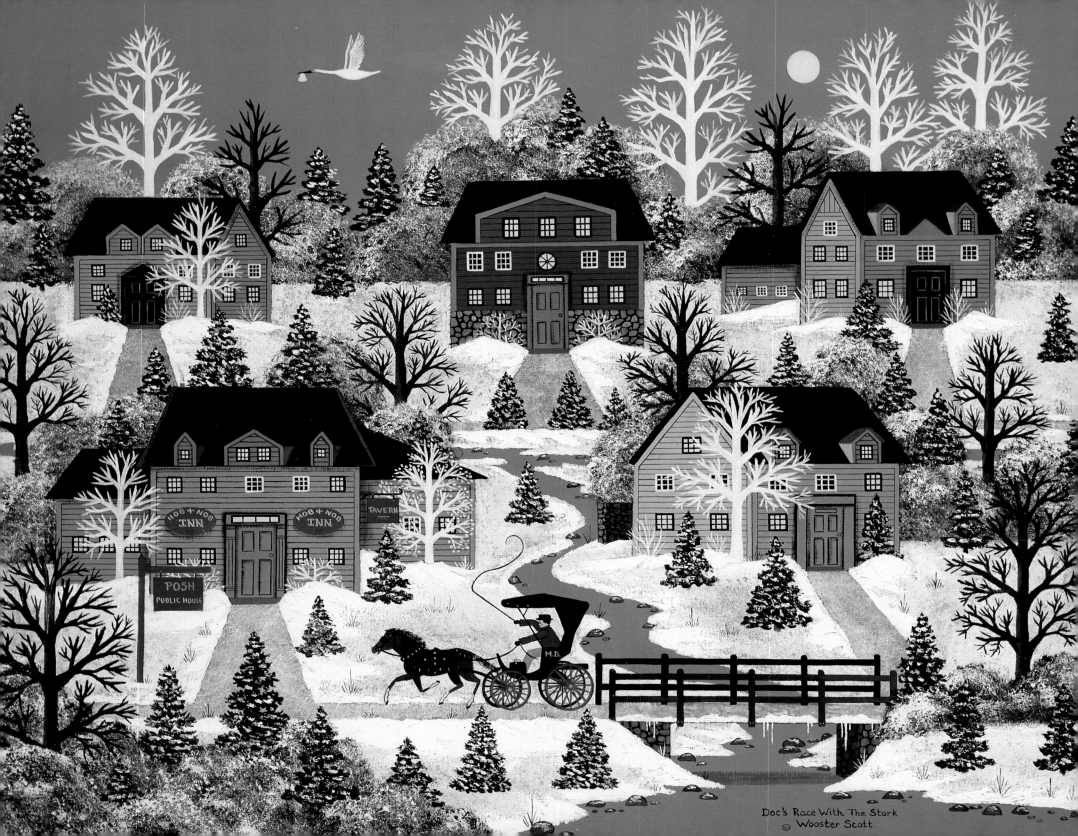

Doc's Race With The Stork
© Wooster Scott

Doc's Race with the Stork

At the moment it's a dead heat between old Mr. Stork and Doc Poindexter in the race to Mrs. Parmenter's bedside. Doc has a mind to stop for a refreshment at the Hob-Nob Tavern. But duty calls and Mr. Stork is gaining ground.

If Doc Poindexter beats that blasted bird to the finish line, maybe the new mother will name her baby after Doc. If it's a boy, of course.

How does Peter Poindexter Parmenter strike you?

DOC'S RACE WITH THE STORK
Original oil on canvas 24 x 30 in (60.9 x 76.2 cm), 1989
Offset lithograph 20 x 25 in (50.8 x 63.5 cm), 1991

Before the Nine O'Clock Bell

The three Rs were very much a part of this school's curriculum. And it was simple to distinguish between the boys and girls. Boys wore trousers and their hair short. Girls wore skirts and their hair long.

No lethal weapons were brought to classrooms and the teacher didn't take her life in her hands by turning her back to her pupils.

Youngsters were better educated in those times. But, happily, American students who genuinely seek an education can attain that goal today.

BEFORE THE NINE O'CLOCK BELL
Original oil on canvas 16 x 20 in (40.6 x 50.8 cm), 1992
From the collection of The Buckley School
silk screen serigraph 16 x 20 in (40.6 x 50.8 cm), 1992

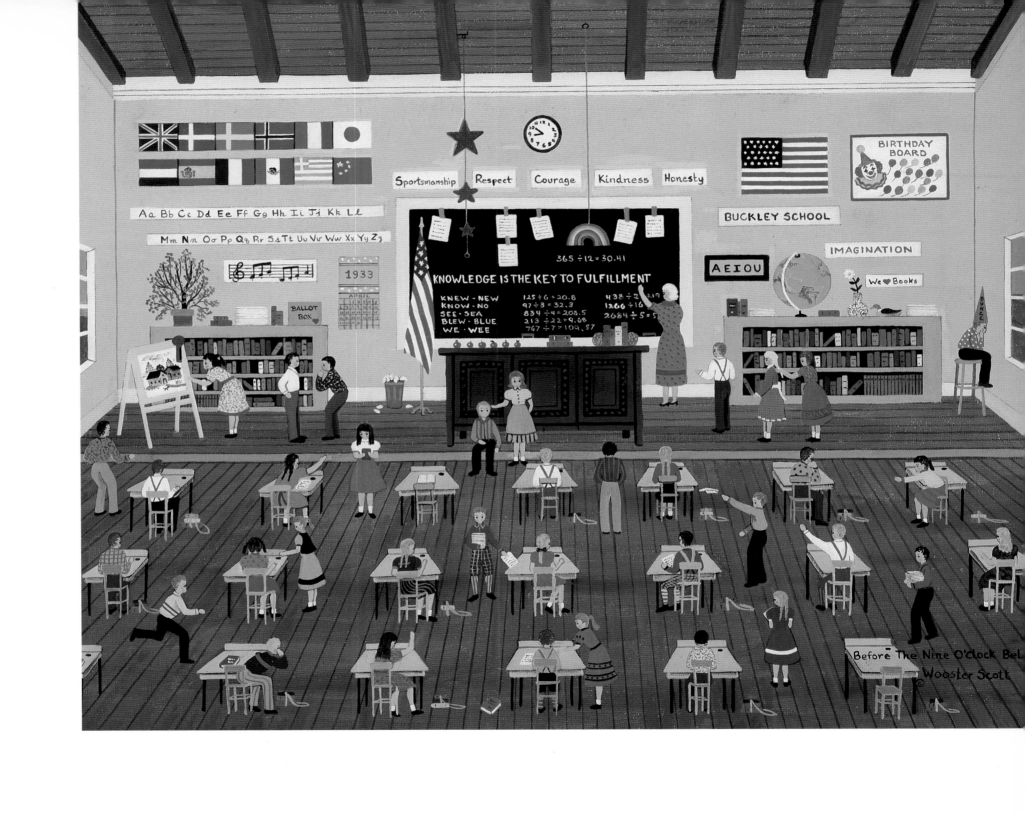

Beyond the Pumpkin Patch

Demons, goblins and ghosts.

Oh, my!

Not a fit night out for you

Or I.

The witches moon is rising fast.

This Halloween may be our last!

BEYOND THE PUMPKIN PATCH
Original oil on canvas 18 x 20 in (45.7 x 50.8 cm), 1982

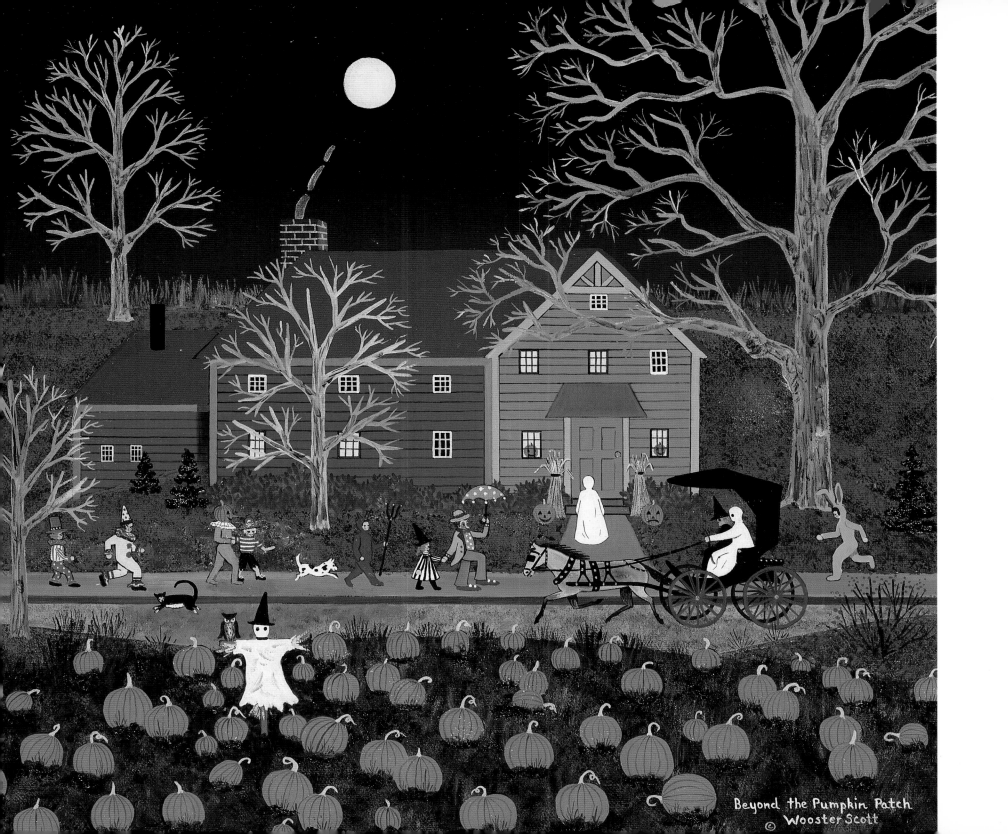

Beyond the Pumpkin Patch
Wooster Scott

Aeries for Canaries

Cstm. apts for cpls, sngls, riv/vu, terr. Ntg down, easy terms. Love birds welcome.

AERIES FOR CANARIES
Original oil on canvas 30 x 24 in (76.2 x 60.9 cm), 1992

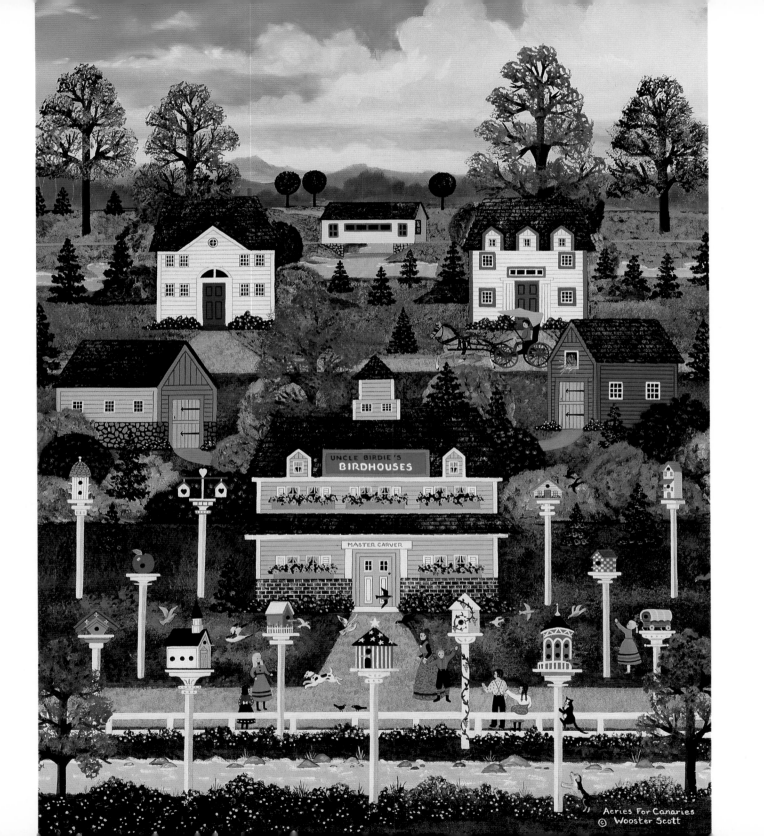

UNCLE BIRDIE'S
BIRDHOUSES

MASTER CARVER

Aeries For Canaries
© Wooster Scott

The Cape Milford Light

It's breezy on the Cape where gale-driven tides can blow ships right onto the beach. Were it not for the Milford Light piercing the storming gloom, many a vessel would founder. But not this beautiful day. If you were a ship you might gently nudge up to this inviting beach to laze in the luxury of a balmy New England afternoon.

THE CAPE MILFORD LIGHT
Original oil on canvas 30 x 40 in (76.2 x 101.6 cm), 1982
Silkscreen serigraph 32 x 24 in (81.2 x 60.9 cm), 1983

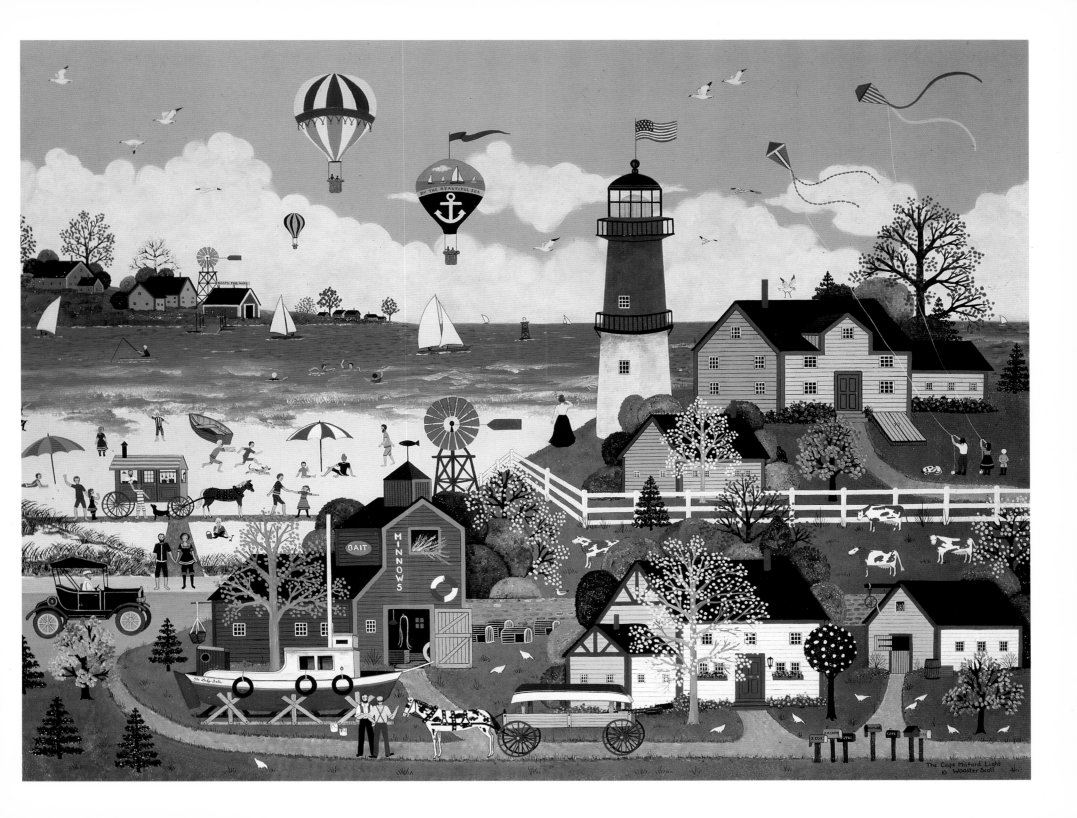

The Cape Milford Light
© Wooster Scott

A Profusion of Posies

Jane Wooster Scott has created a botanical wonderland of beautiful blossoms not to be found anywhere else but on this blooming canvas.

To be sure, not all these bountiful blooms can be found in botanical reference books. Not all of them have been identified as indigenous to any country or clime.

But if ever you see such a wondrous sight in your travels, be sure you've been led down the garden path.

A PROFUSION OF POSIES
Original oil on canvas 20 x 24 in (50.8 x 60.9 cm), 1993

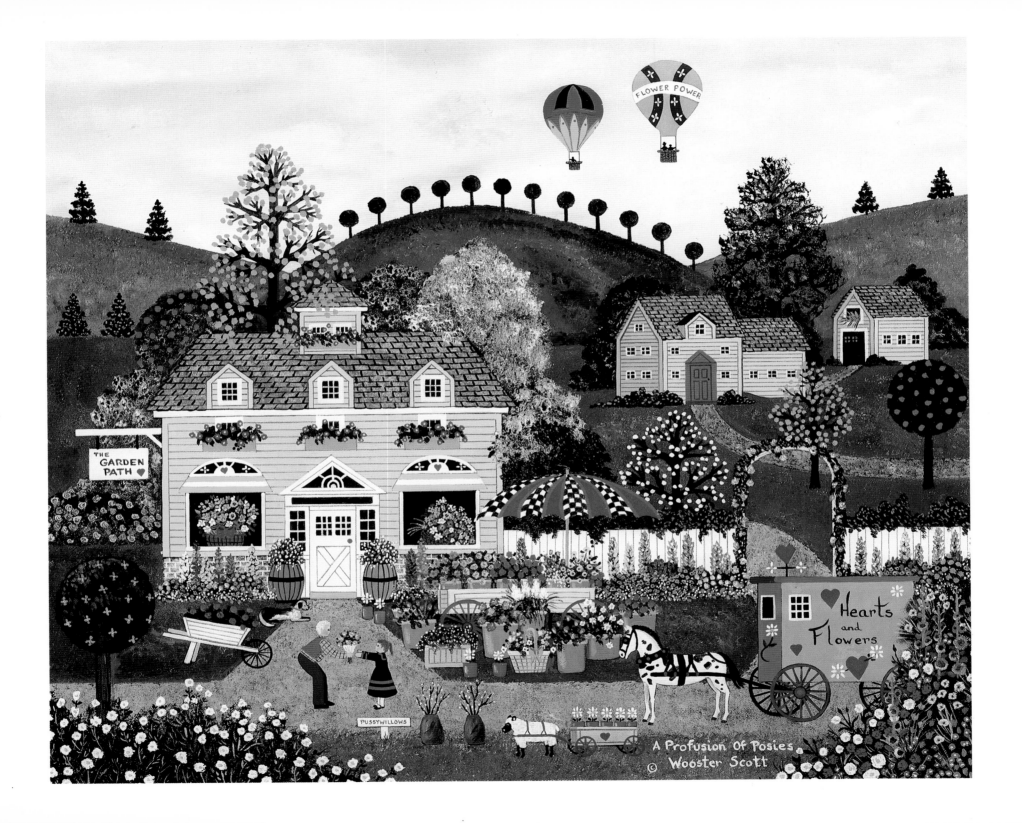

A Profusion Of Posies
© Wooster Scott

Command Performance

There's something wondrous about children and providence, children and the Creator. Especially when they raise pure voices to heaven. Maybe it's because they've left God so recently and sing in sweet reverence to their Maker.

COMMAND PERFORMANCE
Original oil on canvas 20 x 24 in (50.8 x 60.9 cm), 1990

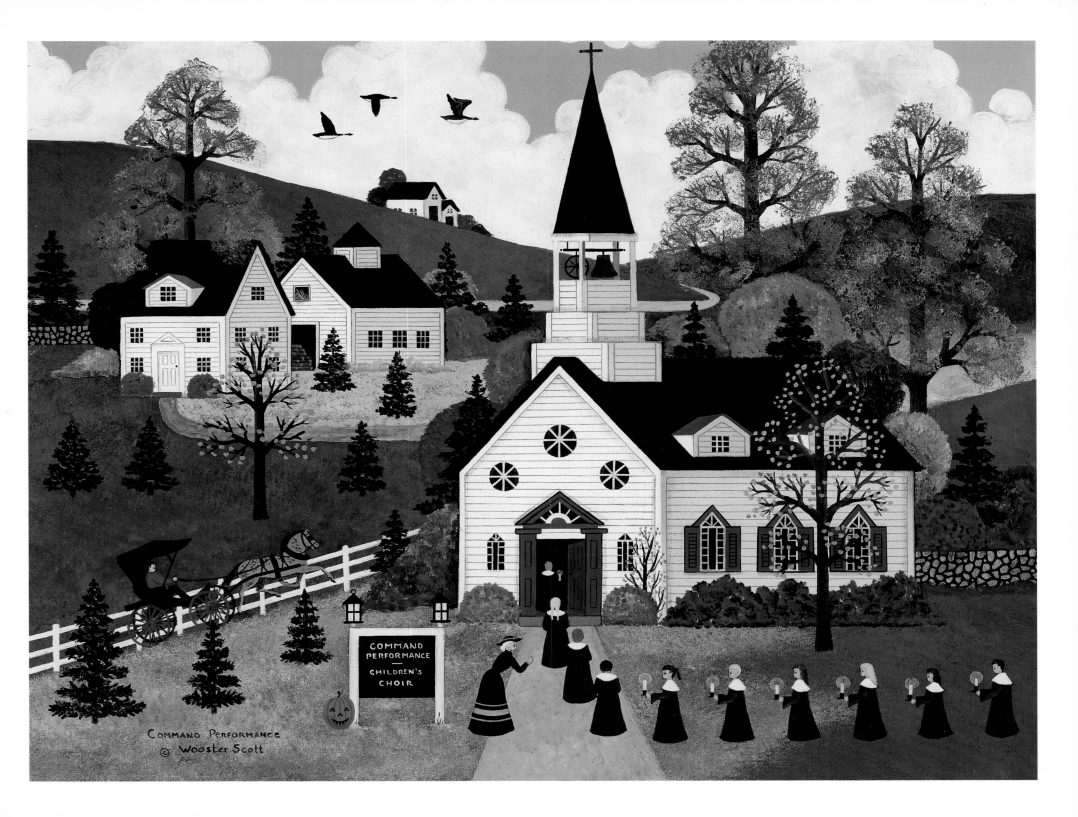

COMMAND
PERFORMANCE
—
CHILDREN'S
CHOIR

Command Performance
© Wooster Scott

Coupled

Newlyweds, we beseech you, beware!

Proceed with caution if you dare.

On departing these portals

You'll find you're mere mortals

But perhaps you're too eager to care.

Happily Ever After

There's solemnity to marriage 'midst nature's wonders.

No chapel compares to the astral dome of the heavens.

No carpet is so perfect as Earth's green mantle.

What better witnesses than the silent sentinel trees?

Feel the enduring substance of the towering mountain.

A burbling stream sings a paean to your future.

Listen and look about you, young bride and groom.

Your vows will echo in the soul of the planet.

Earth has given you her best; now you must give her yours.

(Top)
COUPLED
Original oil on canvas 16 x 20 in (40.6 x 50.8 cm), 1991
Offset lithograph 13 x 16¼ in (33.0 x 41.2 cm), 1992

(Bottom)
HAPPILY EVER AFTER
Original oil on canvas 24 x 30 in (60.9 x 76.2 cm), 1992
From the collection of Mr. and Mrs. Peter Kremer
Offset lithograph 11¼ x 14 in (28.5 x 35.5 cm), 1992

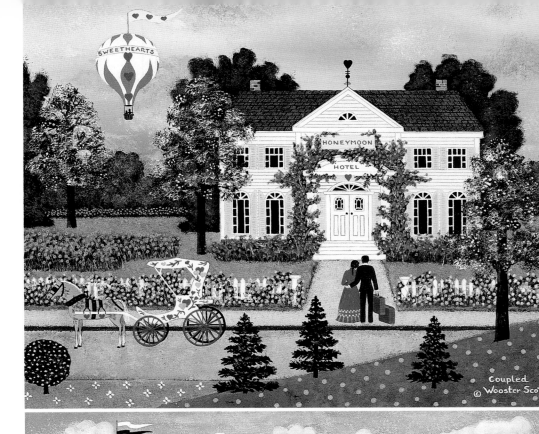

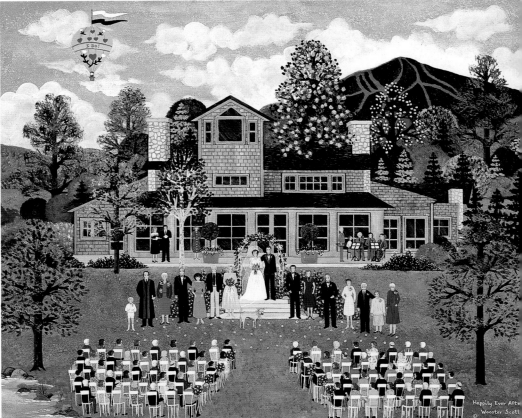

The Dow Is Up!

Wall Street's New York Stock Exchange has become the world's great financial center, a temple to fuel international economies. The constant flurry of action with traders shouting sell and buy orders in their indecipherable codes is a fascinating experience.

Even in the heart of high finance the artist finds the activity exciting and a vital part of our culture worth painting for posterity.

There is no more welcome news to millions of American stockholders than a financial report that leads off with "The Dow is Up!"

THE DOW IS UP!
Original oil on canvas 20 x 24 in (50.8 x 60.9 cm), 1985
From the collection of Karen Cameron
Silkscreen serigraph 20 x 24 in (50.8 x 60.9 cm), 1985

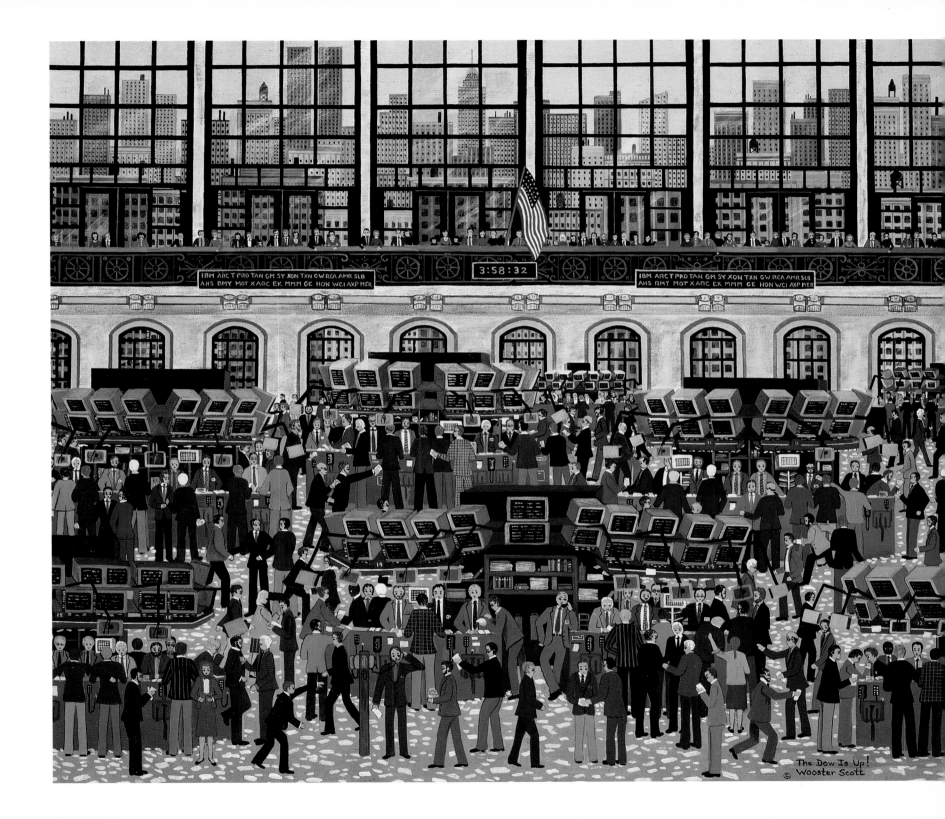

The Dow Is Up!
Wooster Scott

Easter at the White House

This painting has historical significance. It has hung in the President's house at 1600 Pennsylvania Avenue.

Jane Wooster Scott was officially commissioned to do the painting while President Ronald Reagan was in office.

It includes such Eastertime customs as egg rolling and an Easter egg hunt on the South Lawn of the best-known and beloved residence in the U.S.A.

EASTER AT THE WHITE HOUSE
Original oil on canvas 30 x 24 in (76.2 x 60.9 cm), 1986

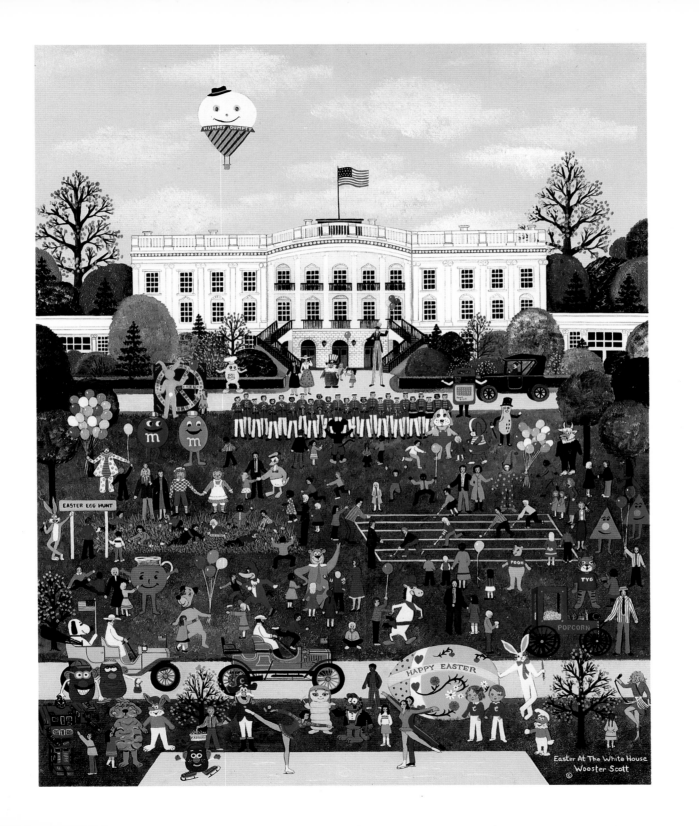

Easter At The White House
Wooster Scott
©

Eighth Avenue

How many New Yorkers, do you suppose, take time to see the beauty of their city in the pulsating bustle of daily life in Manhattan?

Beauty is here, almost everywhere you turn your eyes. If you look for it.

The newspaper kiosk is real. So is Central Park and the most spectacular skyline of all, an urban marvel more complex and delicately fashioned than all Seven Wonders of the ancient world.

One hopes New Yorkers stop again and again, as we tourists do, to stare with wonder at our planet's most magnificent living sculpture. It could not have been envisioned a thousand years ago. Not even a century ago.

Who can imagine the splendors humankind will create a thousand years from now?

EIGHTH AVENUE
Original oil on canvas 16 x 20 in (40.6 x 50.8 cm), 1984
From the collection of Ron Sunderland

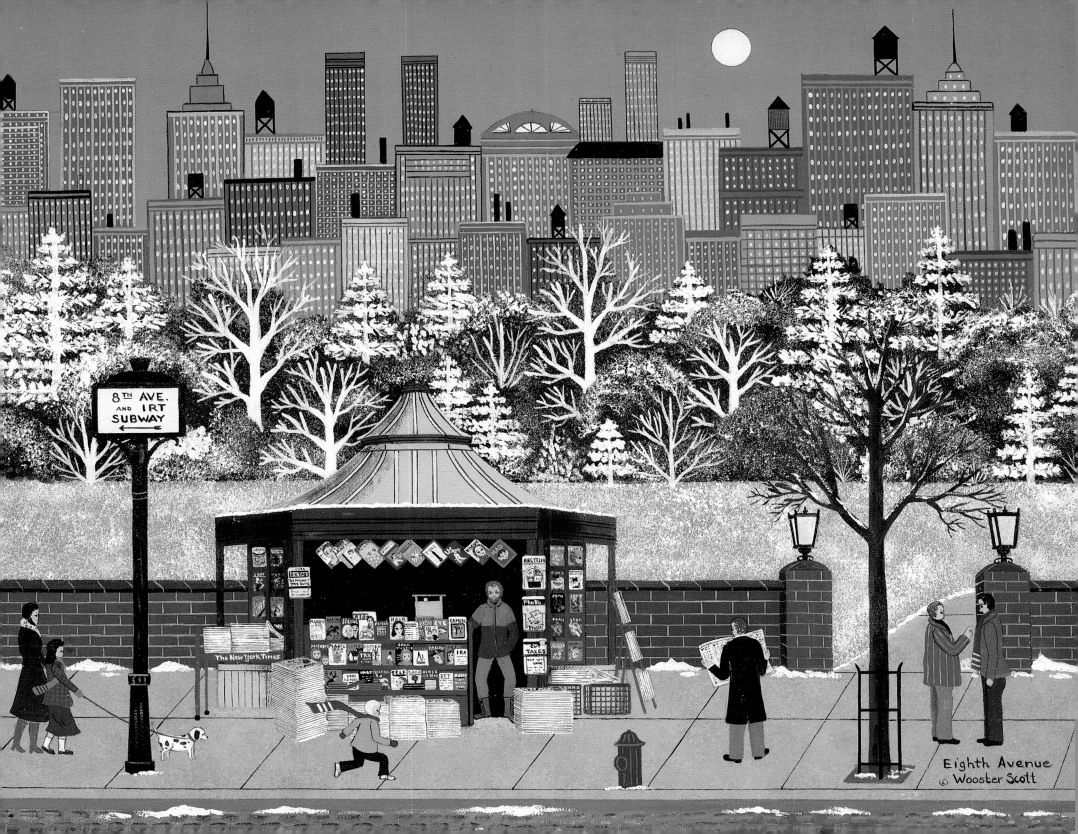

8TH AVE. AND IRT SUBWAY

The New York Times

Eighth Avenue
© Wooster Scott

Feminists Beware!

This bastion of male good fellowship could not exist today without pickets, placards and shouting females demanding entrance and equal rights.

Why?

There is nothing special about MEN ONLY establishments except the absence of women, uninhibited masculine banter and stupidity. Why should men not have that right? Men are more than pleased that women have exclusive female establishments.

Is it possible women, too, occasionally appreciate respite from their gender?

(Top)
FEMINISTS BEWARE!
Original oil on canvas 20 x 24 in (50.8 x 60.9 cm), 1990
Offset lithograph 10½ x 12⅝ in (50.8 x 60.9 cm), 1991

La Femme Fatale

A chance meeting perhaps?

Almost certainly not.

As she so often does, the artist allows us to reach our own conclusions. The lady in her fanciest frills, complete with matching parasol, clearly has bewitched the unsuspecting seafarer. A captain by the look of his stripes and the cut of his jib.

But Jane Wooster Scott has given us more to think about than this innocent rendezvous. There are two femmes fatale in this painting. The older damsel sets an example in affairs of the heart for the fledgling lass who has captivated an admirer of her own.

LA FEMME FATALE
Original oil on canvas 20 x 24 in (50.8 x 60.9 cm), 1989
From the collection of Mr. and Mrs. Mahammed Mortazavi
Offset lithograph 10¾ x 12⅞ in (27.3 x 32.6 cm), 1991

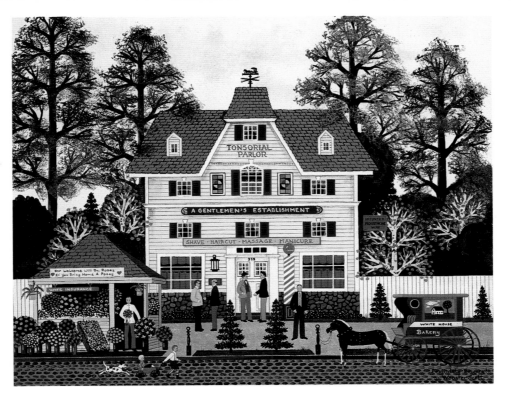

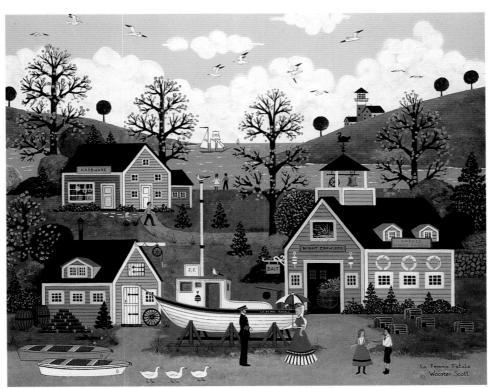

Moonlight Merriment

There is an invigorating element about the holidays that inspires winter-bound citizens to get out into the glittering evening, bundled up and filled with a desire to keep moving, if for no other reason than to keep from freezing.

Father Frost can take credit for the joyous activity on this nippy night when a full moon casts a benevolent light on the merrymakers.

MOONLIGHT MERRIMENT
Original oil on canvas 20 x 24 in (50.8 x 60.9 cm), 1993
From the collection of Kim Verde
Offset lithograph 16 x 19⅓ in (40.6 x 48.7 cm), 1993

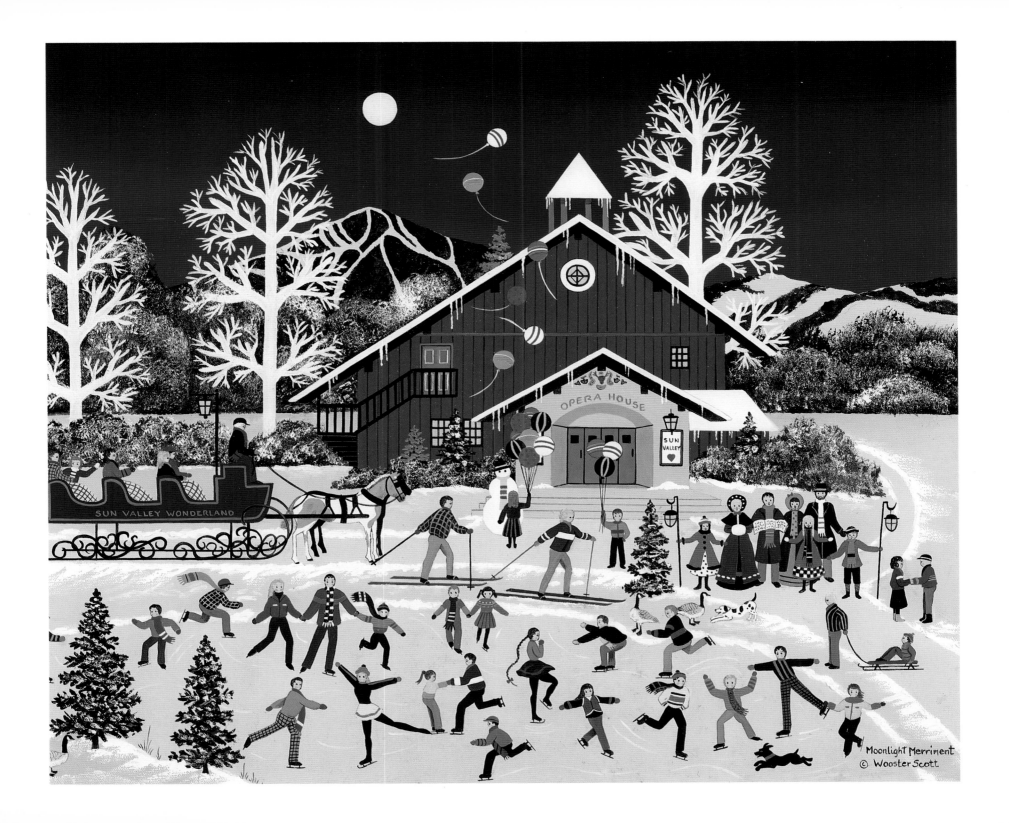

Moonlight Merriment
© Wooster Scott

Admiring the New House

Intimidated by its grandeur, a young family stands in awe of its soon-to-be new home. This classic Victorian edifice will cosset and nurture its new inhabitants, perhaps for generations to come.

(Left)
ADMIRING THE NEW HOUSE
Original oil on canvas 24 x 18 in (60.9 x 45.7 cm), 1984
From the collection of Ed McMahon

Crispy Day at Butternut Junction

The yellow roofs and caramel clouds gave this painting a natural title. We see a remarkably neat depot in a remarkably orderly community. Wouldn't it be terrific if the railroad engine had a yellow smoke stack and all the freight cars were butternut yellow too?

(Right)
CRISPY DAY AT BUTTERNUT JUNCTION
Original oil on canvas 30 x 24 in (76.2 x 60.9 cm), 1982
From the collection of Mr. and Mrs. William Ahmanson

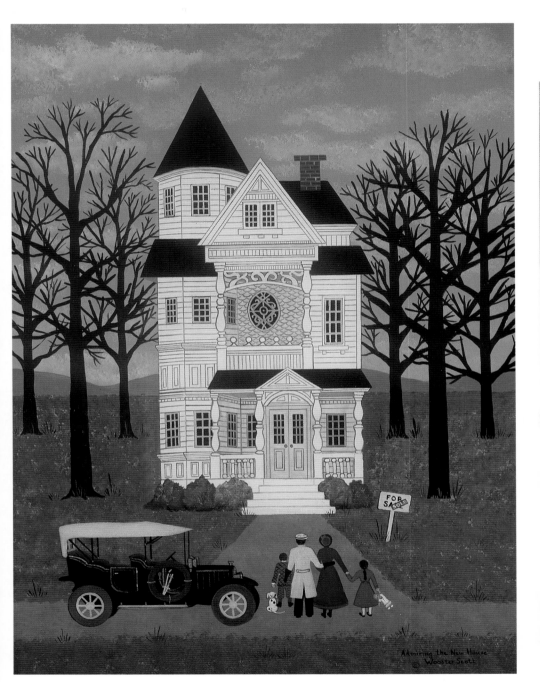

"Admiring the New House
© Wooster Scott

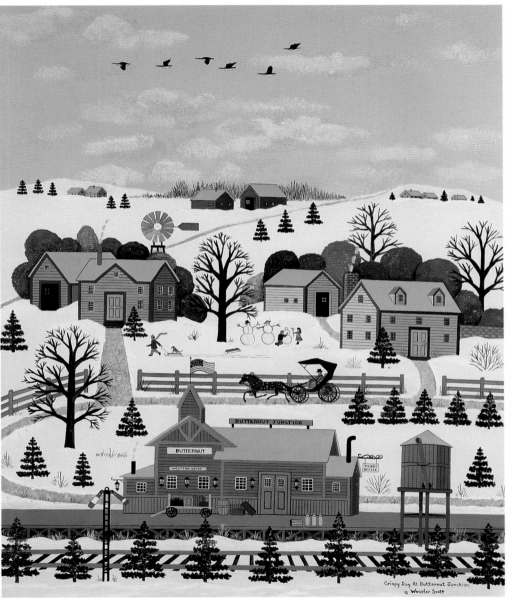

Crispy Day At Butternut Junction
© Wooster Scott

Bountiful Harvest

Few dynamics create greater feelings of well-being in humankind than Earth's rich harvest. Her bounty grants our very lives each autumn, rewarding labor, restoring faith, insuring the future.

Be it rich bottom loam, as the artist depicts, or hard-scrabble crofts in faraway lands, our earth feeds, clothes and shelters each living creature. Yet, like ungrateful children, we plunder and abuse our profoundly nurturing planet, our universal parent.

Please, revere her, all.

BOUNTIFUL HARVEST
Original oil on canvas 24 x 30 in (60.9 x 76.2 cm), 1992
Silkscreen serigraph 23¼ x 29 in (59.0 x 73.6 cm), 1993

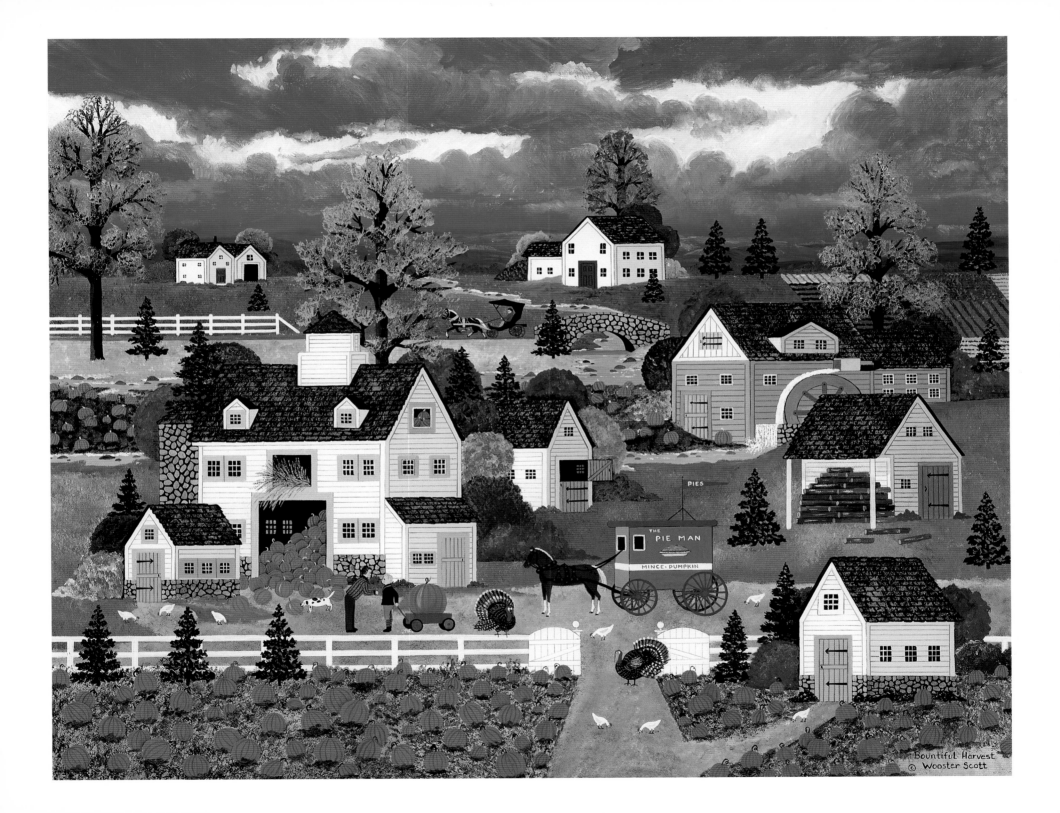

Bountiful Harvest
© Wooster Scott

A Time for Sugaring

Among America's most cherished traditions is the annual winter tapping of giant sugar maples in New England. The custom, called "sugaring off," began shortly after the Puritans arrived at Plymouth Rock.

The delicious harvest continues four hundred years later with the process almost unchanged. Sap is collected in pails from spiggots pounded through the bark of each tree. The sap is poured into kettles to boil away impurities, congealing in a succulent residue. When mixed with snow, while still viscous and hot, it produces instant candy, much favored by Yankee youngsters. But mostly it becomes famed New England maple syrup to sweeten hotcakes, waffles and other culinary delights around the civilized world.

A TIME FOR SUGARING
Original oil on canvas 30 x 40 in (76.2 x 101.6 cm), 1991
From the collection of the artist
Silkscreen serigraph 24 x 32 in (60.9 x 81.2 cm), 1993

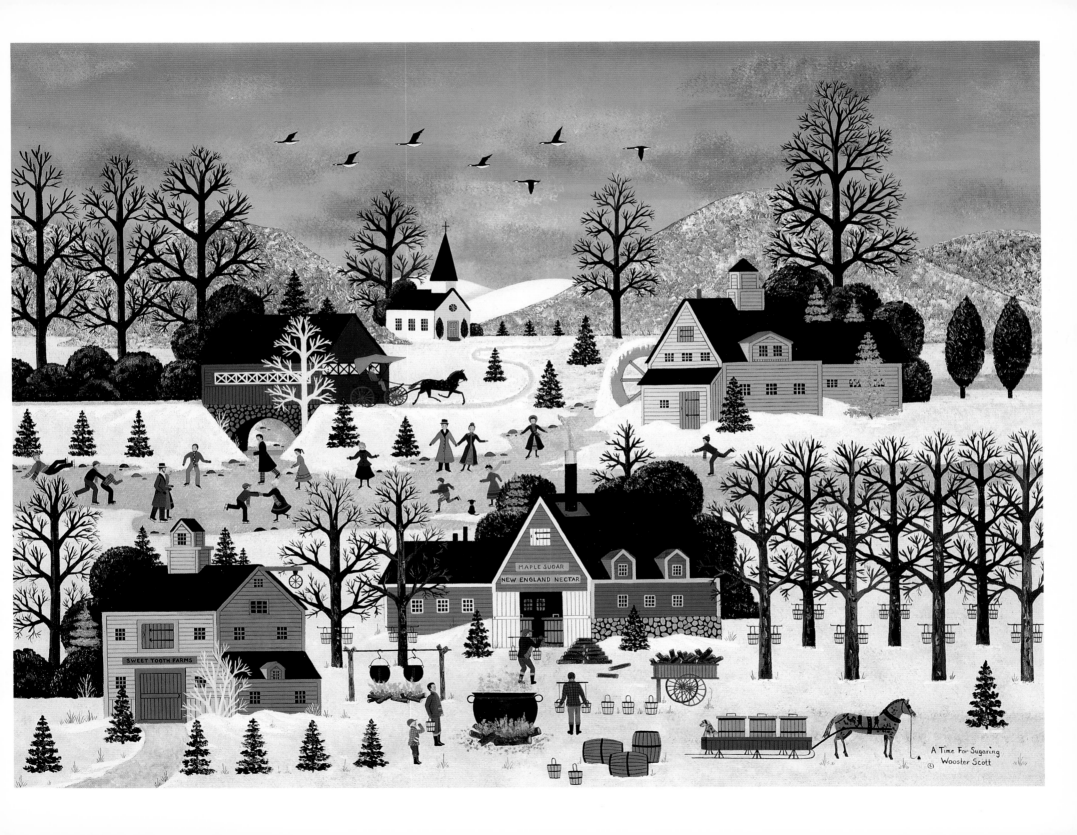

SWEET TOOTH FARMS

MAPLE SUGAR
NEW ENGLAND NECTAR

A Time For Sugaring
Wooster Scott

Sunday in New England

Composition, design and color are the triad on which the artist renders her view of the world around her. The composition becomes more than the sum of its component parts, in this case a complex of homes, shops, streams and sea supporting a network of human activities. Instinctively, this painter, with no formal training, brings diverse elements together to create a unique whole whose purpose is to pleasure the eye and other sensibilities.

SUNDAY IN NEW ENGLAND
Original oil on canvas 30 x 40 in, (76.2 x 101.6 cm), 1987
From the collection of Mr. & Mrs. John Ruffo

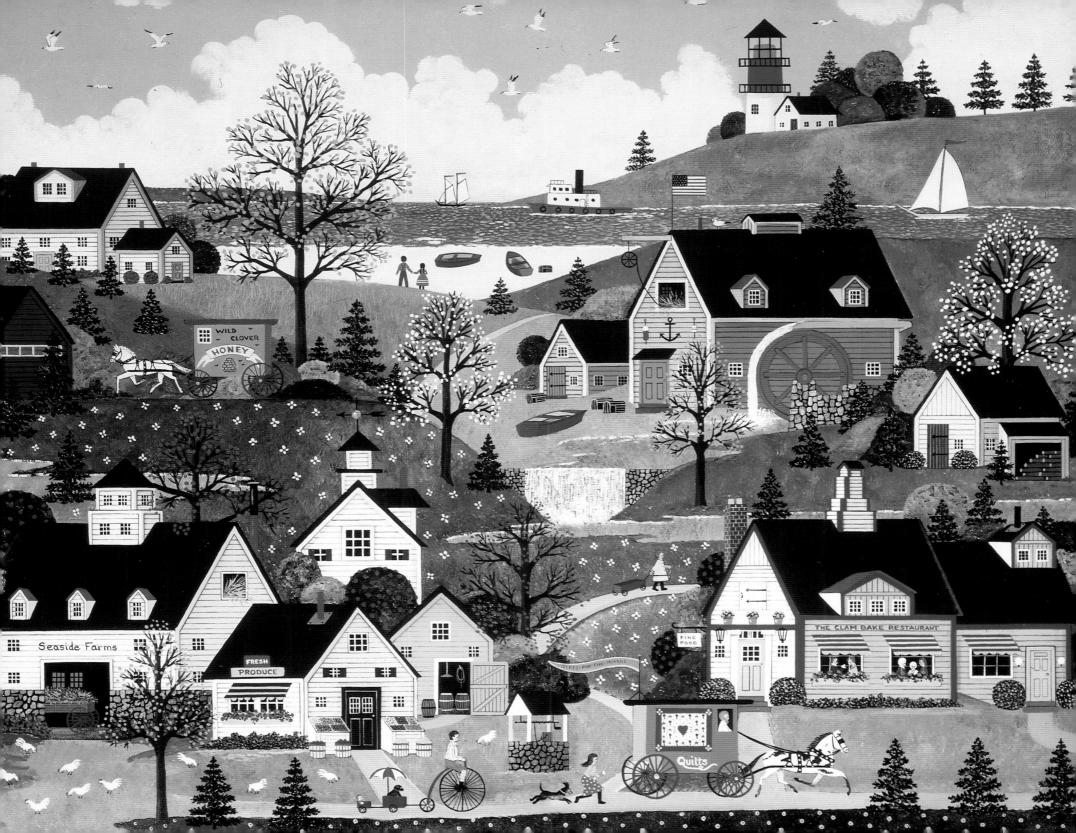

Swing Your Partner

Hey now, dancers, do-si-do,

Swing your partners to and fro.

Step to the left, sashay to the right,

Promenade down, now ain't we a sight!

This here barn dance is a 100 percent bonafide American western cultural event, maybe in Oklahoma, Texas or Colorado before the land was fully tamed. A balmy night with a full moon rising has coaxed musicians and dancers out into the air where vittles are cooking and the cider is cool. But you better keep your eye on Caleb and Lulu Jane dancing up a storm out by the old silo.

SWING YOUR PARTNER
Original oil on canvas 24 x 30 in (60.9 x 76.2 cm), 1988
Offset lithograph 21 x 26 in (53.3 x 66.0 cm), 1988

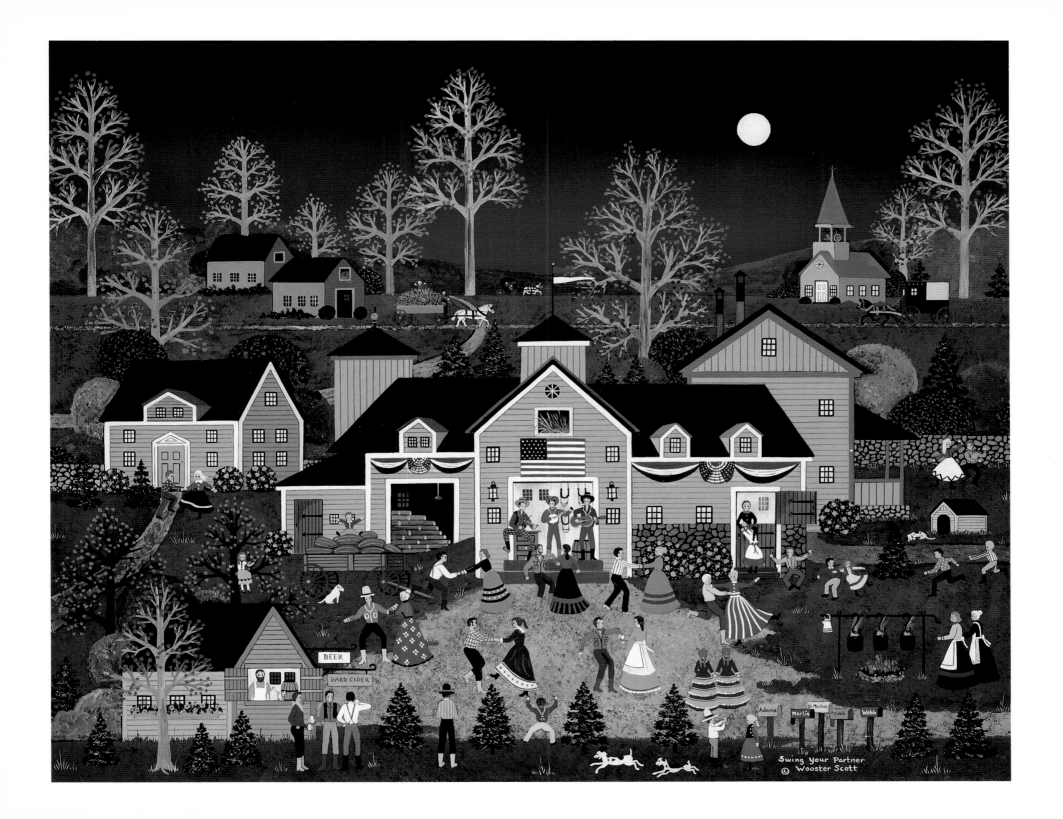

BEER

HARD CIDER

Adams Martin Di Martino Cobb Webb

Swing Your Partner
© Wooster Scott

Tender Ministrations

Veterinarians are heroes to animal lovers of every stripe, particularly this rural practitioner whose patients include an alarming variety of four-footed critters. He's accustomed to horses, cows, dogs and cats, and even the odd goose or goat. But pity the horse doctor on this free clinic day when he spots that black and white polecat varmint near the head of the line.

TENDER MINISTRATIONS
Original oil on canvas 24 x 30 in (60.9 x 76.2 cm), 1992

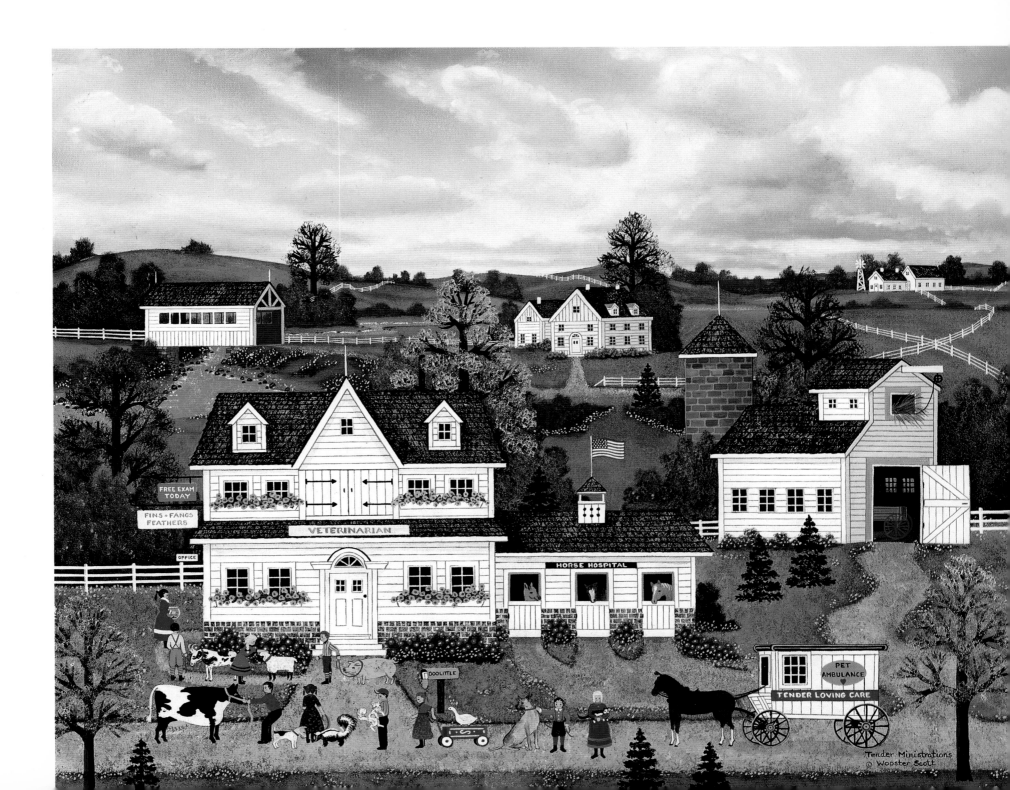

Autumn Hayride

Many a freckle-faced girl received her first kiss on just such an excursion, and many a red-faced boy got a slap in the face. Doubtless, many a husband and wife later recalled the exchange with affection.

Autumn was best for hayrides, cool enough for snuggling in the fresh-cut straw with its warm, pungent scent. There were sing-songs, *Wait Till The Sun Shines Nelly* and *Down By The Old Mill Stream*. And whoops of joy—until the sun went down.

Once the full moon climbed in the sky, silence descended on the wagon except for the plodding clip-clop of old Dobbin, interrupted now and again by a giggle and, ouch! the occasional slap.

If you are seventy or older, perhaps you remember.

(Top)
AUTUMN HAYRIDE
Original oil on canvas 20 x 24 in (50.8 x 60.9 cm), 1982
From the collection of Arthur Crames

A Lonely Trek

Some men chose to open mercantile establishments in population centers, throw open their doors and invite the world to beat a path to their emporiums. Other entrepreneurs could not adjust to the immobility of city life although they were merchants at heart.

Restlessness of independent men brought forth the peddler who eventually produced the traveling salesman. In the 18th and 19th century peddlers were commonplace across the great expanses of the vast American continent.

Their spirit of adventure, quest for new horizons and a pioneering instinct fulfilled their dreams of independence and freedom while providing them a means to earn a living.

But they paid a price, too. There were cheerless, lonely nights between hamlets, villages and isolated farmhouses with no families to welcome them, no cheery hearths. But they found solace in the ever-changing beauty and wonder of a land of surpassing beauty and variety.

(Bottom)
A LONELY TREK
Original oil on canvas 12 x 24 in (30.4 x 60.9 cm), 1991
From the collection of the artist

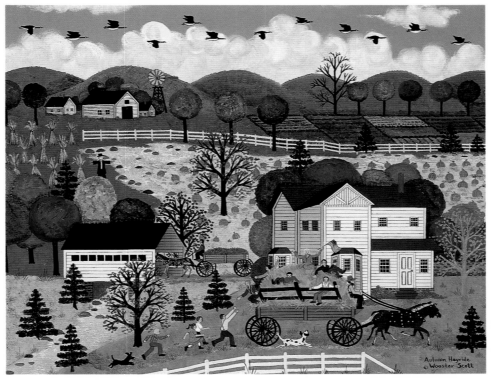

Autumn Hayride
© Wooster Scott

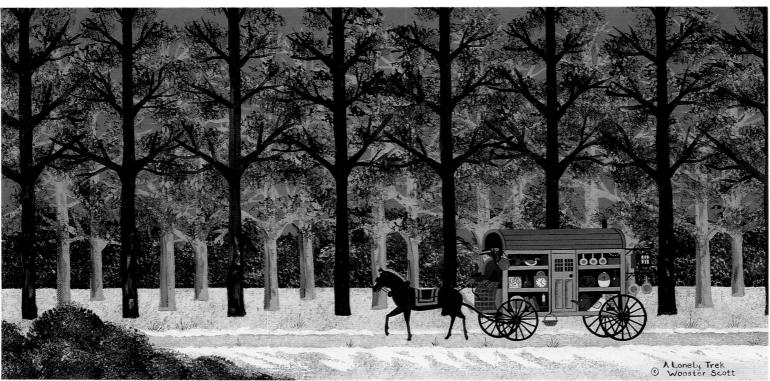

A Lonely Trek
© Wooster Scott

Tomorrow's Champs

A frozen pond, clamp-on skates and tree limbs carved into proper hockey sticks made instant stars of this gaggle of future athletes. A cast-off shoe sole or scrap of burl served as a puck. The hard-fought match raged on till sunset, only to resume the next day after chores. Some day, mark my words, they'll be playing in the NHL.

Damn betcha!

TOMORROW'S CHAMPS
Original oil on canvas 16 x 20 in (40.6 x 50.8 cm), 1992
From the collection of Mr. & Mrs. Lloyd Pettit

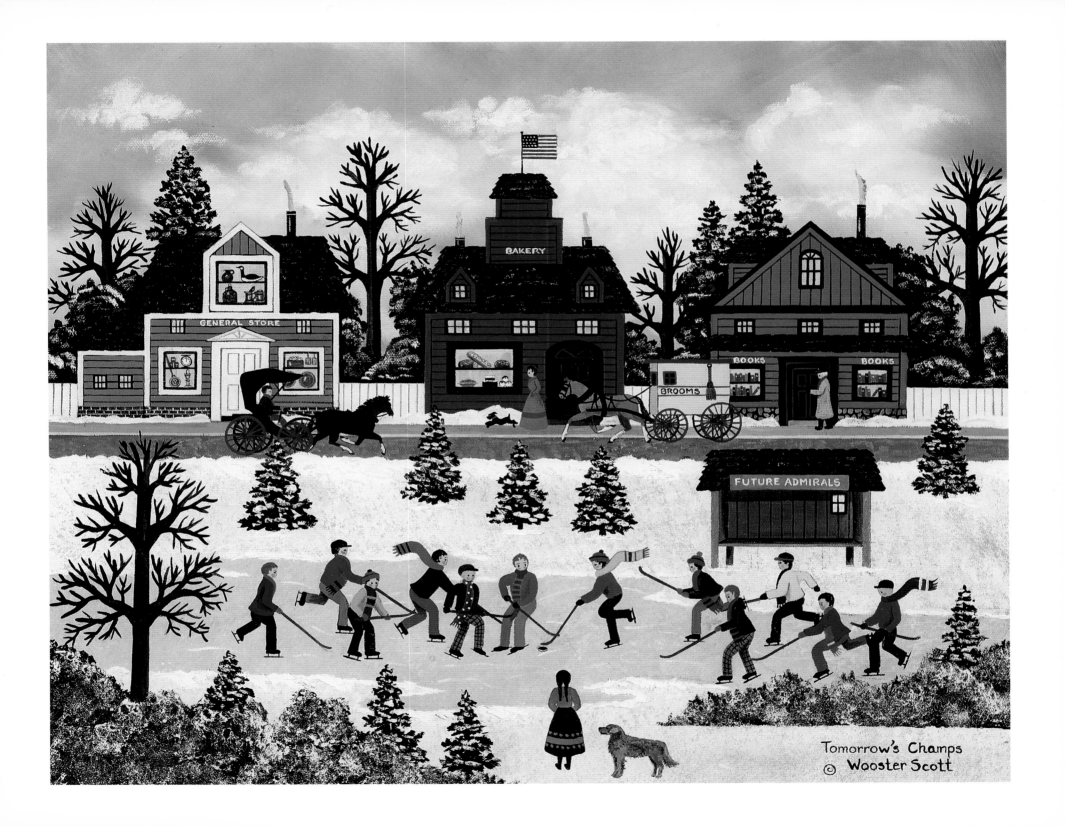

GENERAL STORE

BAKERY

BROOMS

BOOKS BOOKS

FUTURE ADMIRALS

Tomorrow's Champs
© Wooster Scott

Central Park Contrast

It takes all kinds. City folk and country folk.

On this moonlit evening a handful of New Yorkers have it both ways in the pasture of the great American metropolis. New York's traditions are rooted in pre-Revolutionary days, embedded in Manhattan Island's solid granite, meant to last forever.

If you happen upon Central Park, climb atop an ancient rock poking through the earth. Then glance at the city's breathtaking skyline. One gets the feeling those towering spires, too, will endure for thousands of years. At least as long as the mossy boulder you're standing on.

CENTRAL PARK CONTRAST
Original oil on canvas 40 x 30 in (101.6 x 76.2 cm), 1986
From the collection of Mr. and Mrs. Robert Ruggles

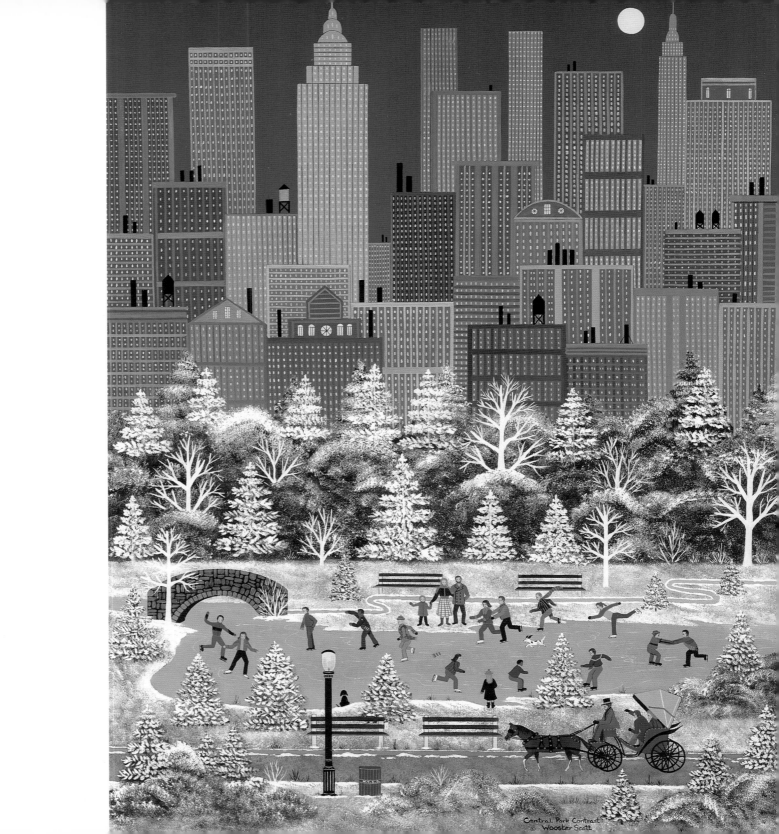

Central Park Contrast
© Wooster Scott

Queen of the Trail

The preoccupied nimrod must have hooked a whopper of a rainbow in the fast-moving mountain stream. Else he has no excuse for not admiring the parade of exquisite equestriennes on their magnificent mounts passing by.

More than likely, this is just another fish story.

It could happen.

QUEEN OF THE TRAIL
Original oil on canvas 24 x 30 in (60.9 x 76.2 cm), 1991
From the collection of Mr. and Mrs. Harry Jones
Offset lithograph 16 x 20 in (40.6 x 50.8 cm), 1993

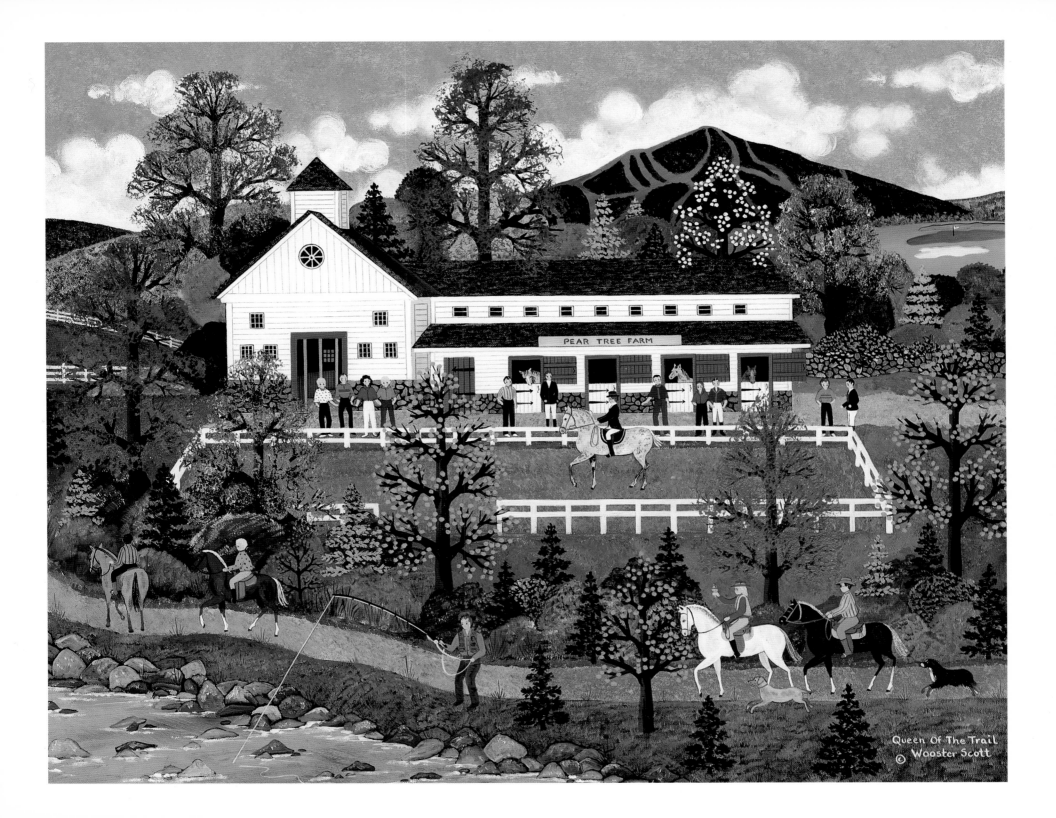

Queen Of The Trail
© Wooster Scott

Moonlight Funning

The boundless joy of Jane Wooster Scott's paintings is apparent in
all aspects of *Moonlight Funning*, reflecting the essential optimism of the
artist. Clearly, she views the world as a place of hope, elan and innocent
pleasures. Would it were thus.

MOONLIGHT FUNNING
Original oil on canvas 20 x 24 in (50.8 x 60.9 cm), 1988
Silkscreen serigraph 22 x 28 in (55.8 x 71.1 cm), 1990

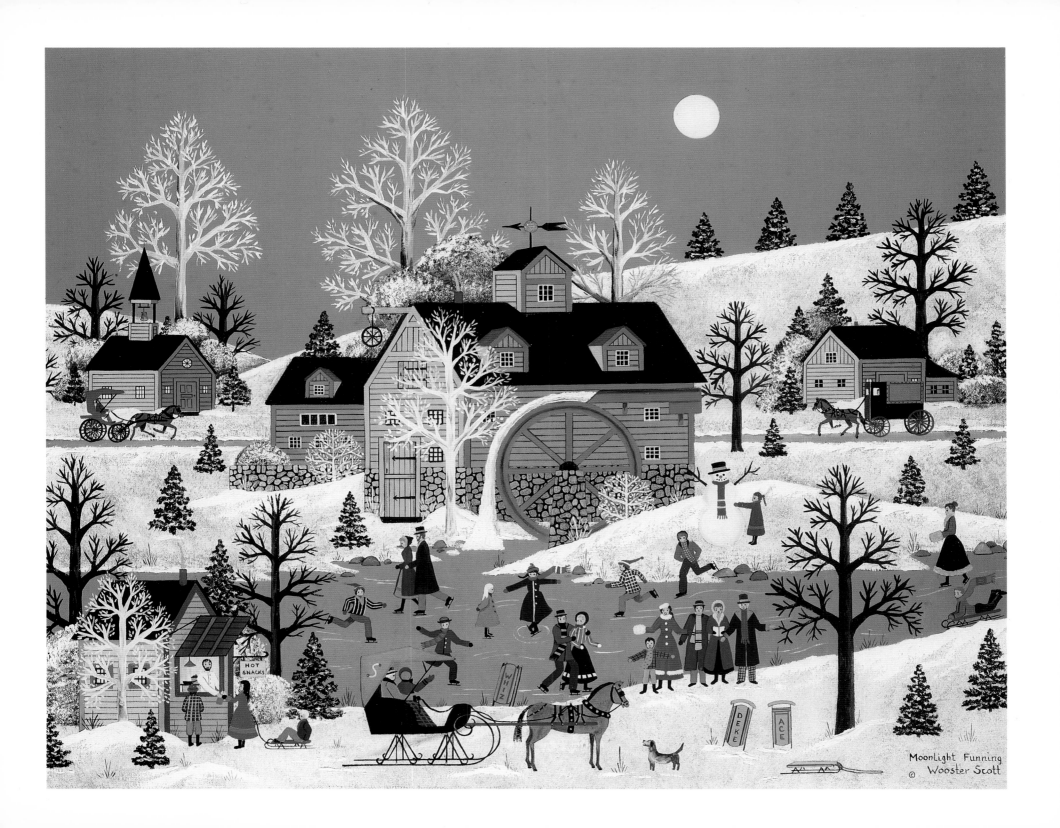

Moonlight Funning
© Wooster Scott

The 12:09 – On Time Again!

Sure as shootin' folks in Sweet Apple Junction could set their timepieces by the 12:09 as it rattled and clanked into the depot, its stack belching smoke, its firebox shooting sparks and setting our noses aquiver with the pungence of burning coal.

It was such a gleaming, pretty thing, the 12:09, a living link to the rest of the world, arriving chock full of fascinating outlanders with straw suitcases, leather grips and mysterious-looking satchels. Sometimes the baggage car carried big old wood and metal trunks with genuine stickers from far-away lands.

Townsfolk came arunning to see who was boarding the train. And who was getting off. Our lives were sure to change somewhat with every arrival and departure.

'Course, once in a while the 12:09 was a mite late. Sometimes it didn't stop at all. The engineer would just blast the whistle and clang the bell as he tore on through. But then nobody would have heard of Sweet Apple Junction at all if it wasn't for the Union Pacific Railroad, Inc.

THE 12:09 — ON TIME AGAIN!
Original oil on canvas 30 x 40 in (76.2 x 101.6 cm), 1989
Silkscreen serigraph 22¾ x 30 in (57.7 x 76.2 cm), 1989

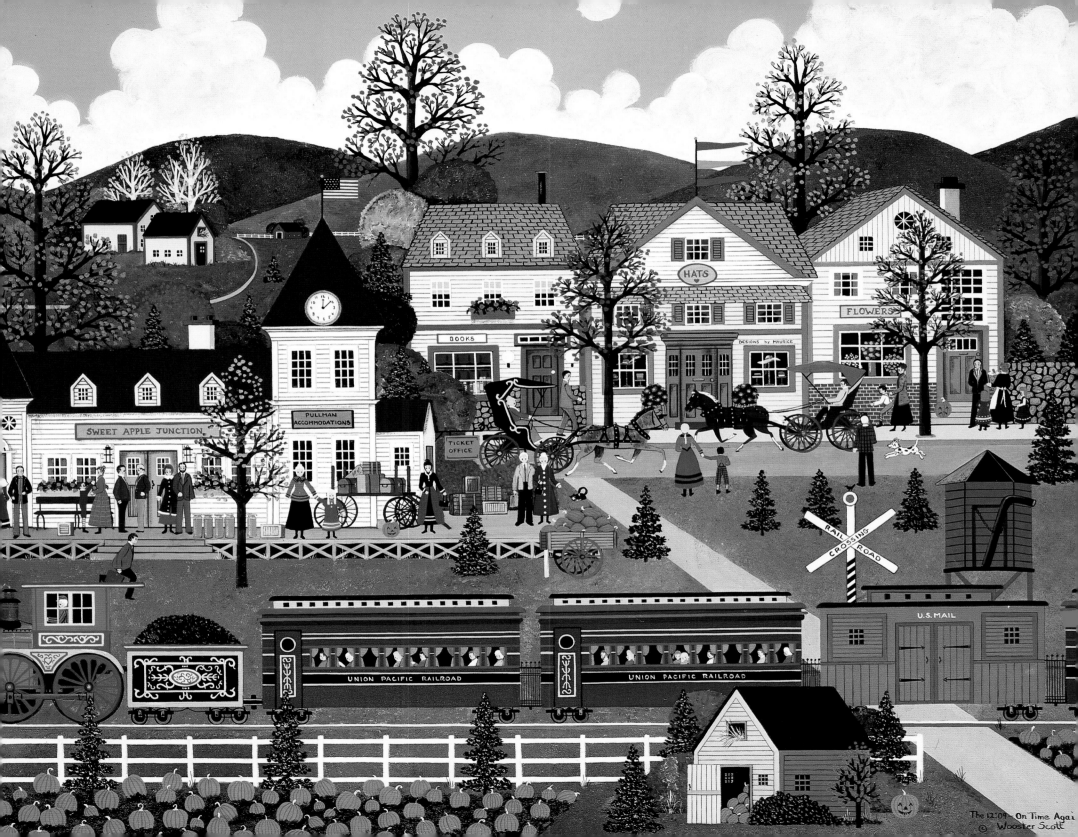

The 12:09 – On Time Aga[in]
© Wooster Scott

Yankee Enterprise

Cottage industries blossomed in Colonial America and have proliferated ever since. This turn-of-the-century scene, or something very much like it, is seen in almost every hamlet across this great land. Old work ethics die hard, especially for those who stock the larder and put a little wheat in the bin.

Profitable handicrafts, hobbies and piece-work are Yankee traditions, customs that gave birth to a hundred homilies: A penny earned...Satan finds mischief...a stitch in time...waste not, want not...as ye sow...penny wise...many hands make light work...charity begins at home...a bird in the hand...

YANKEE ENTERPRISE
Original oil on canvas 40 x 30 in (101.6 x 76.2 cm), 1989
From the collection of the artist
Silkscreen serigraph 25 x 34½ in (63.5 x 87.6 cm), 1989

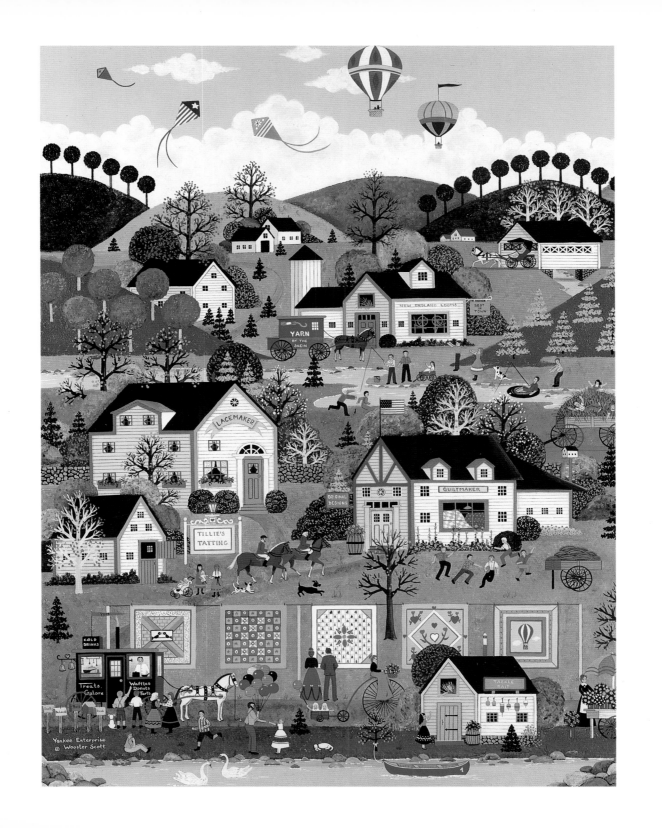

The Heritage Suite

Some things haven't changed much in the past American century.

Kids still get soaked wearing yellow slickers, galoshes and floppy sou'westers to school on rainy days.

Club members commonly collect around the eighteenth green in the final round of the country club championship.

Milkmen, though a dwindling tribe, persist in some communities, bottles clinking on their rounds at the crack of dawn.

And wherever Christmas is celebrated there are carollers and sleigh rides if the snow is deep enough.

We cherish these small evidences of continuity in our national heritage, fragments that make up the fabric of our lives.

(Top Left)
DOWNPOUR DOWN EAST
Original oil on canvas 20 x 24 in (50.8 x 60.9 cm), 1991
Silkscreen serigraph 13 x 16 in (33.0 x 40.6 cm), 1993

(Top Right)
THE MILKMAN'S ROUTE
Original oil on canvas 20 x 24 in (50.8 x 60.9 cm), 1992
Silkscreen serigraph 13 x 16 in (33.0 x 40.6 cm), 1993

(Bottom Right)
HOLIDAY SLEIGH RIDE
Original oil on canvas 24 x 30 in (60.9 x 76.2 cm), 1992
From the collection of Mr. and Mrs. David Cerva
Silkscreen serigraph 13 x 16 in (33.0 x 40.6 cm), 1993

(Bottom Left)
PUTT FOR THE CHAMPIONSHIP
Original oil on canvas 24 x 30 in (60.9 x 76.2 cm), 1991
Silkscreen serigraph 13 x 16 in (33.0 x 40.6 cm), 1993

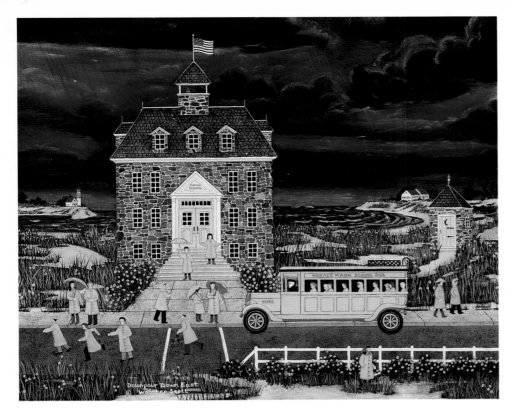

Downpour Down East
© Wooster Scott

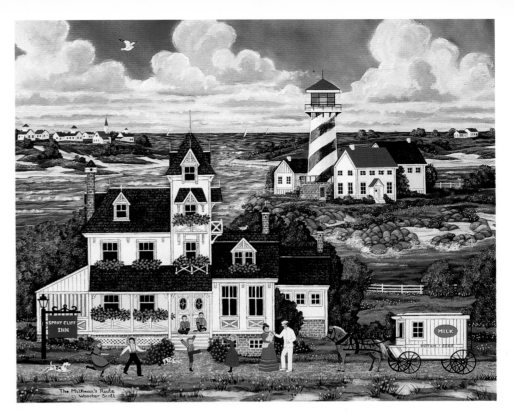

The Milkman's Route
© Wooster Scott

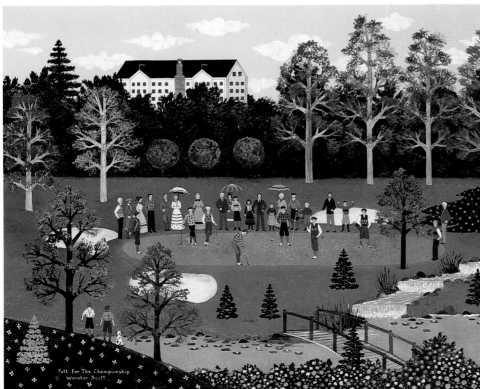

Putt For The Championship
© Wooster Scott

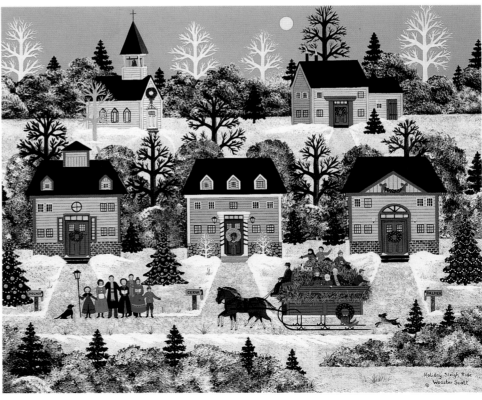

Holiday Sleigh Ride
© Wooster Scott

Laying in Provisions

Every farm and ranch family a century and more ago couldn't make do without a wagon. Usually it was at least a half a day's ride to the general store to stock the larder with necessities for a month or two at a time. It's not like you could jump into the family station wagon and drive a few blocks to the supermarket.

Farmers' wives had pantries, root cellars and spring houses in which to store perishables. One good thing, in wintertime there was no shortage of refrigeration space, leastwise not during a two-month cold snap.

LAYING IN PROVISIONS
Original oil on canvas 16 x 20 in (40.6 x 50.8 cm), 1985
From the collection of Ambassador & Mrs. William Lane
Offset lithograph 16 x 20 in (40.6 x 50.8 cm), 1985

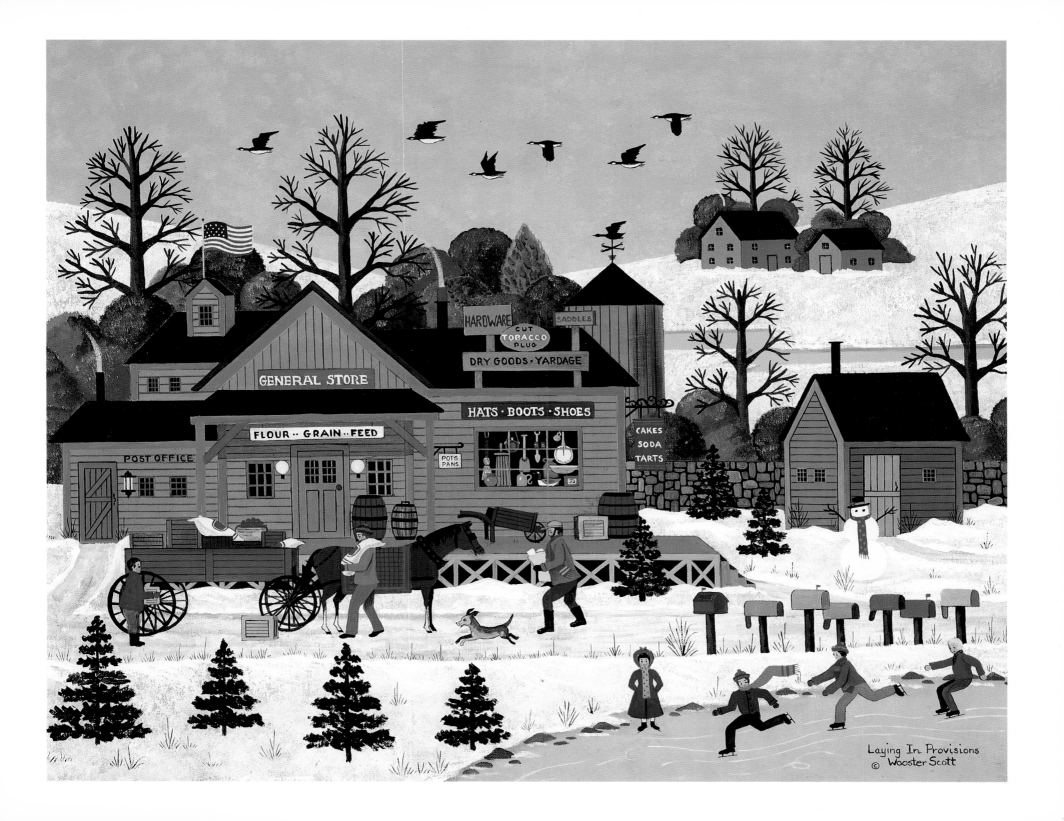

Laying In Provisions
© Wooster Scott

A New Beginning

A futuristic Noah's Ark is a grand departure for the artist as she combines her naif technique with visions of outer space a century hence. *A New Beginning* represents Scott's expanding exploration into an unfamiliar environment and time. All the same, she remains faithful to her love of bright, primary colors, whimsy and clean lines. Again, one is made aware of the serious subtext of Scott's central theme in this work: mankind thrusting to new horizons to preserve and protect all of Earth's creatures.

A NEW BEGINNING
Original oil on canvas 24 x 24 in (60.9 x 60.9 cm), 1991

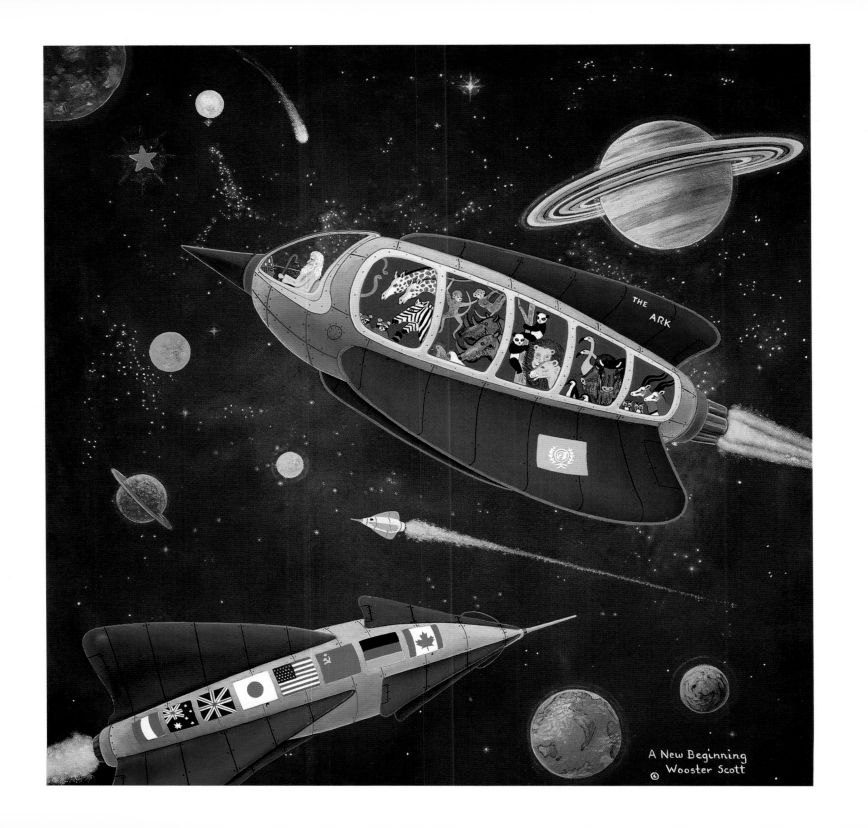

A New Beginning
Wooster Scott

Mother's Day

Note: There isn't a father in sight.

MOTHER'S DAY
Original oil on canvas 18 x 26 in (45.7 x 66.0 cm), 1984
From the collection of Mr. & Mrs. Granville Van Dusen

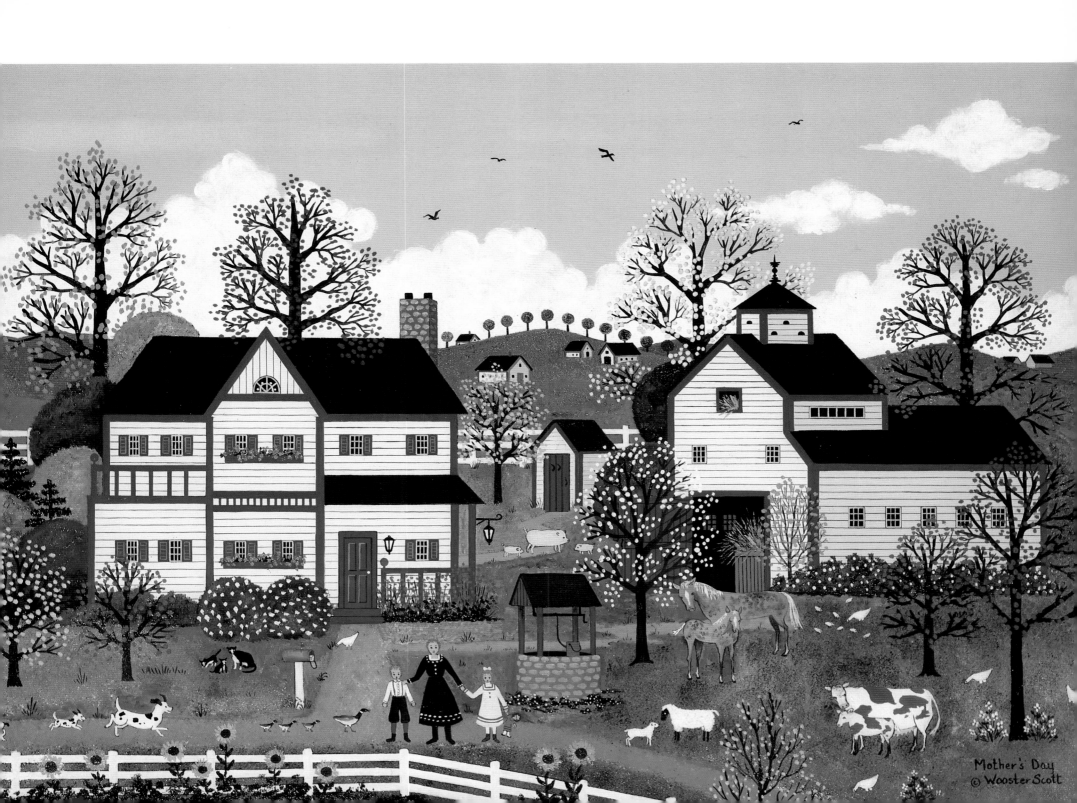

Mother's Day
© Wooster Scott

A Special Moment in Time

There are such moments in the lives of us all, special times to hold in recollection always. They needn't be glorious events, spectacular vistas or beloved friends. The moment comes from within, crystallized when time is taken to smell the roses. Steal a moment of your own right now. Hold the image if you can, for it may not come your way a second time.

(Top)
A SPECIAL MOMENT IN TIME
Original oil on canvas 30 x 30 in (76.2 x 76.2 cm), 1989
Silkscreen serigraph 29 x 29 in (73.6 x 73.6 cm), 1990

The Pride of Pottstown

A new-fangled genuine Hurricane steam pumper is what it is. This here fire-fighting apparatus is horse-drawn and able to pump the reservoir dry if needs be to douse the next blaze in our town. There's a hand-forged brass bell, too. The volunteer brigade can hardly sit still, waiting for somebody's barn to get hit by a bolt of lightning or something.

(Bottom)
THE PRIDE OF POTTSTOWN
Original oil on canvas 24 x 24 in (60.9 x 60.9 cm), 1991

A Special Moment In Time
by Wooster Scott

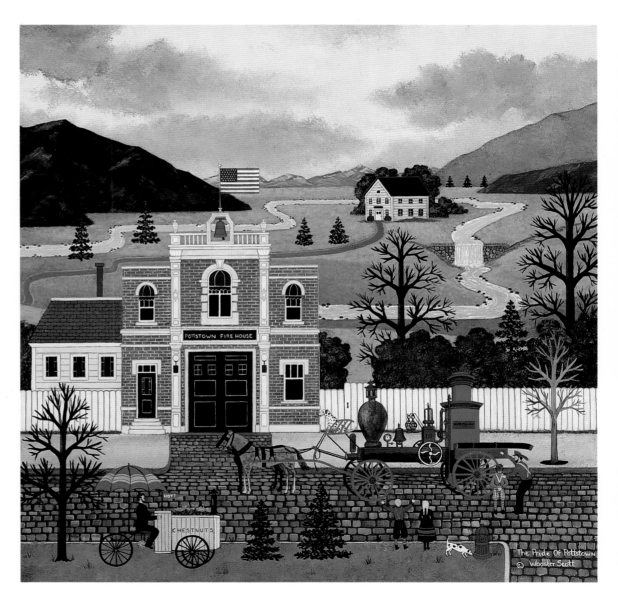

The Pride Of Pottstown
© Wooster Scott

Outfoxing the Gentry

Renard, the foxy quarry of red-jacketed hunters and dashing horses, is safely ensconsed where his pursuers are least likely to find him.

Can you?

OUTFOXING THE GENTRY
Original oil on canvas 24 x 30 in (60.9 x 76.2 cm), 1992

Outfoxing The Gentry
© Wooster Scott

Nutcracker Fantasy

One can almost hear the strains of Tchaikovsky's *Nutcracker Suite* with an American beat in this festive phantasmagoria concocted by Jane Wooster Scott. Her superb sense of design and ever-brilliant colors, combined with a vivid imagination, are manifest in this memorable painting.

NUTCRACKER FANTASY
Original oil on canvas 20 x 24 in (50.8 x 60.9 cm), 1992
Offset lithograph 17 x 20½ in (43.1 x 52 cm), 1993

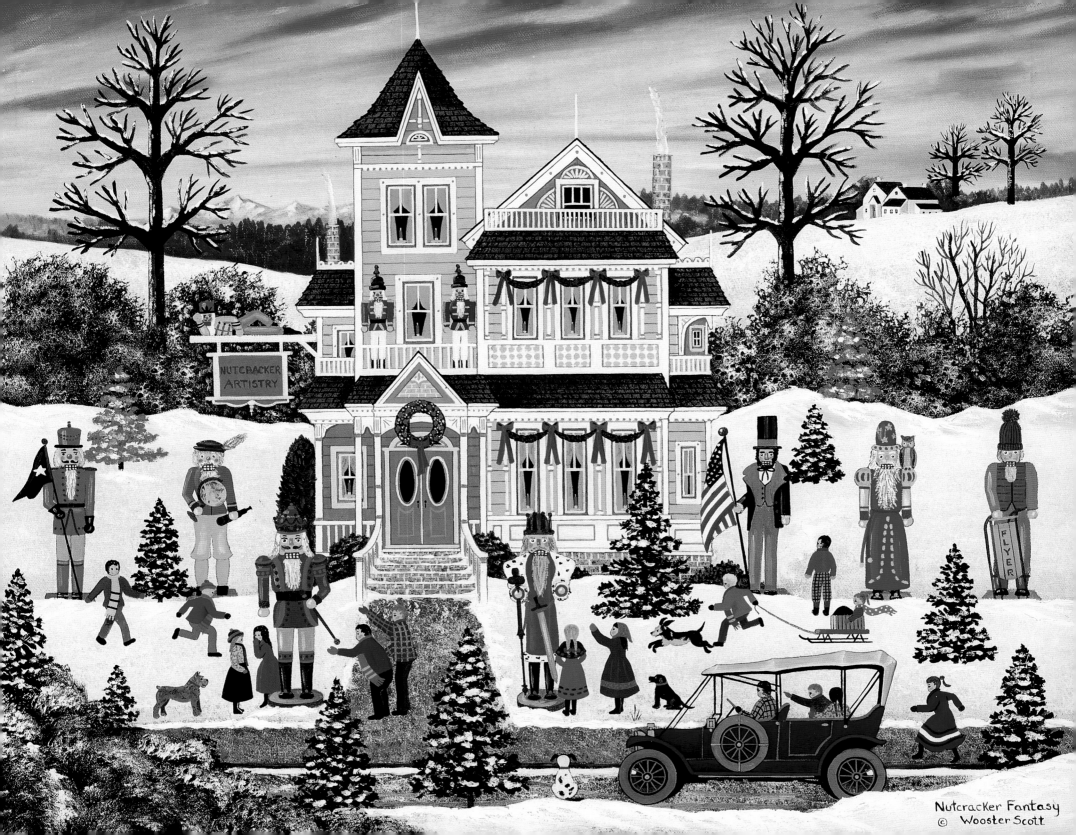

Nutcracker Fantasy
© Wooster Scott

Ego Trip

Test your acuity:

How many Jane Wooster Scott paintings are represented on the opposite page?

The question isn't as simple as it might appear.

Yes, there are three paintings in the gallery window. And three others being admired out-doors on easels.

That makes six in all. Right?

There are more in plain sight.

One is the painting itself, *Ego Trip*.

That's seven.

Can you find the eighth?

It's the side panel of the florist's wagon, the bowl of blue posies on a checkered stand, a rare Wooster Scott still life.

EGO TRIP
Original oil on canvas 20 x 24 in (50.8 x 60.9 cm), 1984
From the collection of Gavin McLeod
Offset lithograph 18 x 21⅝ in (45.7 x 54.9 cm), 1990

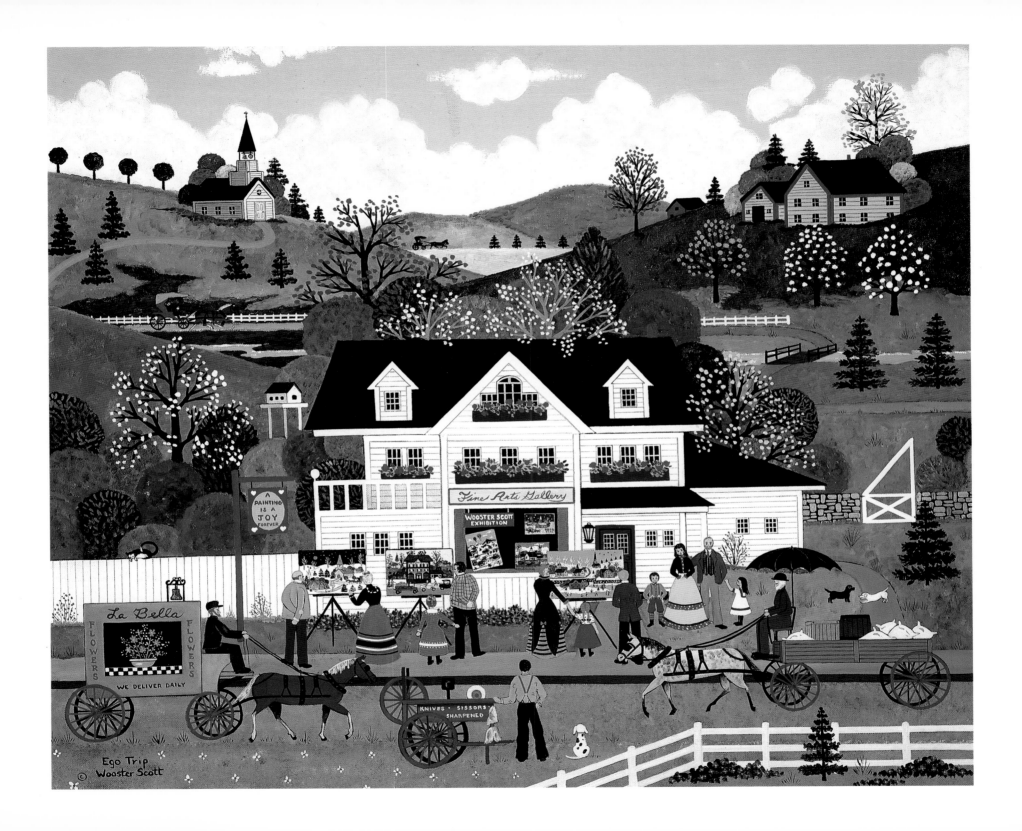

A
PAINTING
IS A
JOY
FOREVER

Fine Arts Gallery

WOOSTER SCOTT
EXHIBITION

La Bella

FLOWERS FLOWERS

WE DELIVER DAILY

KNIVES · SISSORS·
SHARPENED

Ego Trip
© Wooster Scott

Seashore Shenanigans

Seashore holidays are a universal blessing to denizens of temperate climes. This particular stretch of inviting beach could be almost any strand along America's Eastern Seaboard from Maine to the Carolinas. Few, however, are as fancy as this 1890's pleasure spot with its colorful pier and many attractions.

Chilly water and burning sand give bathers the exhilaration of being safely on land while daring to enter the province of the untamed bounding main.

SEASHORE SHENANIGANS
Original oil on canvas 24 x 30 in (60.9 x 76.2 cm), 1990
Silkscreen serigraph 24 x 30 in (60.9 x 76.2 cm), 1990

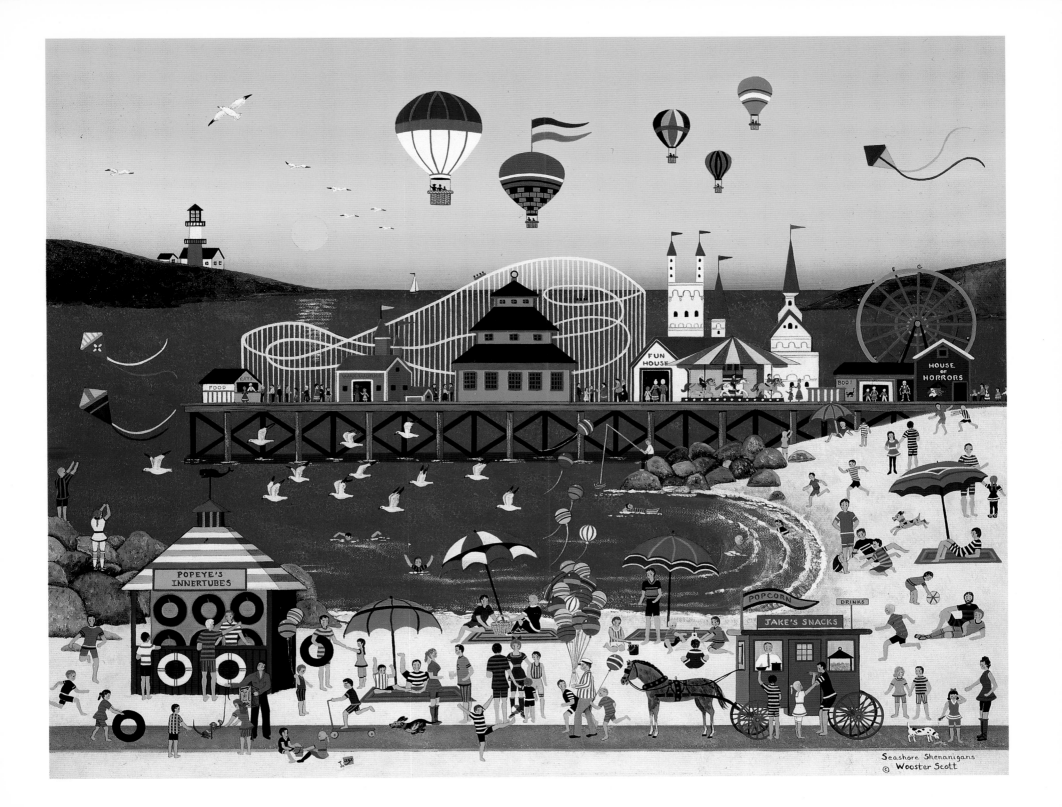

Seashore Shenanigans
© Wooster Scott

Sun Valley Magic

It was love at first blush when Jane Wooster Scott first visited the famed international ski resort in Sun Valley, Idaho, early in her career as a professional painter. Many of her remarkable paintings have been done in this spectacular hideaway in the rugged Sawtooth high country, ringed by towering peaks, among them Bald Mountain, depicted in numerous Scott canvases.

Scott, a non-skier, was moved by the majesty of the terrain (part desert, part alpine), its wildlife and magistereal silence. The quaint villages of Ketchum, nearby Hailey and Stanley provide turn-of-the-century buildings that also show up in her paintings. The drama of the area's four distinct and colorful seasons appeal to childhood recollections of her youth along Philadelphia's Main Line.

It was all there in wilderness Idaho. There for painting fresh, clear streams perfumed by blooming cottonwoods, meadows with beaver ponds, black nighttime skies adorned with stars in such profusion their light—called starshine—casts shadows.

There, too, are delicate high-altitude wild flowers, critters of every western description—elk and deer, fox and badger, antelope and bear. Yes, coyotes, the occasional mountain lion and a rare wolf or two.

Here, Scott has reproduced Sun Valley's Lodge and Inn, its ice rink, opera house and other amenities that entice visiting sportsmen and women from around the world. They come for athletic excitement and discover overpowering beauty.

And some, as did painter Scott, choose to make it home.

SUN VALLEY MAGIC
Original oil on canvas 40 x 50 in (101.6 x 127.0 cm), 1987
From the collection of The Sun Valley Co.
Offset lithograph 21 x 27 in (53.3 x 68.5 cm), 1987

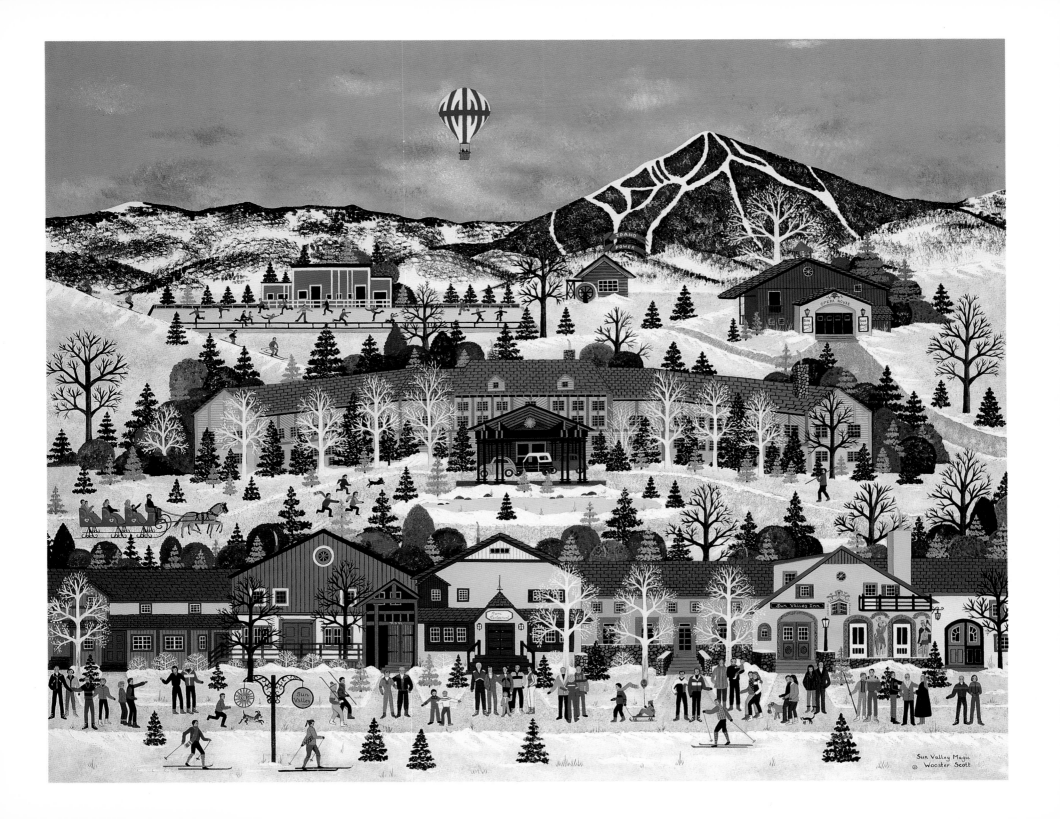

Sun Valley Magic
© Wooster Scott

Vintage Vanities

This automobile show features oldtimers made for two-lane roads, each model crafted with love and individual style. One could distinguish a Huppmobile from a Reo, Packard from a Terraplane, Nash from Hudson, Stanley Steamer from Hispano Suiza.

Makers took pride in the curve of a fender, the uniqueness of a grill, the height of a tonneau, identifiable touches of brass and chrome. Traffic moved less swiftly, giving pedestrians time to admire the graceful parade of motorcars, unknowing they would one day breed clogged freeways, choking smog and obscene death tolls.

So here's to the good old days when gasoline cost fifteen cents a gallon.

VINTAGE VANITIES
Original oil on canvas 30 x 30 in (76.2 x 76.2 cm), 1991

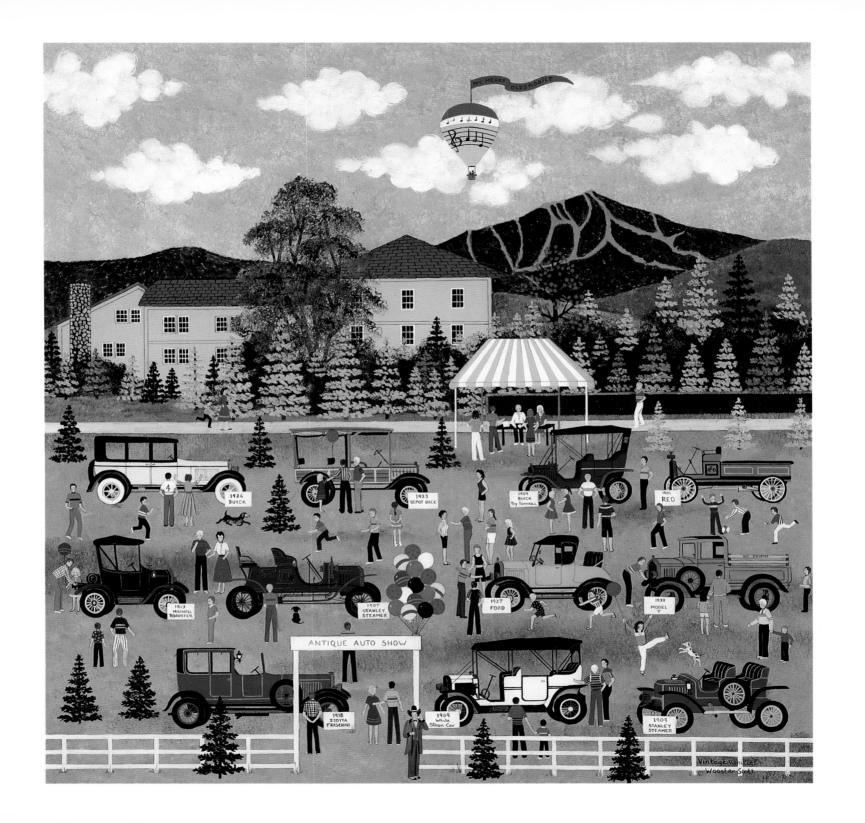

Sippin' Sodas at Ridley High Hangout

Listen closely, members of the class of '41, for the strains of Benny Goodman and Tommy Dorsey inside The Hangout. School's over for the day. You ordered ten-cent cherry cokes for yourself and your steady in cardigan and saddle shoes. A nickel in the jukebox rewarded you with Glenn Miller's *Moonlight Serenade*. A year later you were off to serve your country. If you're a World War II vet your memories will include this truant afternoon, your coke date and the pretty girl you loved so many years ago.

SIPPIN' SODAS AT RIDLEY HIGH HANGOUT
Original oil on canvas 24 x 30 in (60.9 x 76.2 cm), 1980
From the collection of Ashley Scott

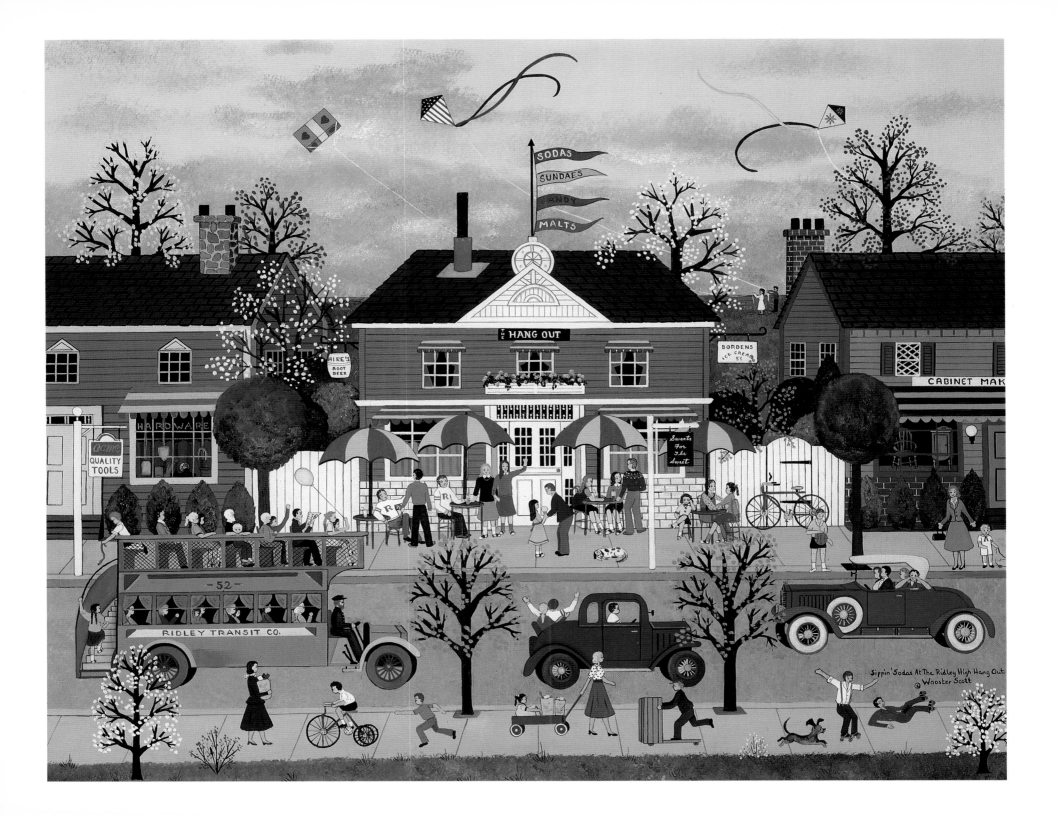

Sippin' Sodas At The Ridley High Hang Out
© Wooster Scott

Family Night at the Black Horse Inn

All roads in Jefferson County led to the Black Horse Inn, catering to rural folk who, dressed in sabbath best, congregated for Sunday dinner once a week.

It was a treat for mother to escape kitchen chores, providing a chance to chat with neighbors about the new patterns in the Montgomery Ward catalogue. Kids got to see schoolmates in something other than overalls and gingham.

Papa exchanged news about the crops and weather conditions with the other farmers.

Best of all was the pot roast special with mashed potatoes, pan gravy, green peas and hot apple pie with cheddar. It was expensive all right, a dollar apiece for adults and two-bits for young 'uns, including cornbread with fresh-churned butter and coffee. After a hard week on the farm, the Black Horse Inn was a welcome luxury.

FAMILY NIGHT AT THE BLACK HORSE INN
Original oil on canvas 30 x 30 in (76.2 x 76.2 cm), 1982
From the collection of the artist

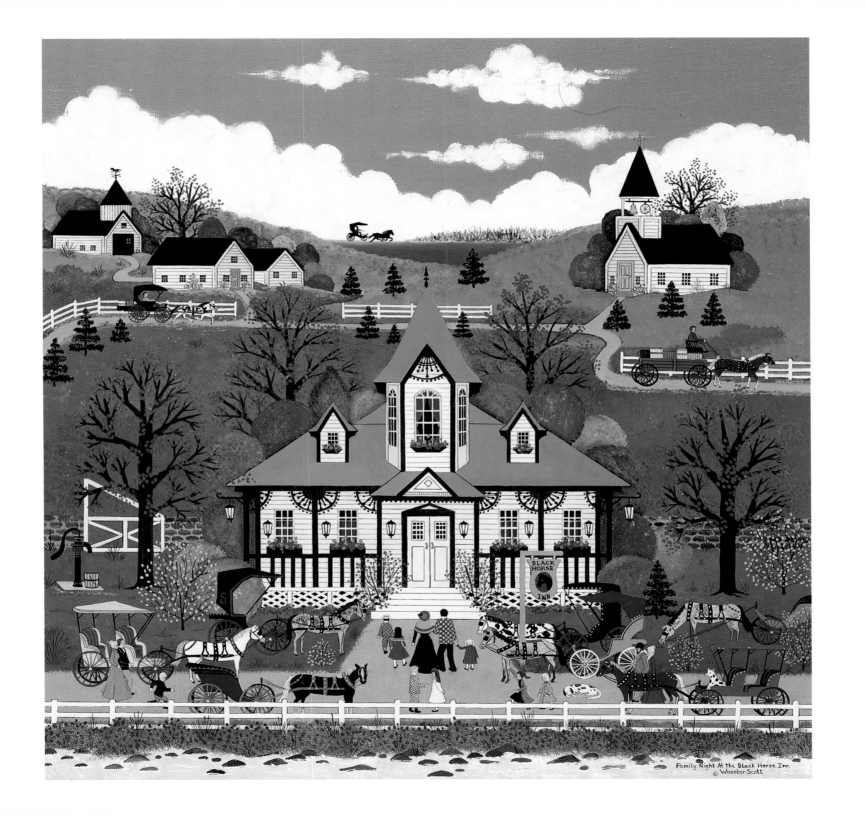

Family Night At the Black Horse Inn
© Wooster Scott

The Volunteer Fire Brigade

It was a civic duty to be a volunteer firefighter. When the bell atop the firehouse pealed across the landscape, volunteers dropped what they were doing, sprinted for the colorful pumper, hitched the team and clattered off to extinguish the blaze.

In the middle of this night the dauntless townsmen of Chester bolted from warm beds and distraught wives to dash to the rescue, tugging on boots and seal oil slickers as they ran. Prepared to jump aboard is their Dalmatian mascot, *Spot*. If need be, the hardy smoke-eaters will muster a bucket brigade, passing slopping pails of water, one to the other, from the nearest creek or pond.

But it's wintertime: the pond is frozen and the creek's run dry. Worse still, the brave volunteers will be mad as turpentined cats when they find it's only Buster Hockensacker's outhouse in flames. Spot could have put it out by himself.

THE VOLUNTEER FIRE BRIGADE
Original oil on canvas 30 x 40 in (76.2 x 101.6 cm), 1987
From the collection of Michael Cameron
Offset lithograph 21 x 28 in (53.3 x 71.1 cm), 1988

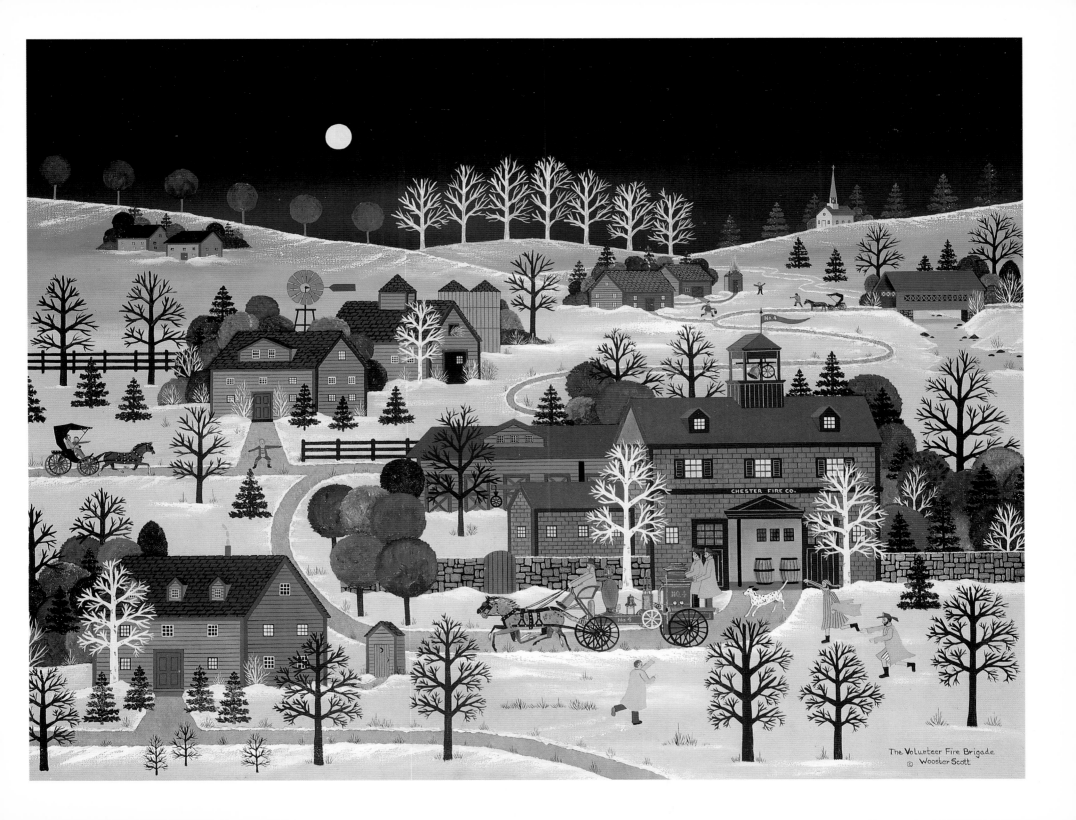

The Volunteer Fire Brigade
© Wooster Scott

Family Frolic

The best of both worlds?

It's a challenge melding your love for two such geographically separated states as Ohio and Idaho, some two thousand miles apart.

But the McNamee family of Kettering, Ohio, worked it out by commissioning Jane Wooster Scott to set their Kettering home in the mountain fastness of Sun Valley, Idaho, and include representations of the large, athletic family.

The artist finds the McNamees happily engaged in their favorite sports, surrounded by the familiar elements of their two homes.

FAMILY FROLIC
Original oil on canvas 40 x 30 in (101.6 x 76.2 cm), 1992
From the collection of Mr. and Mrs. Charles McNamee

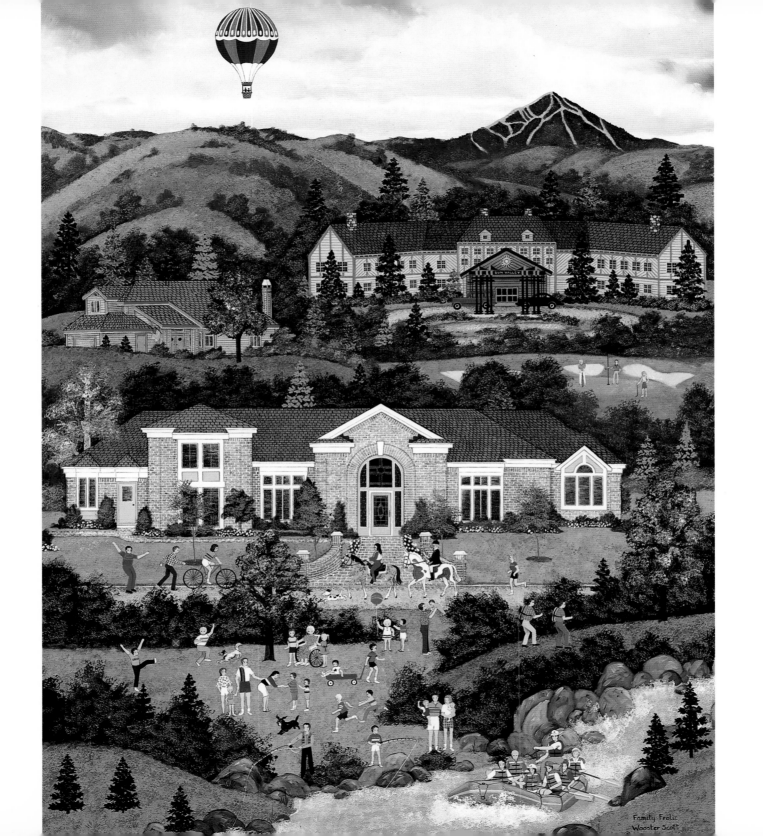

Family Frolic
Wooster Scott

Springtime in the Cascades

Springtime is sweet and short in the Cascade Range of America's vast Northwest. As snow reluctantly retreats in the high country, trees don their delicate spring greens. Sleeping seed pods awaken to decorate the land with a verdant mantle of brief and fragile life. The mountains, source of rills, creeks, streams and rivers, nourish all life on Earth, once again have fulfilled their providential mission and silently await the refreshing storms to come.

SPRINGTIME IN THE CASCADES
Original oil on canvas 30 x 40 in (76.2 x 101.6 cm), 1991
From the collection of Mr. & Mrs. David Clack

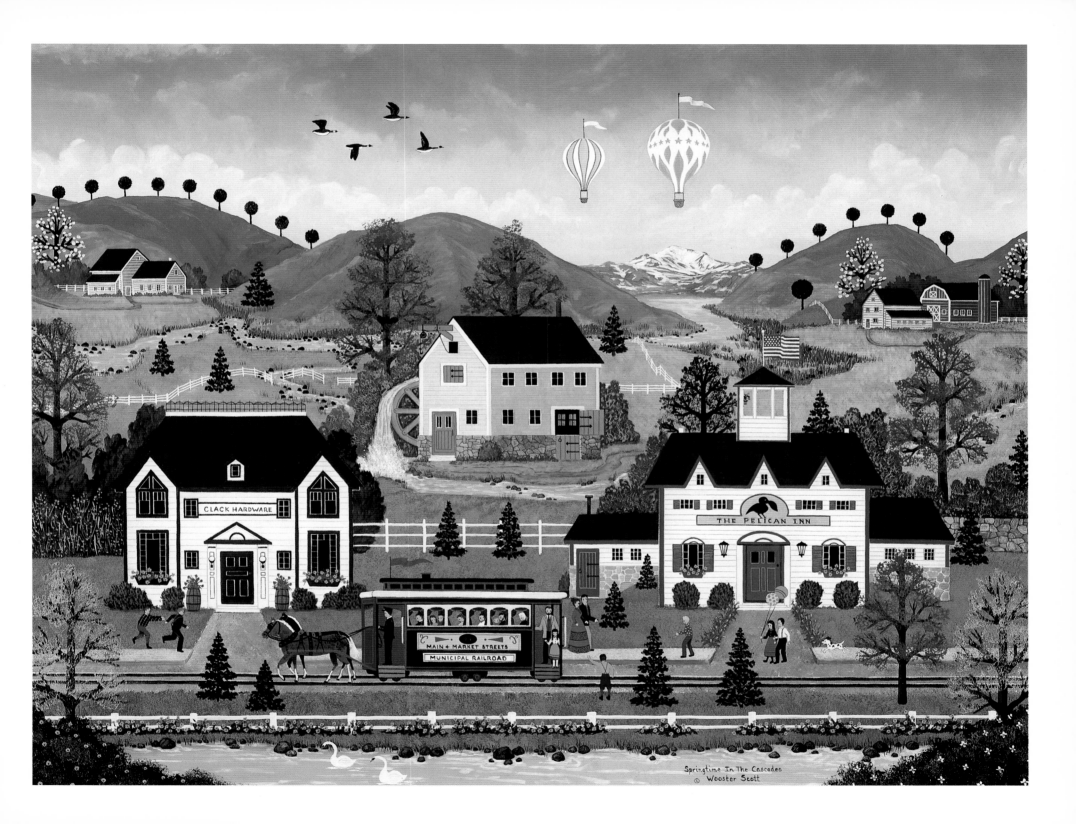

Springtime In The Cascades
© Wooster Scott

Wet Your Whistle and Warm Your Toes

Appetites sharpened while skating the pond,

As laughter and gaiety fashioned a bond.

Jack Frost painted roses

On cheeks, ears and noses.

Now hark to the song of blades cutting the ice,

Then into the shoppe, hot chocolate with spice.

Skate swiftly, skate briskly till daylight is spent,

Then give thanks to the fates for this fun-filled event.

WET YOUR WHISTLE AND WARM YOUR TOES
Original oil on canvas 20 x 24 in (50.8 x 60.9 cm), 1990
From the collection of Mr. & Mrs. Michael Kazanjian
Offset lithograph 18 x 21⅝ in (45.7 x 54.9 cm), 1990

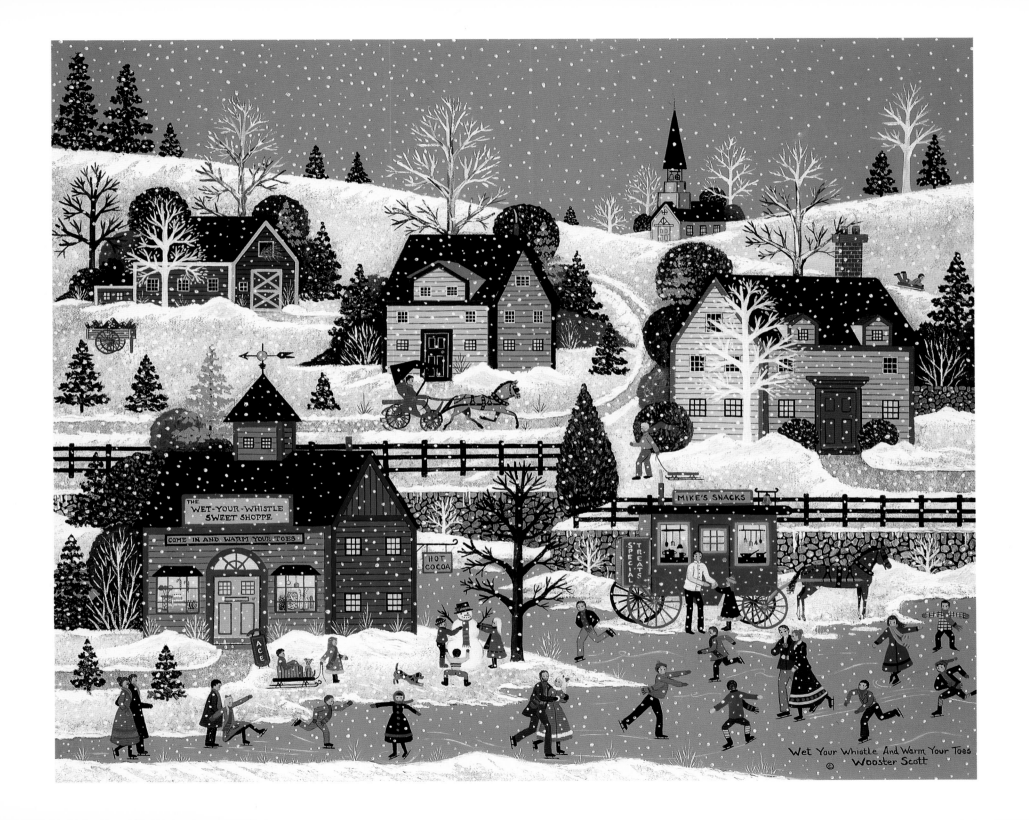

The City Suite

Our country's most awesome man-made monuments are her skylines, chisled skyscrapers, steeples and towers, supplicants to higher orders.

In her City Suite artist Jane Wooster Scott combines *Dog Walking: A Nightly Ritual* in New York and *The City By The Golden Gate* in San Francisco, highlighting their distinct silhouettes.

Separated by the breadth of a continent, these cultural giants may catch our attention with their skylines, but it is their residents who give these metropoli their souls and glory.

(Bottom Right)
DOG WALKING: A NIGHTLY RITUAL
Original oil on canvas 30 x 24 in (76.2 x 60.9 cm), 1990
Silkscreen serigraph 20 x 16 in (50.8 x 40.6 cm), 1991

(Top Left)
THE CITY BY THE GOLDEN GATE
Original oil on canvas 24 x 30 in (60.9 x 76.2 cm), 1988
From the collection of Mr. & Mrs. William Pereira
Silkscreen serigraph 16 x 20 in (40.6 x 50.8 cm), 1991

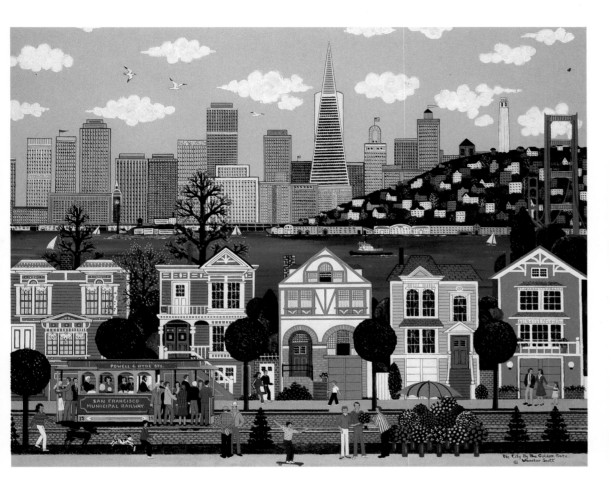

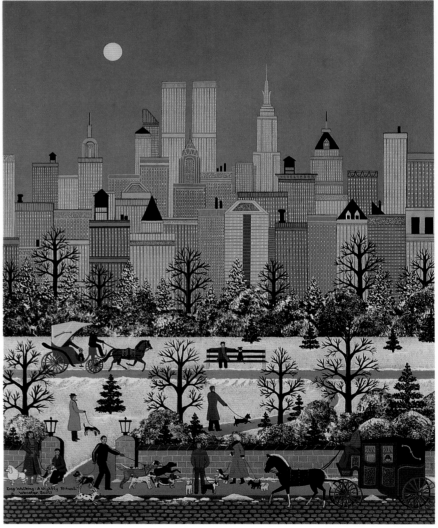

The Ballet School

Every girl in the dance class dreams of prima ballerinahood.

Swan Lake in silken leotard, white mesh tutu and satin toe shoes. Each girl pictures the faultless plie, arabesque, pas de deux and pirouette.

There!

In the very first row of The Opera House sit proud mother and beaming father, envious little sister, abashed younger brother. It's a full house, all breaths held anticipating HER entrance.

Dance, ballerina. Dance. Dance. Dance.

Triumph!

Standing ovation.

Bouquets

"Brava!"

"Encore!"

BONK!

"Very well, young ladies," calls Madame Muckenthaller, "shall we try the arabesque again, please."

THE BALLET SCHOOL
Original oil on canvas 16 x 20 in (40.6 x 50.8 cm), 1977
From the collection of Mr. & Mrs. Paul Newman

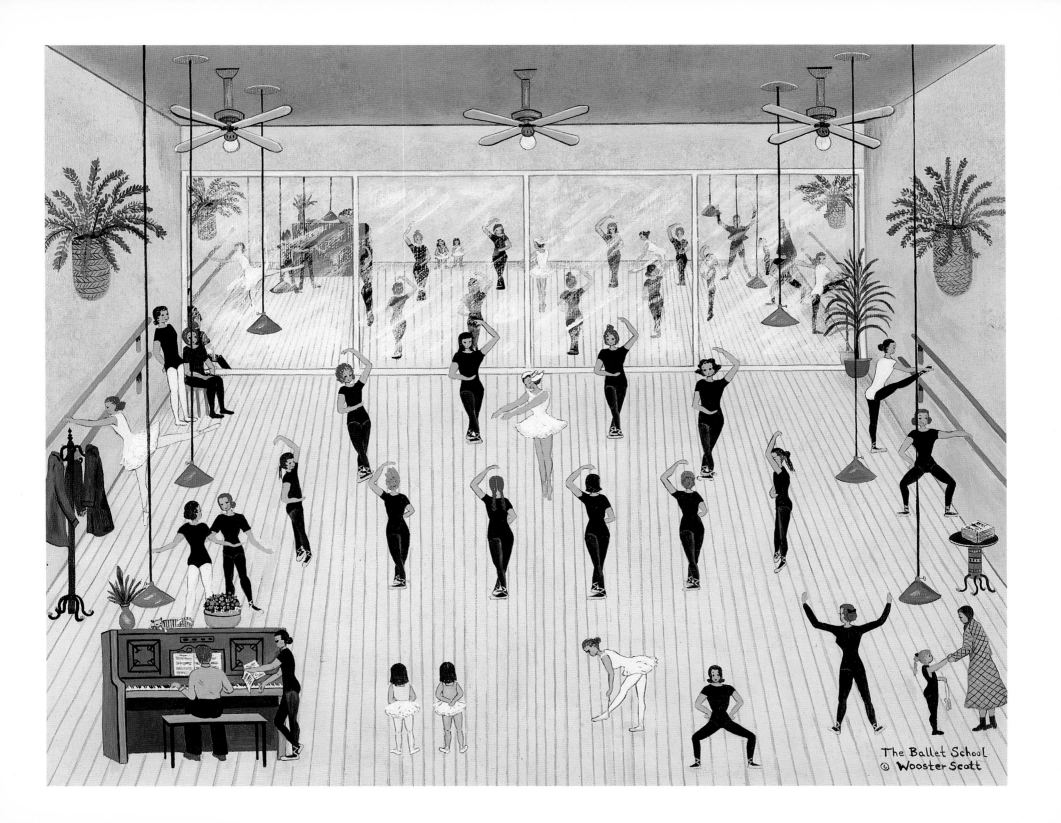

The Ballet School
© Wooster Scott

Cubs Fever

Hope springs eternal in the breasts of all Chicago Cubs baseball fanatics. Among the most ardent fans in the country, Cub followers have rooted for a World Series in vain for almost fifty years.

One of the oldest established franchises in the National League, the Cubs motto is based on a favorite American battle cry of unrequited optimism: *Wait Until Next Year!*

CUBS FEVER
Original oil on canvas 24 x 30 in (60.9 x 76.2 cm), 1990
From the collection of Mr. and Mrs. Gerry Rubin

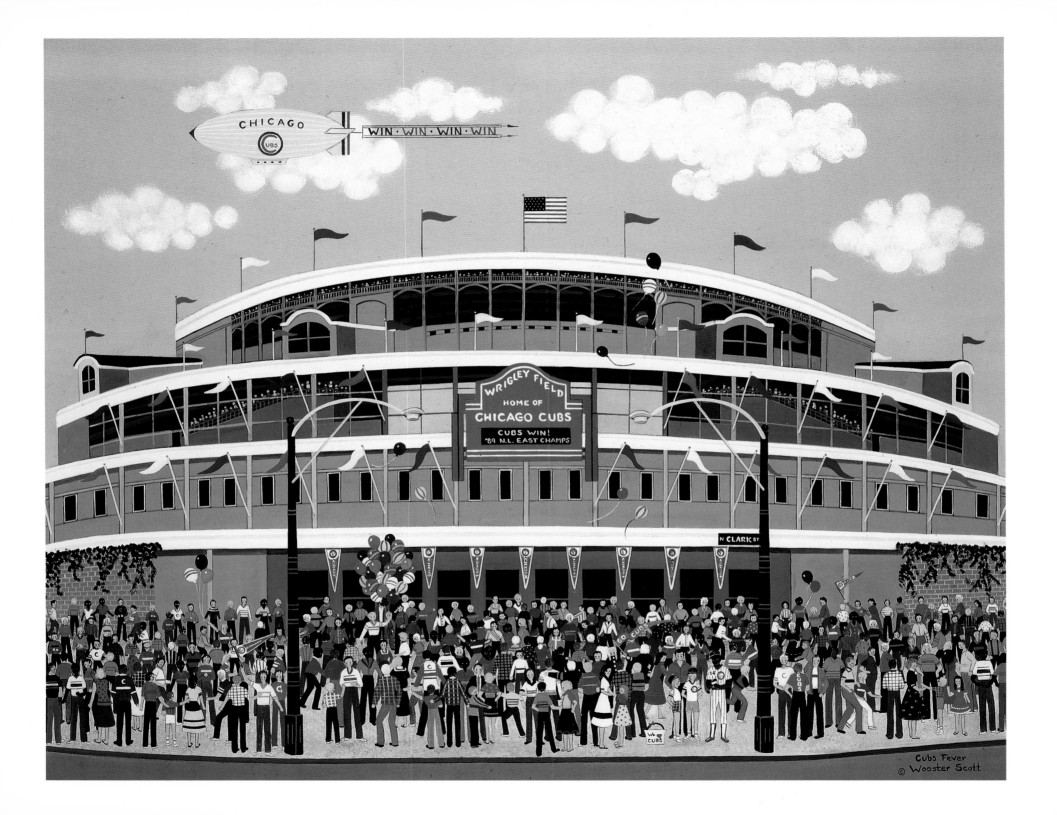

Fitchburg Township Fair

This painting is the only evidence remaining of the great Fitchburg Township Fair of 1893. As you can see, it was a bodacious jubilee for the entire county. But not one soul is still alive to tell us about it.

I remember my great grandaddy telling me he was just a tad when his daddy took him to the fairgrounds to see the fun.

History remembers battles and statesmen and natural calamities. But there's hardly a footnote in history books about good times like the Fitchburg Fair. Perhaps if you show this lovely rendering to your own offspring, maybe a few of the good old times will be remembered, too.

FITCHBURG TOWNSHIP FAIR
Original oil on canvas 30 x 40 in (76.2 x 101.6 cm), 1982
From the collection of Mr. and Mrs. John Moser
Offset lithograph 20 x 27 in (50.8 x 68.5 cm), 1988

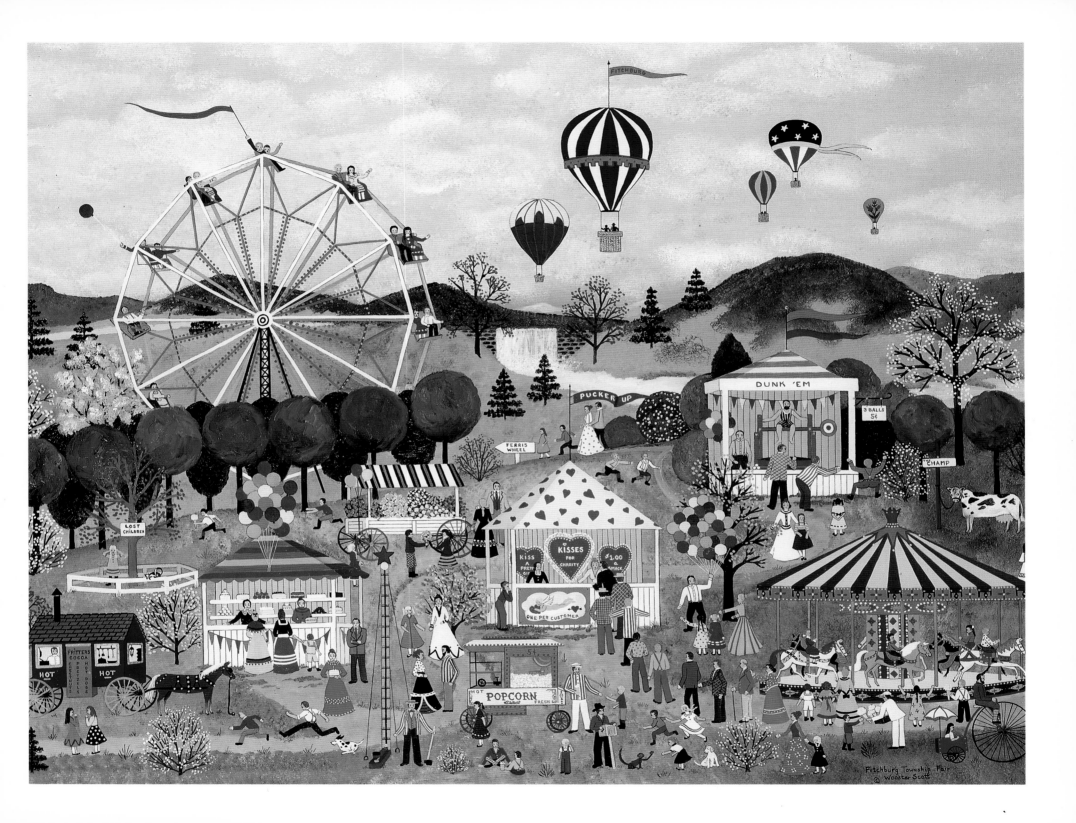

Fitchburg Township Fair
© Wooster Scott

Down Memory Lane

It's sad to think someday soon children will become adults believing all shops, mercantiles, boutiques and emporiums exist only in enclosed malls reeking of stale food, piped-in elevator music, artificial light and recycled air.

Ask your offspring or grandchildren to stroll down this *Memory Lane* where individual tradesmen and artisans hawked their wares in bright sunshine and fresh air, accompanied by the music of songbirds. Tell them of a time before food-processing, fancy packaging, assembly line groceries, frozen dinners and shopping carts. A time when you knew the baker, when friendly peddlers came to the door, when a clock shop was as much a work of art as the timepieces within.

Enjoy your childrens' disbelief when you speak of an era before fast food, where mommies cooked and daddys worked and families sang around the piano or played word games in the parlor.

They will enjoy your stories more than the violence on the TV set. Have faith in that.

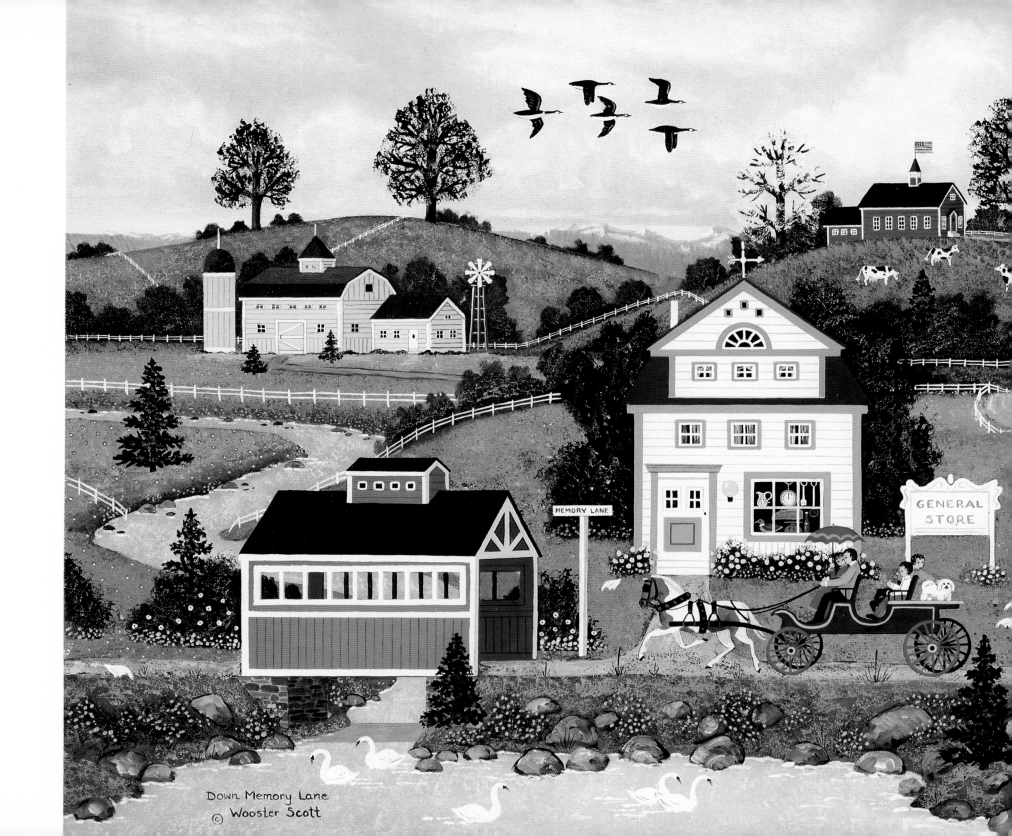

Down Memory Lane
© Wooster Scott

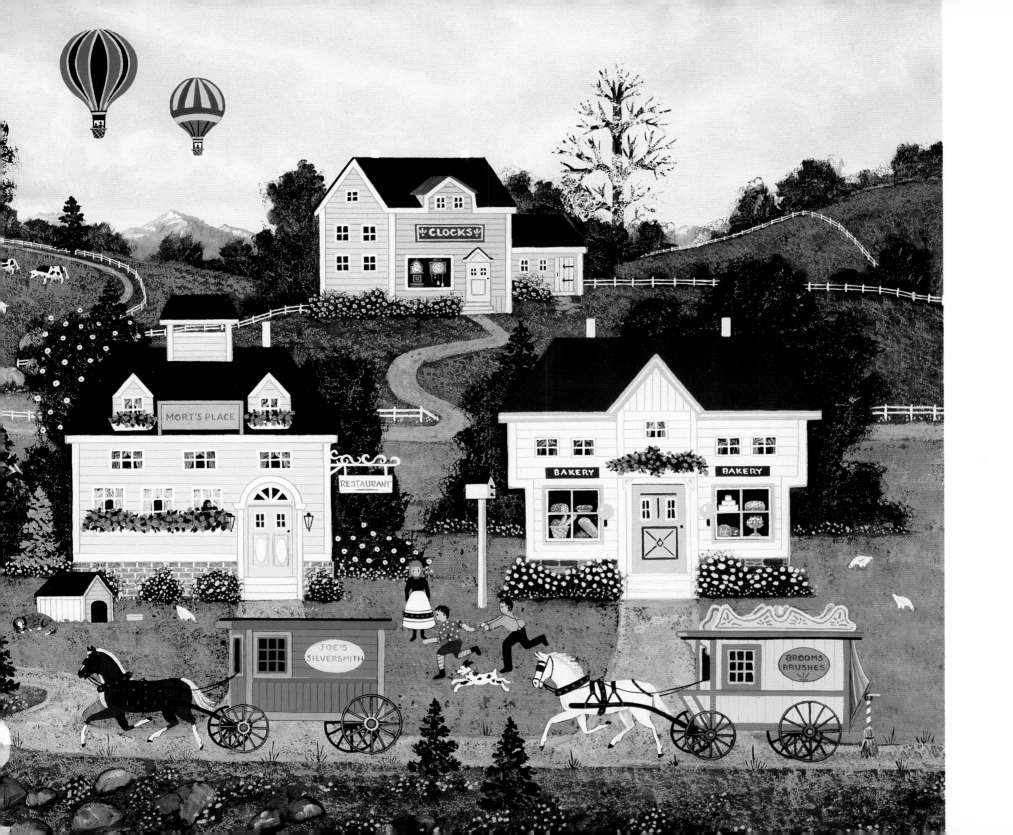

Friday Night Cotillion

Miss Fimple was a genteel spinster of refinement whose cotillions were the bane of every boy and a joy to all the girls. Miss Fimple played foxtrots, waltzes and two-steps on the gramaphone, teaching boys and girls to be young gentlemen and young ladies.

It was tiresome learning etiquette and good manners, especially after the punch bowl ran dry.

All these years later Miss Fimple's cotillions seem quaint, the girls glowing in their pretty little dresses, the boys perspiring in their suits and neckties. Their conduct was mostly exemplary as they learned to respect each other.

How different from rap concerts, blasting keyboards, amplified guitars and screaming, half-naked performers.

That was then. This is now.

I'll take then.

FRIDAY NIGHT COTILLION
Original oil on canvas 11 x 14 in (27.9 x 35.5 cm), 1980
From the collection of Mr. and Mrs. Steve Wynn

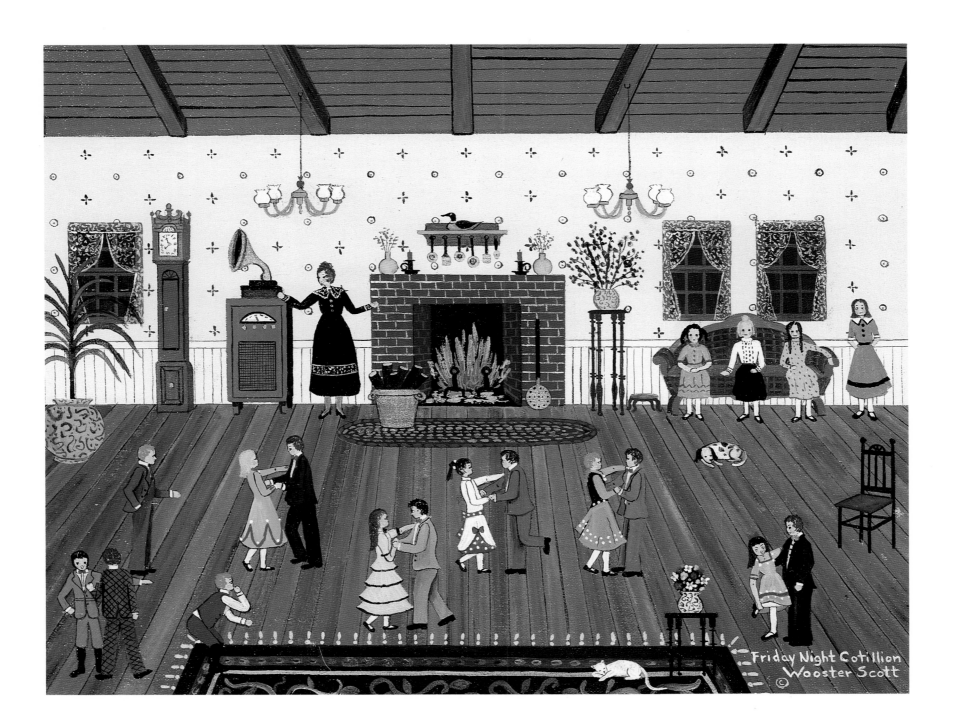

Friday Night Cotillion
Wooster Scott

Goblins on a Rampage

You know good and well the outhouse is on its way to some inappropriate place, like decorating the courthouse lawn this Halloween night. A few pumpkins will be missing by sunup, too.

If you look closely, you'll see the front gate is gone. The rascals carried it off last Halloween, along with the cement birdbath, which was imported from Astabula. Or was it Zanesville?

But nobody in these parts throws a snit tizzy over young folk raising hell on Halloween. We did worse when we were young. Anyhow, we know the neighbors' kids, even in those masks.

These imps don't scare us. Except that weird character outlined against the harvest moon. She looks like Harlan Hefflefinger's mother-in-law, and everybody is afraid of her.

GOBLINS ON A RAMPAGE
Original oil on canvas 20 x 24 in (50.8 x 60.9 cm), 1988
From the collection on Cynthia Klapper
Offset lithograph 17 x 20 (43.1 x 50.8 cm), 1988

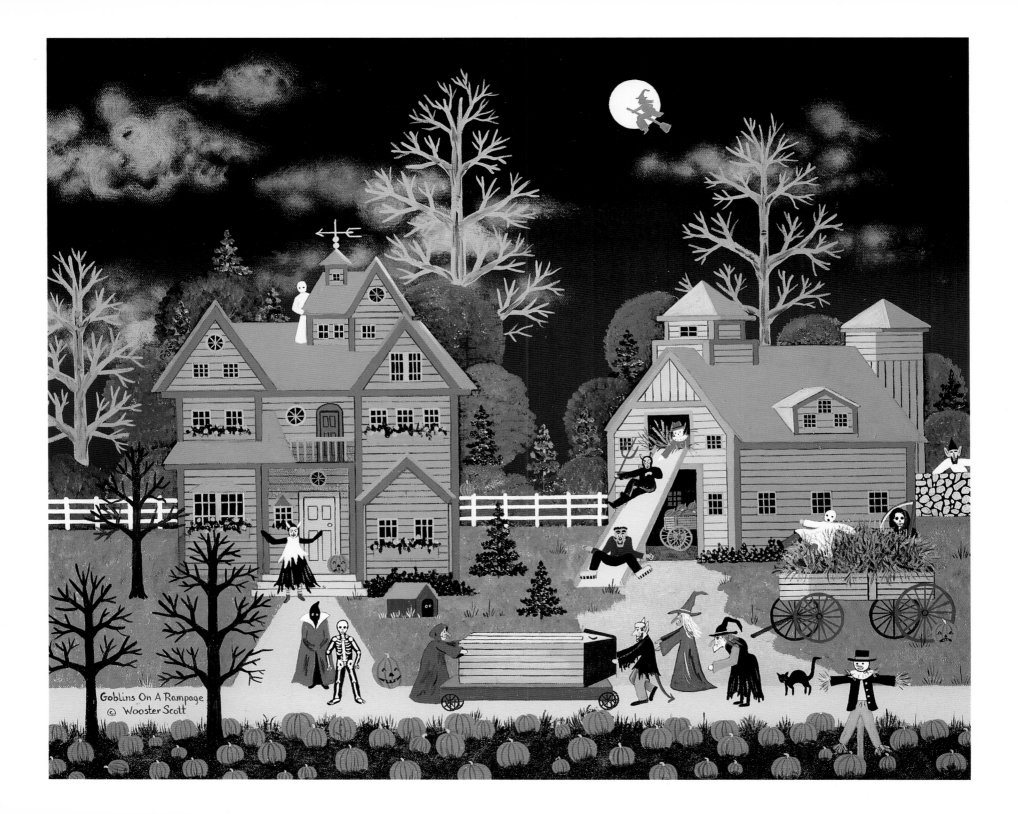

Goblins On A Rampage
© Wooster Scott

Concert on the Lawn

This painting is based on an authentic charity concert at the famed John S. Phipps home called Old Westbury Gardens on Long Island, NY, an annual event benefitting the North Shore University Hospital at Glen Cove. Many individuals represented in the foreground are genuine Long Islanders who participate in the charity year after year.

Generosity is one of the nation's most cherished traits, as much a part of the national character as Horatio Alger.

Few cultures boast a private sector that supports so many worthy causes, provides for the needy and assists the less fortunate through charity events and individual donations.

Generosity makes the United States a most unique society, one of a kind in the long history of mankind.

(Left)
CONCERT ON THE LAWN
Original oil on canvas 28 x 22 in (71.1 x 55.8 cm), 1989
From the collection of the North Shore University Hospital at Glen Cove
Offset lithograph 22 x 17⅜ in (55.8 x 44.1 cm), 1989

Cold Snap in Bitterroot Valley

The quietude of a winter landscape from the height of a soaring hot-air balloon is unimaginable. The clarity of a barking dog, the cry of a child or the clip-clop of horses hooves give the impression that you are hearing sounds for the very first time.

Perhaps it is the godlike overview of the balloonist's perspective that adds to the purity of sight and sound, enhancing all sensibilities, sharpening wits, generating new appreciation for so many of the things we take for granted.

(Right)
COLD SNAP IN BITTERROOTVALLEY
Original oil on canvas 24 x 20 in (60.9 x 50.8 cm), 1984
From the collection of Mr. and Mrs. Perry Leff (Abbe Lane)

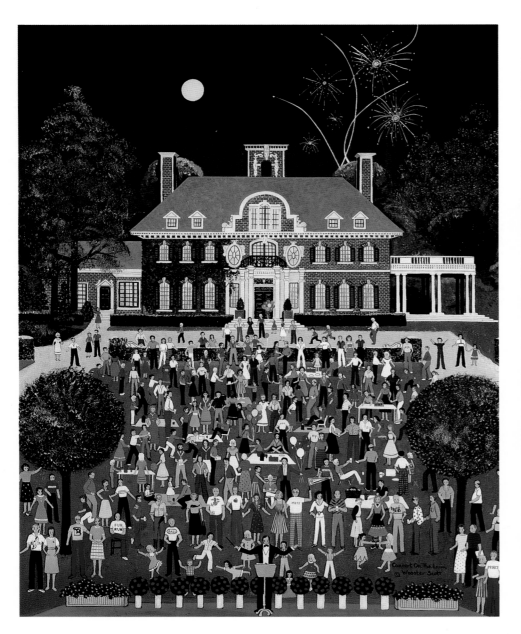

Concert On The Lawn
© Wooster Scott

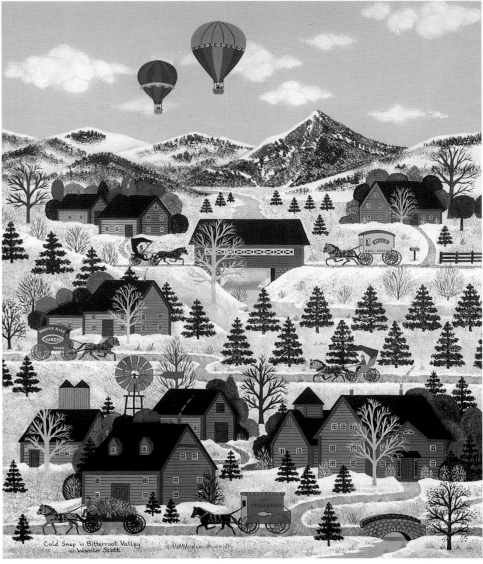

Cold Snap in Bitterroot Valley
© Wooster Scott

Friendly Encounters, Giraffe Manor, Kenya

The artist traveled to Giraffe Manor (yes, there is such a place) in Kenya *after* she painted this entrancing scene for the California Special Olympics. She was astonished to discover how much reality matched her vision based on photographs. But the real surprise was the greetings she received each morning when she was awakened in her second floor bedroom by an inquisitive giraffe poking its head into her quarters through an open window.

FRIENDLY ENCOUNTERS, GIRAFFE MANOR, KENYA
Original oil on canvas 24 x 30 in (60.9 x 76.2 cm), 1990
From the collection of Mr. and Mrs. James Benson
Offset lithograph 17⅜ x 22 in (44.1 x 55.8 cm), 1990

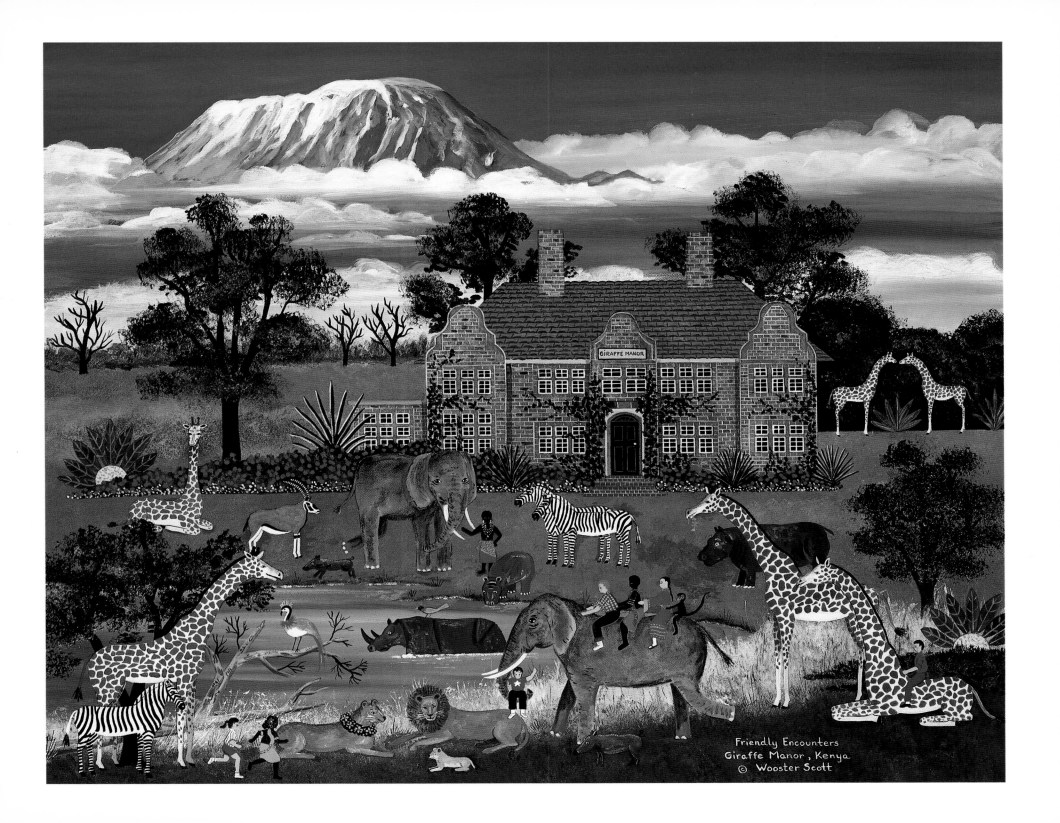

Friendly Encounters
Giraffe Manor, Kenya
© Wooster Scott

Good Neighbors

Praise be, some traditions never die. Not altogether.

Among the oldest, most enduring traits in our national character is neighborliness, borrowing a cup of sugar, loaning a lawnmower or simply pitching in and helping out.

It was easier a century ago when Americans depended on one another in a pinch, when a task was made lighter by friendly folk.

The ultimate community project was a barn-raising with people freely contributing time, skills and energy toward improving a neighbor's life. It beat mailing a check to some organized charity for people you'd never meet.

And nobody took a percentage of the roof or a section of wall for administrative costs. You know?

GOOD NEIGHBORS
Original oil on canvas 30 x 30 in (76.2 x 76.2 cm), 1991
Silkscreen serigraph 19 x 25⅜ in (48.2 x 64.4 cm), 1992

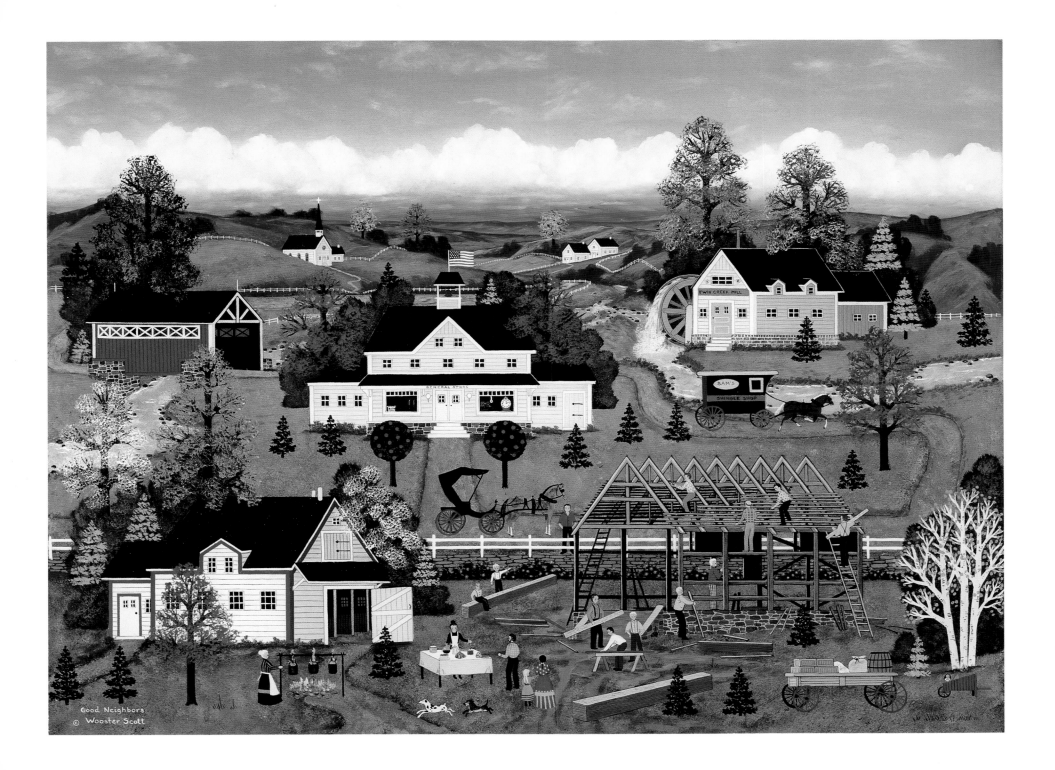

Good Neighbors
© Wooster Scott

The Gulls of Maine

Seagulls, a ubiquitous breed, might be the restless souls of ancient mariners. They crowd the air over every port and inlet of the seven seas, wheeling and mewing in cacophonic insurrection. They bob on waves like whitecaps, quarreling in disputations over morsels from passing fishing boats. They dive hungrily with disconcerting bravery into schools of small fish.

This brigade of gulls spangles the skies over a small Maine cove on a summer's day. Though beautiful and graceful on the wing, they shatter the stillness with endless accusations.

Much as they are among us, gulls are a mystery, too. We never see them after sundown. Where do they go? Where do they sleep, these noisy busybodies of the skies?

THE GULLS OF MAINE
Original oil on canvas 20 x 24 in (50.8 x 60.9 cm), 1984
From the collection of Mr. and Mrs. Jerry London
Offset lithograph 18 x 21½ in (45.7 x 54.6 cm), 1987

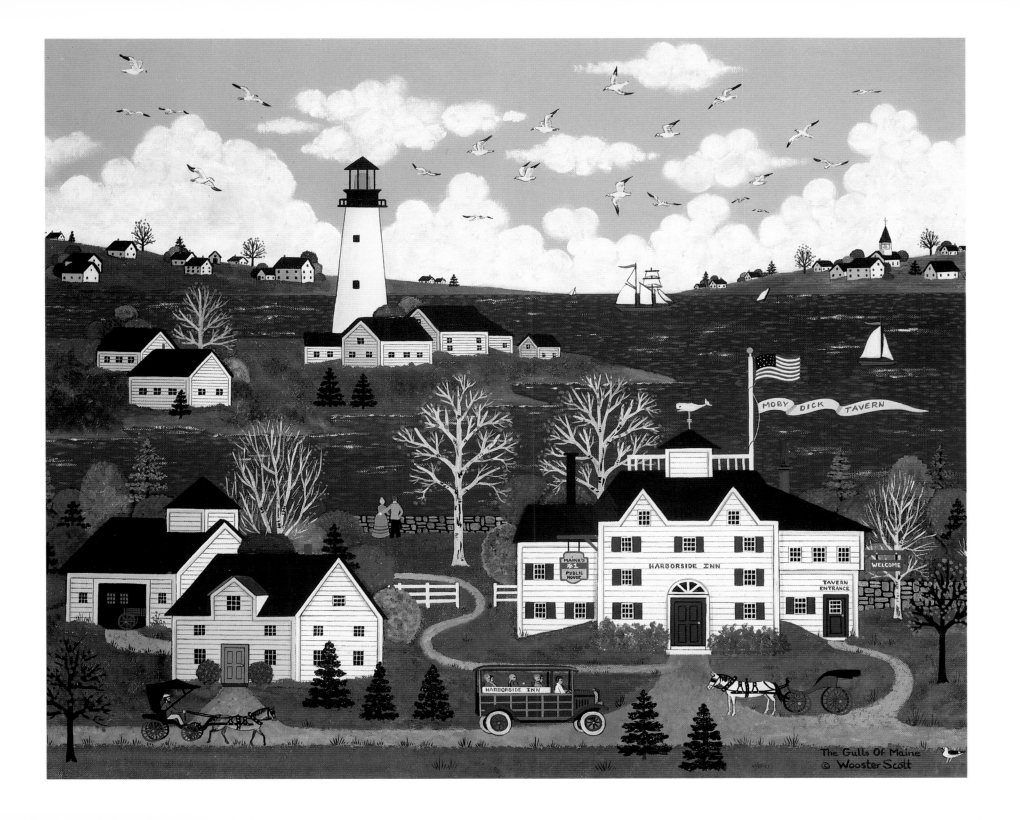

"The Gulls Of Maine"
© Wooster Scott

A Happening on Foxboro Pond

Ponds are disappearing. Henry David Thoreau's wondrous Waldon Pond is endangered.

Ponds are marvelous gifts of nature, filling depressions gouged by retreating glaciers in the last ice age. For farmers they are reliable sources of water for livestock. Small boys skinny-dip and catch perch in them in summertime. Migrating waterfoul stop for refreshing baths and a cool drink.

Trees and shrubs, reeds and cattails grow up around ponds. Birds nest nearby. Ponds attract thirsty night critters, especially racoons.

In winter, ponds become silvery playgrounds for skaters, as you can see in this happy scene at Foxboro.

We mustn't lose more ponds to housing developments, shopping malls and concrete condominiums. Such man-made folly will only make more work for Mother Nature when she decides it's time for another ice age.

A HAPPENING ON FOXBORO POND
Original oil on canvas 30 x 40 in (76.2 x 101.6 cm), 1987
From the collection of Mr. and Mrs. Archie Mishkin
Offset lithograph 20 x 28 in (50.8 x 71.1 cm), 1987

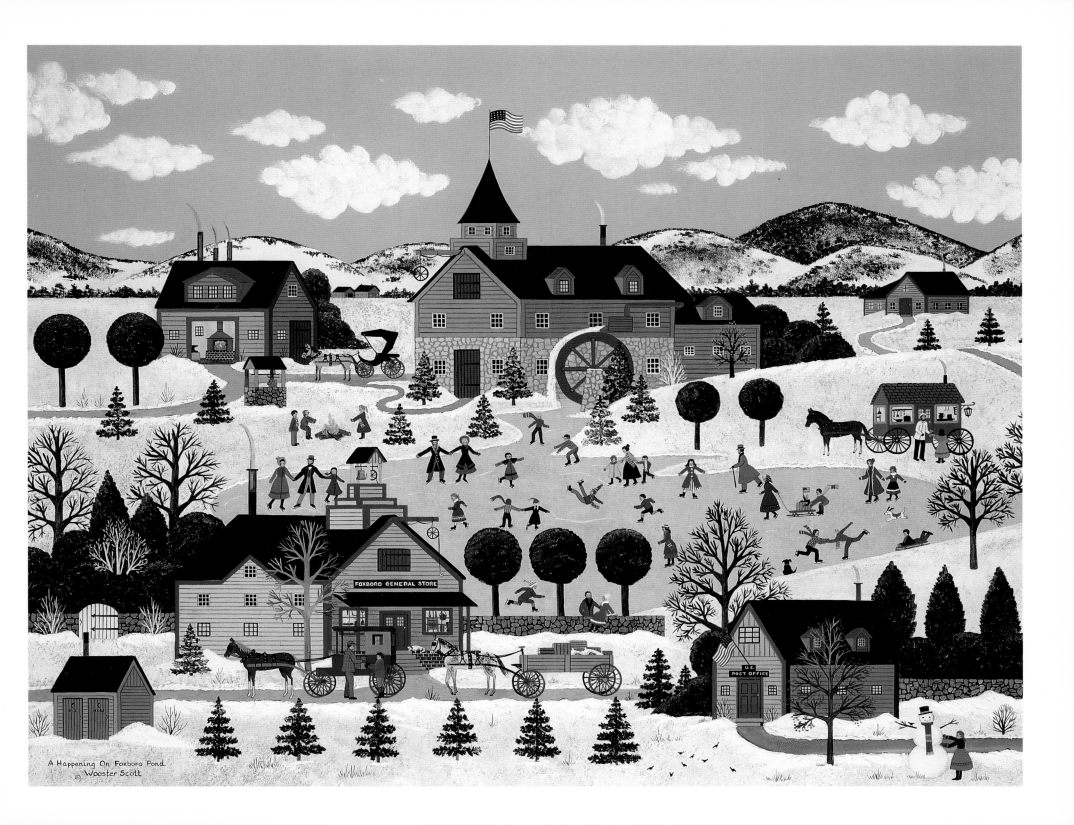

A Happening On Foxboro Pond
© Wooster Scott

Ice Cream Social

Charity events once were called *socials* or *sociables*, where folks raised funds for good causes.

Ice cream socials were a favorite with the ladies because menfolk behaved themselves. There were only three flavors: chocolate, strawberry and vanilla, hand-cranked at home with rich farm cream, sugar and flavoring in a canister surrounded by rock salt. Kids pitched in with the cranking to be rewarded with licking the churn clean.

At this social there are booths for candy, cold drinks and baked goods, too. These days cakes and cold drinks and candy still taste pretty much the same. But no matter how many flavors fancy ice cream factories turn out, they can't compare to hand-churned, chunky home goodness.

No, by golly.

No, siree.

Absolutely not.

Never!

ICE CREAM SOCIAL
Original oil on canvas 24 x 48 in (60.9 x 121.9 cm), 1990
Silkscreen serigraph 20 x 40 in (50.8 x 101.6 cm), 1990

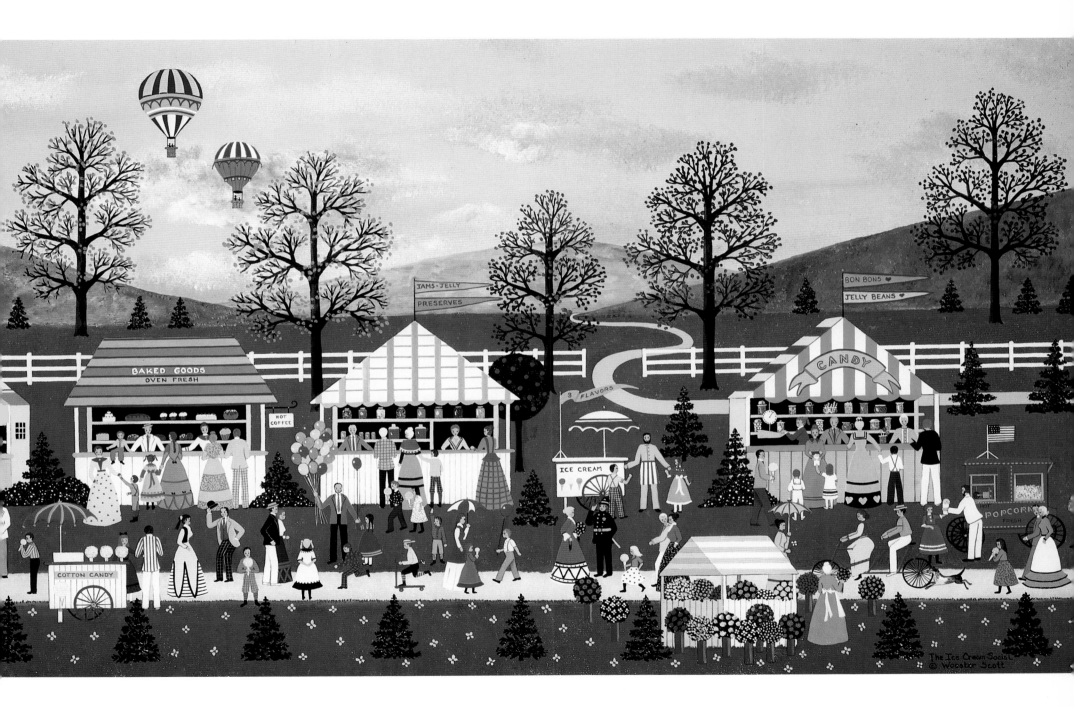

Happy Birthday Hollywood

Hollywood had become a painted jade by her seventy-fifth birthday, a squalid derelict, a boozy harridan ill-used by years of excess and sham.

She is beyond redemption now, seedy, corrupt and no longer beautiful. But there was a time when she shone and sparkled, a beacon of light in a dark and somber world. The silver screen brought laughter and music to the world, provoking thought and delivering beauty through great wars and dreadful catastrophies.

In this painting Jane Wooster Scott steals a moment from Hollywood's youth when the community was the toast of the arts, the hope for global peace and international understanding, the heart of creativity.

Today it is only symbolic of the bottom line:

$$$$$$$$$$$$$$$$$$$$$$$$$$$$$$$$$$

HAPPY BIRTHDAY HOLLYWOOD
Original oil on canvas 30 x 24 in (76.2 x 60.9 cm), 1987
From the collection of Karen Cameron
Offset lithograph 27 x 21 in (68.5 x 53.3 cm), 1987

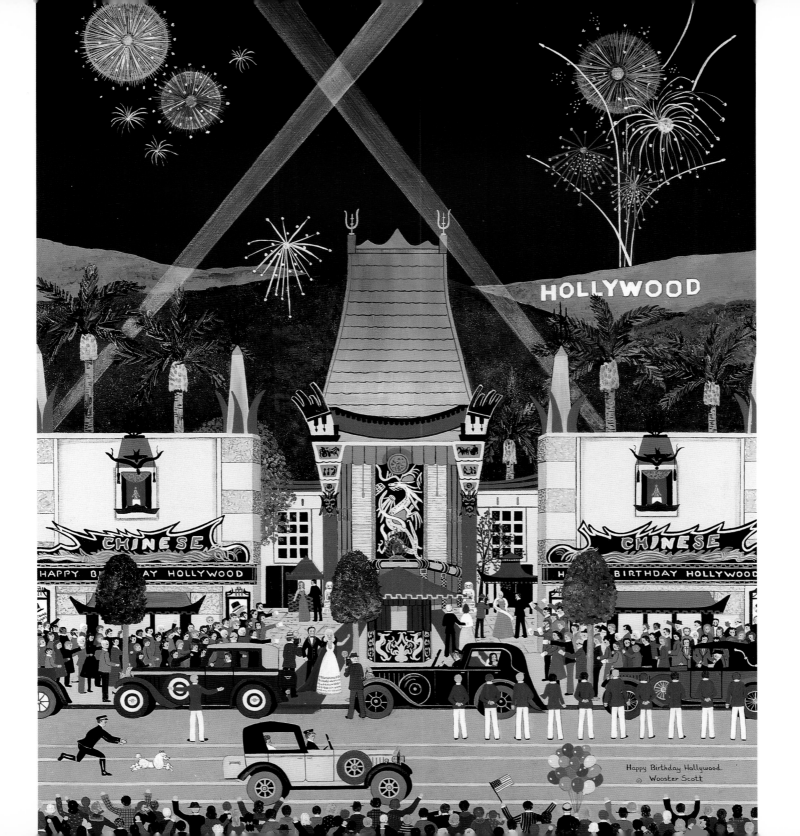

Happy Birthday Hollywood.
© Wooster Scott

Seafaring Sorority Sisters

How do you say, "Giddyap" to a sea horse? These maritime cowgirls, obviously fluent in the language of the deep, canter their frisky mounts along a most unusual bridle path. Having more fun still are their adventurous companions, hitching rides on a bubble-blowing orca. Gossamer plant life and the pilfering octopus add to the beauty of this magical undersea ballet.

SEAFARING SORORITY SISTERS
Original oil on canvas 24 x 24 in (60.9 x 60.9 cm), 1992

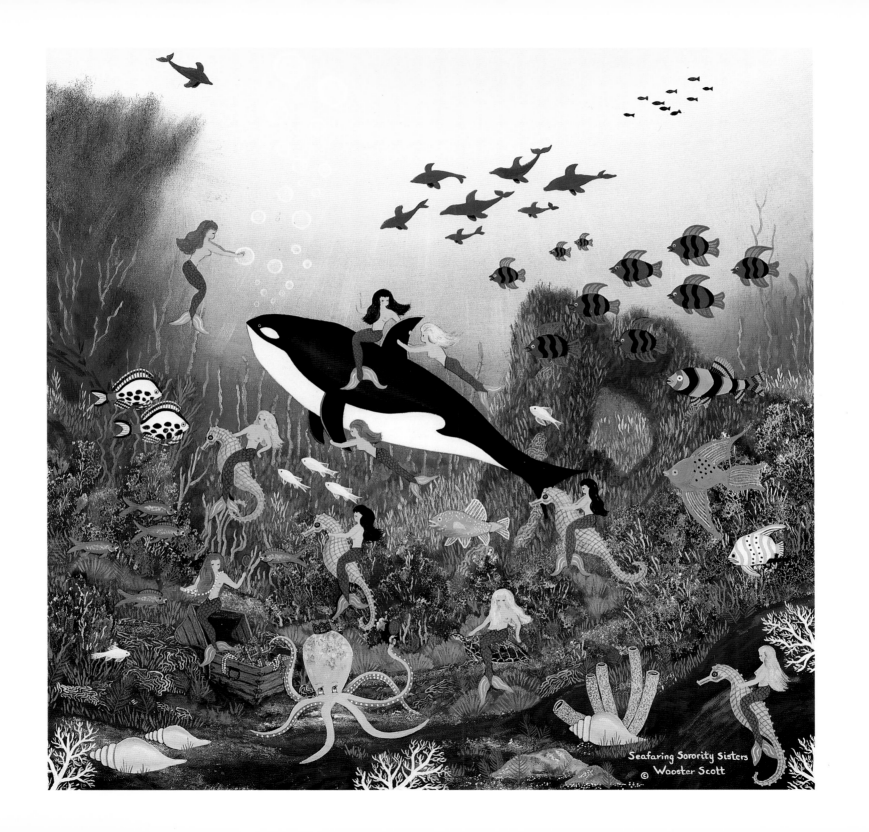

Seafaring Sorority Sisters
© Wooster Scott

Harry's Hangout

The diner was to the '30s, '40s and '50s what fast food joints are to the '70s, '80s and '90s.

Diners once blossomed along the Eastern Seaboard like so many chromium boxcars with big, steamy windows and neon signs, such as Harry's. Inside, floors were generally tile or linoleum. Lengthwise one side was a counter with swivel stools facing the kitchen. Leatherette booths lined the window section. Of course there was a jukebox.

Waitresses served coffee and crullers at breakfast, schlepped burgers and fries at noon. Dinners ran to chicken-fried steak.

Prices were right and the fry-cooks, in paper toques and soiled white aprons, knew their stuff.

Diners weren't franchised like fast-food joints, so there was individuality at Harry's or Joe's or Benny's. They were, however, bound by a single overwhelming appeal to the senses. They all smelled alike.

Delicious.

HARRY'S HANGOUT
Original Oil on canvas 24 x 24 in (60.9 x 60.9 cm), 1991

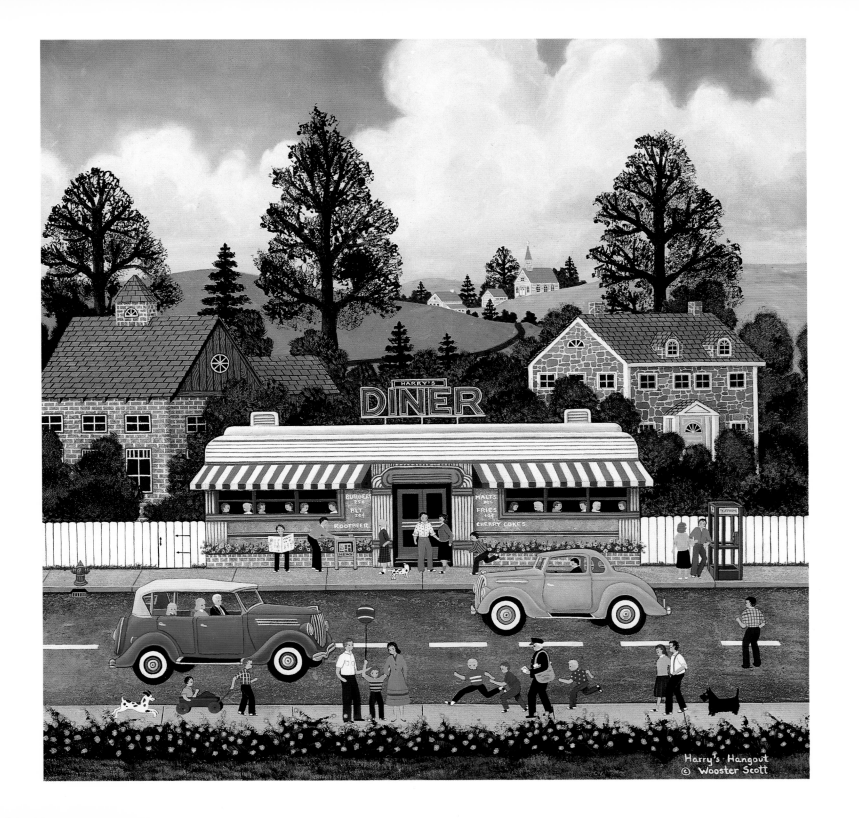

Harry's Hangout
© Wooster Scott

Heroes on Wheels

The United States Cycling Federation commissioned the artist to paint a panoramic view of the first World Cycling Championships ever held in this country. The time: 1986. The place: the Colorado Springs velodrome, set against the majestic Rockies.

Cycling is a curiously silent sport. When the stands are empty, the athletes swing swiftly around the banked track with only the whisper of wind in the spokes and tires singing on concrete.

HEROES ON WHEELS
Original oil on canvas 24 x 30 in (60.9 x 76.2 cm), 1985
Offset lithograph 20 x 24 in (50.8 x 60.9 cm), 1985

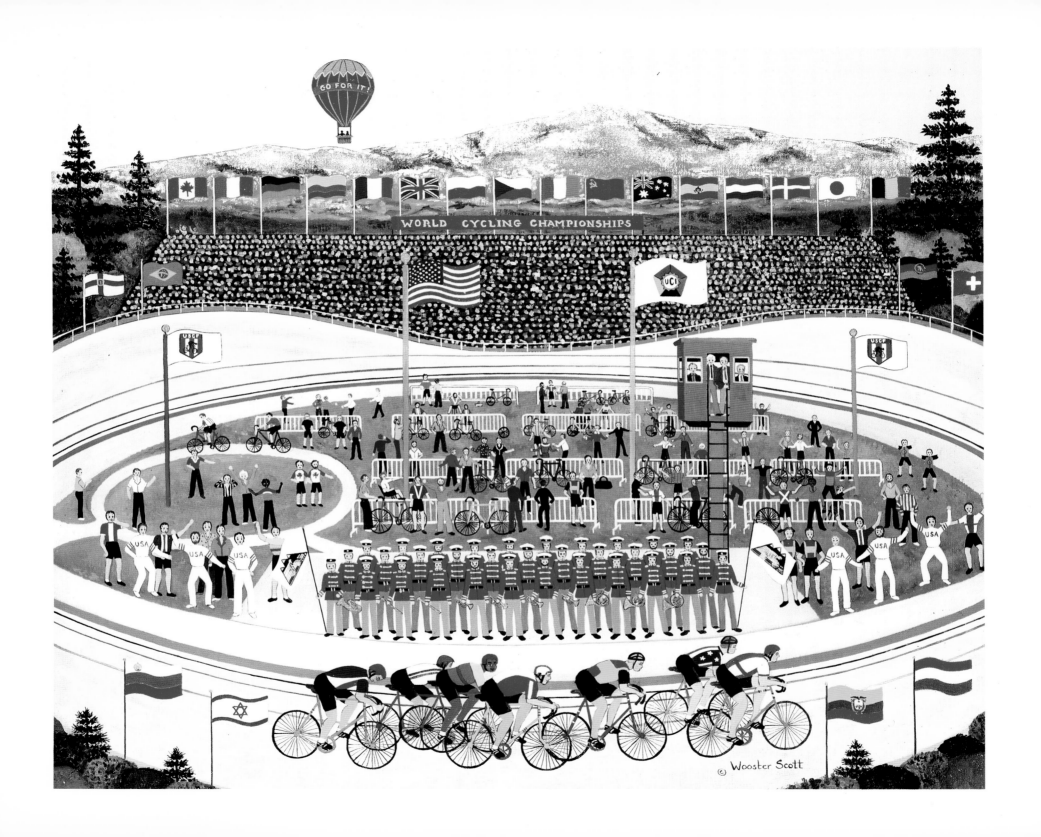

WORLD CYCLING CHAMPIONSHIPS

GO FOR IT!

© Wooster Scott

A Really Swell Parade Down Main Street

It really doesn't matter that there are more paraders than spectators in a small town parade. The folks all know each other anyway. That's what makes a parade like this one so special.

Why, there was one parade in Alamo, Nevada, not too long ago when there wasn't a single spectator on the two-block parade route. The whole town (population 278 souls) was in the parade.

A REALLY SWELL PARADE DOWN MAIN STREET
Original oil on canvas 18 x 24 in (45.7 x 60.9 cm), 1977
From the collection of Mr. and Mrs. Ernest Borgnine

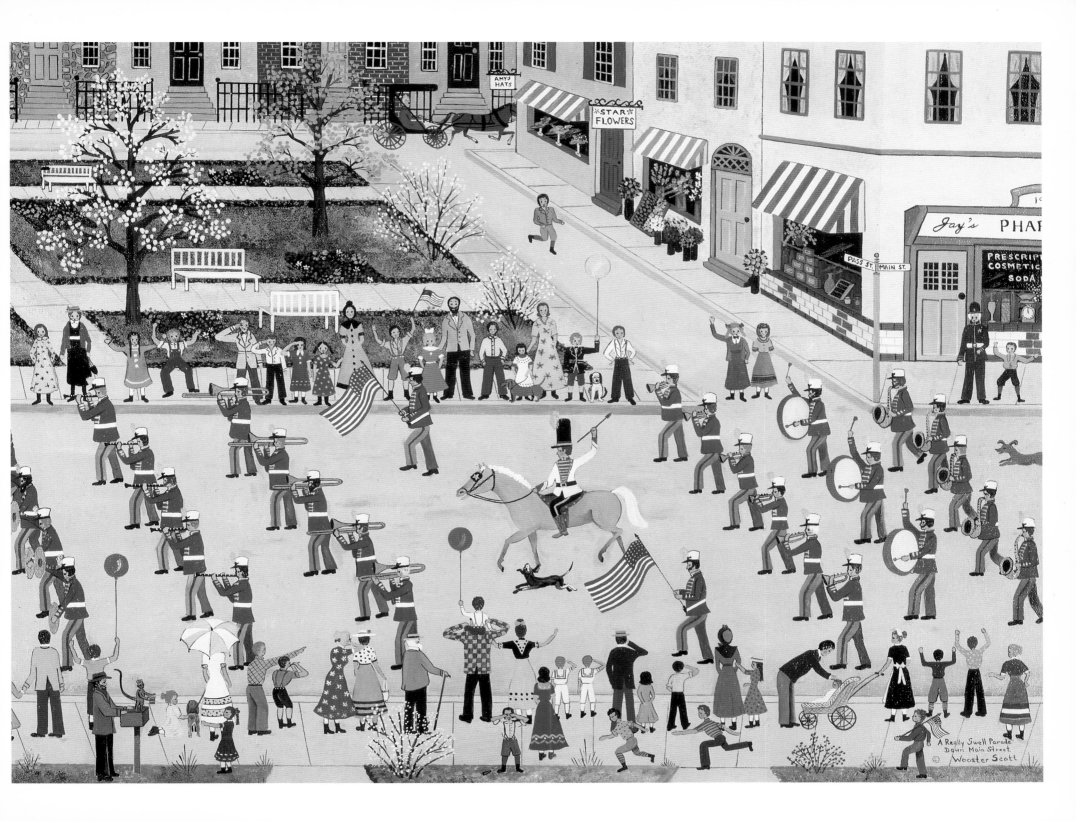

A Really Swell Parade
Down Main Street
© Wooster Scott

The Nativity

Religion is a personal and private matter for most of us. But of all mankind's institutions a belief in greater powers and wisdom, taken on faith, is the most enduring.

THE NATIVITY
Original oil on canvas 19¼ x 14 in (48.9 x 35.5 cm), 1991
From the collection of Mr. and Mrs. John Mack Carter

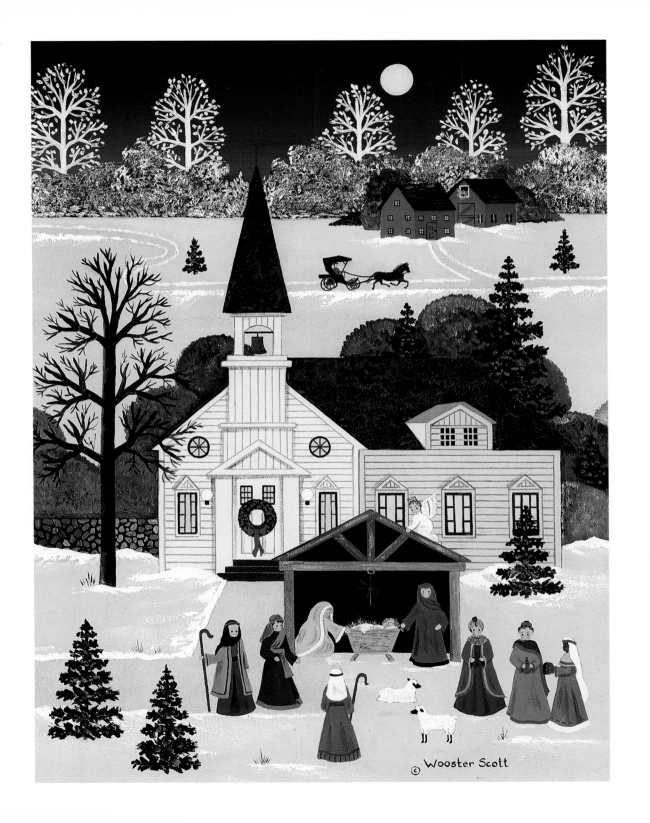

The Taylor Collection

The offspring of Mr. and Mrs. David Taylor commissioned the artist to paint a family portrait in front of their Long Island home, complete with dogs, Nancy's peerless gardens and David's favorite old sports car. It was a welcome and touching gift from the Taylor's grown-up children.

(Top)
THE TAYLOR COLLECTION
Original oil on canvas 24 x 30 in (60.9 x 76.2 cm), 1989
From the collection of Mr. and Mrs. David Taylor

Larsen's Lair

Log houses were a necessity for frontier families who had no other materials at hand from which to build their homes, except for sod houses out on the prairies where there were precious few trees.

But as we approach the 21st century, log houses have become popular in mountain areas of the West. This particular log home belongs to Joyce Larsen of Idaho.

(Bottom)
LARSEN'S LAIR
Original oil on canvas 20 x 24 in (50.8 x 60.9 cm), 1985
From the collection of Joyce Larsen

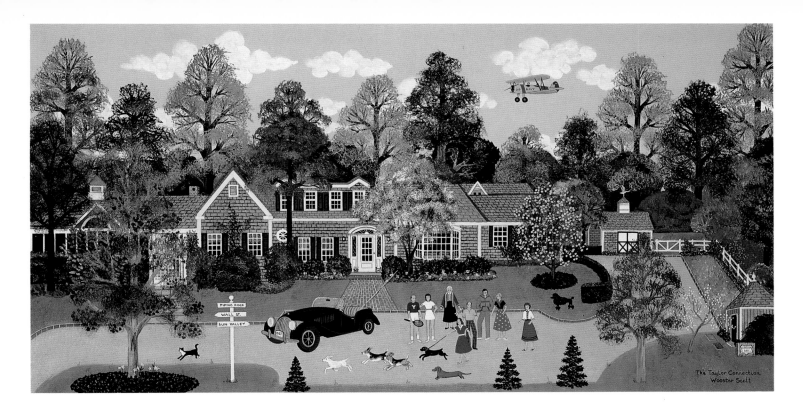

The Taylor Connection
Wooster Scott

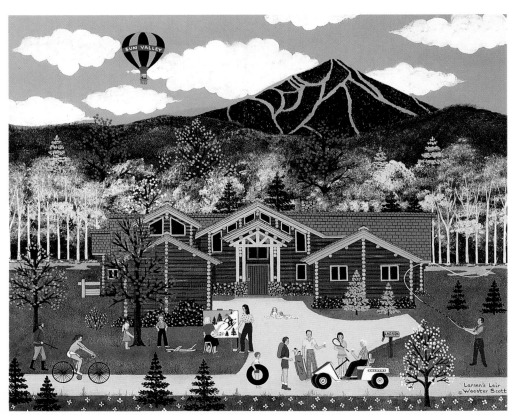

Larsen's Lair
© Wooster Scott

The Greatest Show on Earth

It just didn't get any more exciting than this!

The circus paraded from the train depot big as life through the center of town to Hyram Honnecker's pasture where roughnecks raised the bigtop for *The Greatest Show on Earth*.

Every soul in Eustice County bought a fifty-cent ticket half of that for kids to see the clowns and trapeze flyers, the acrobats and bareback riders, all to the cadence of the brass band and the wheezing steam caliope.

Every soul that is except Winfield Bollenbecker, the town ne'er-do-well. They caught him sneaking under the tent once the show got underway. Poor Winfield got his first job when the circus left town two days later. He was following the elephants and horses, carrying a shovel and looking mighty sorrowful.

200

THE GREATEST SHOW ON EARTH
Original oil on canvas 30 x 40 in (76.2 x 101.6 cm), 1990
Silkscreen serigraph 24 x 32 in (60.9 x 81.2 cm), 1991

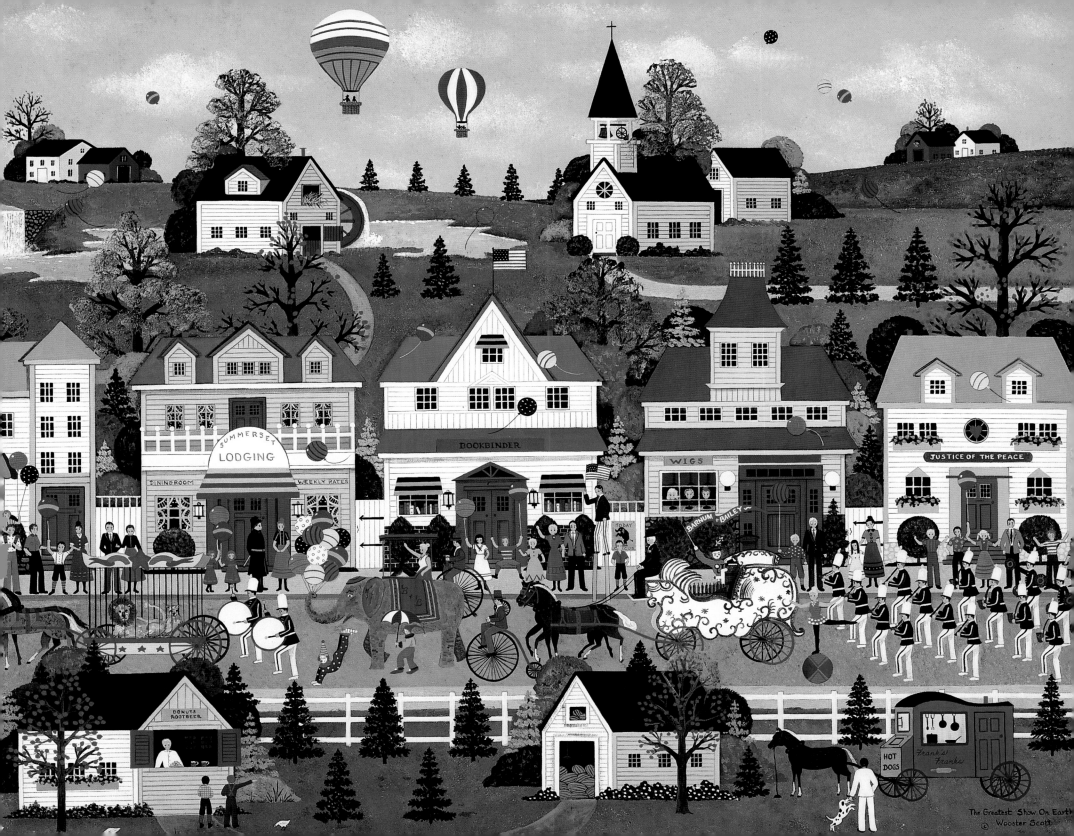

The General Store

The beauty of general stores was their magical aromatic emanations: apples and dill pickles in the produce corner, the crisp freshness of dry goods and bedding, the tang of cloves, wintergreen and ginger in canisters, and new straw brooms. Remember the nip of kerosene for hurricane lamps, the medicinal scent of Mercurochrome and cod liver oil, ugh!

Rust made known its pungent presence at the hardware table, as did irony nails and soothing lubricating oil. Pipe tobacco spoke intriguingly of exotic lands. The ladies' perfume cabinet sang of honeysuckle, orange blossom and attar of roses. And, yes, the inviting piquancy in a hogshead of sorghum molasses.

You could get almost anything at the old general store and, looking back, many a treasure to be found nowhere else.

THE GENERAL STORE
Original oil on canvas 18 x 24 in (45.7 x 60.9 cm), 1978
From the collection of Gloria Gilfenbain

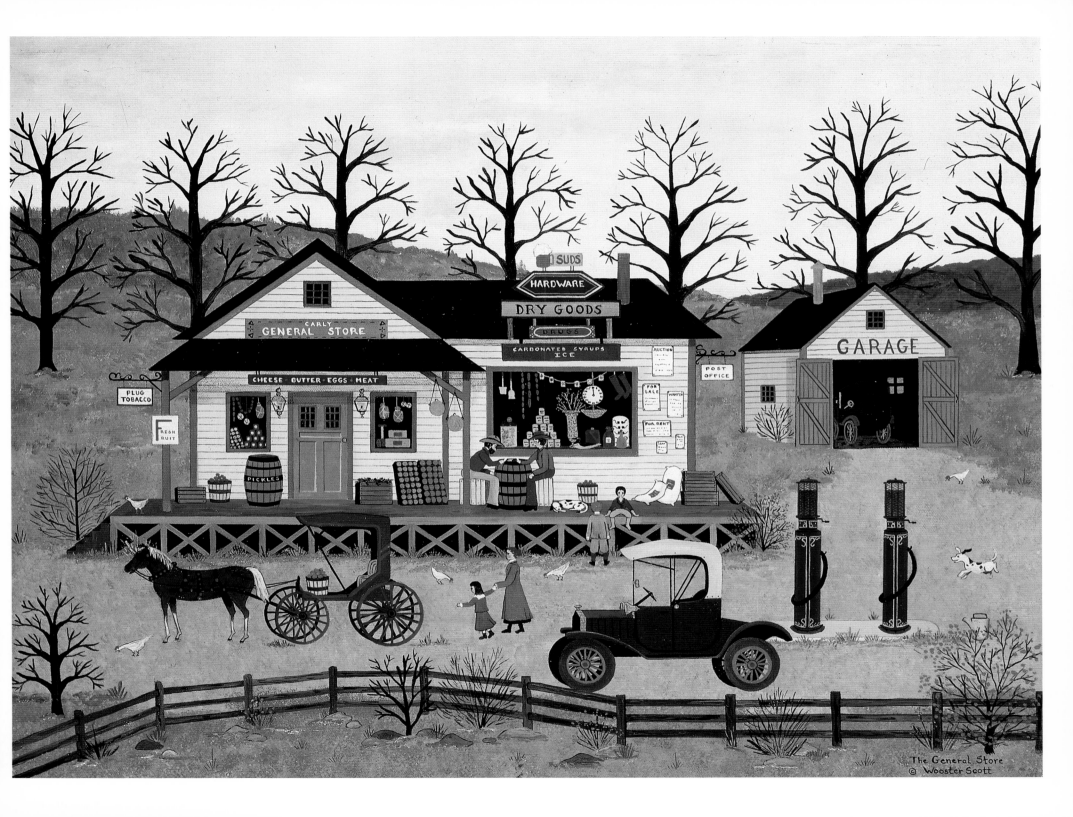

The General Store
© Wooster Scott

A Lark in the Park

A festival of color explodes from pallette to canvas in a

transcendental celebration of joy.

A LARK IN THE PARK
Original oil on canvas 20 x 24 in (50.8 x 60.9 cm), 1992

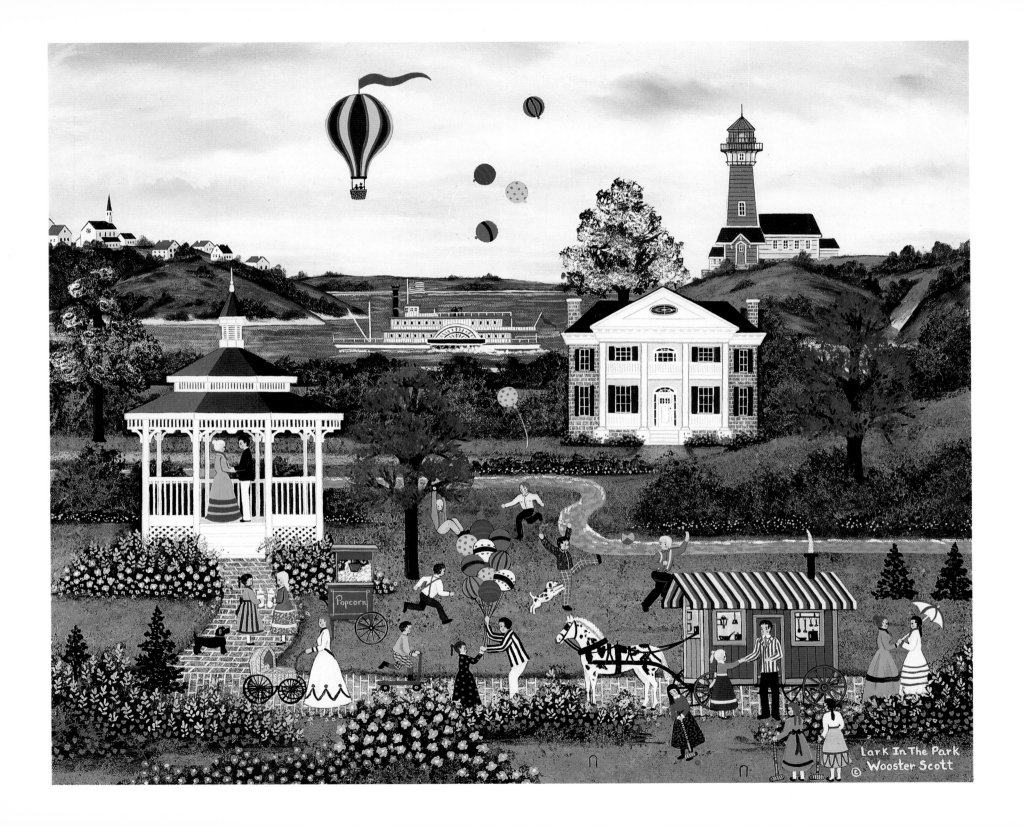

Lark In The Park
Wooster Scott ©

The Magic of McCall

This action-filled painting represents one of the artist's approaches to commissions from collectors seeking to immortalize their families, homes, hobbies, business enterprises and precious possessions on a single canvas. *The Magic of McCall* was painted for Douglas and Betsy Manchester of McCall, Idaho, a growing resort area in the Rocky Mountains.

THE MAGIC OF McCALL
Original oil on canvas 30 x 40 in (76.2 x 101.6 cm), 1992
From the collection of Mr. and Mrs. Douglas Manchester

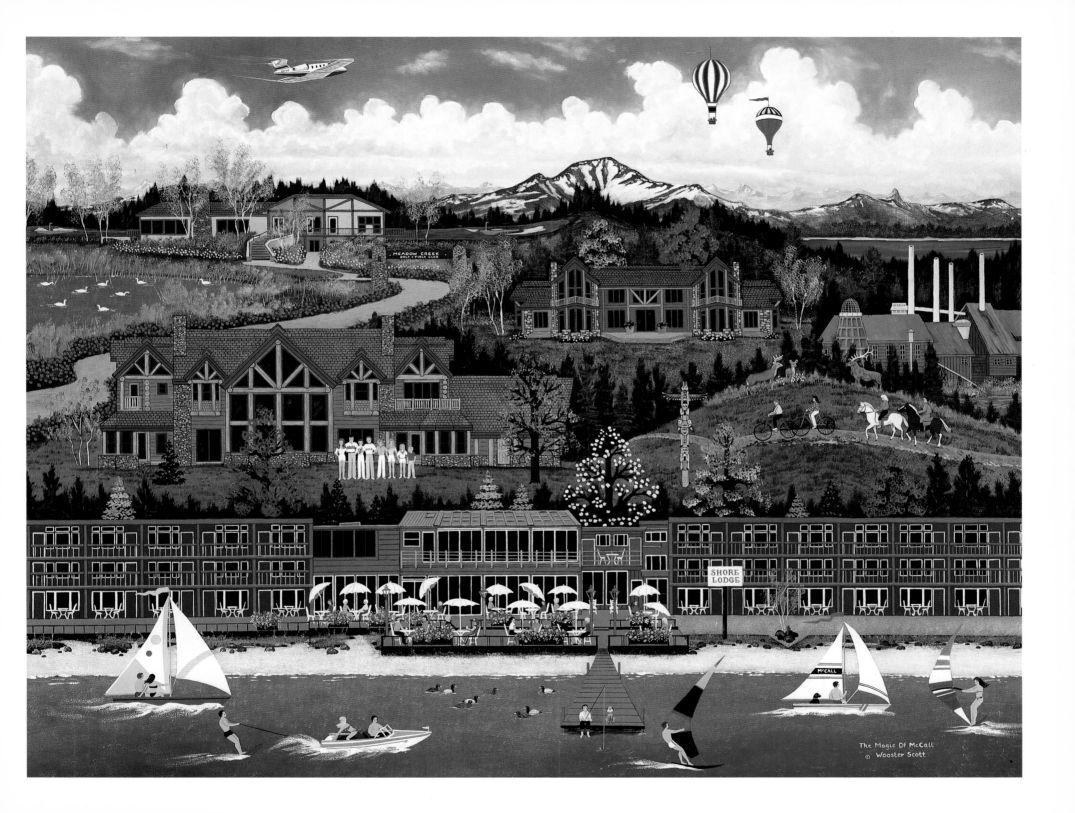

The Magic Of McCall
© Wooster Scott

Loves Me, Loves Me Not?

The war between the sexes has raged for eons, but it was gentle, playful skirmishing in the romantic 19th Century when all women were ladies and men were gentlemen.

Loves Me, Loves Me Not? freeze-frames a moment when a determined lass attempts to interest her reluctant swain in a bridal gown displayed in a Victorian shop window. The balloonist obviously is the lady's ally at a time before *chauvinist* and *feminist* defined the genders. Chivalry in America was at its height. Women were cherished for their femininity and men admired for their gallantry in an era of romantic fantasy. In those less complex times the sexes complemented each other non-competitively.

Yet some things never change. Even now the age-old courting dance continues. Artist Scott was inspired to paint this scene when a friend confided her suitor quickened his pace whenever they strolled past bridal shops. That particular bachelor is now a married man. Doubtless, the same fate befell the young dandy in the painting.

LOVES ME, LOVES ME NOT?
Original oil on canvas 16 x 20 in (40.6 x 50.8 cm), 1992
From the collection of Mr. and Mrs. Steve Ackerman
Offset lithograph 10¾ x 13½ in (27.3 x 34.2 cm), 1993

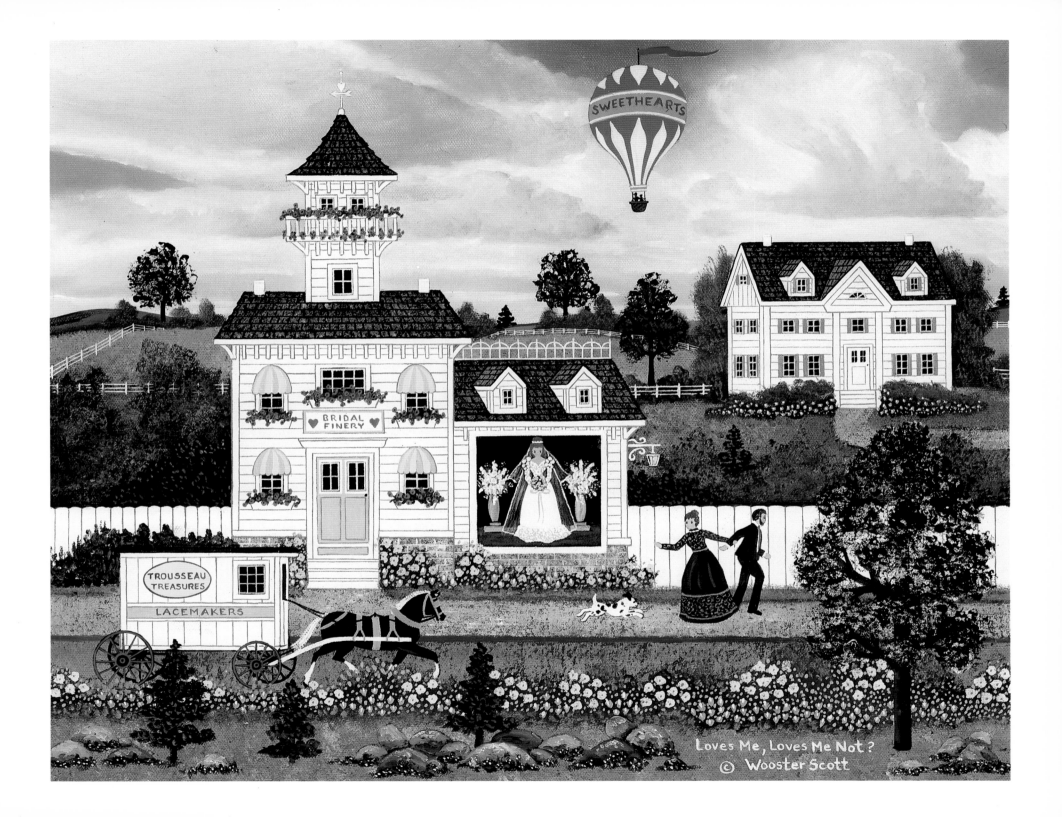

Loves Me, Loves Me Not?
© Wooster Scott

The Independence Day Parade

Few experiences are more inspiring to patriots than the drumbeat cadence, blaring brass and trilling reeds of a proper military band. Truth to tell, America's pulse beats a tad more rapidly when Old Glory passes in review to the stirring tempo of a John Philip Sousa march.

This glorious painting of a small town Fourth of July celebration is the essence of America's pride in having established the first free society on Earth. One can almost hear *The Stars and Stripes Forever* ring out across the land at a time of peace and tranquility.

★ ★ ★ THE UNITED STATES OF AMERICA ★ ★ ★

Has a ring to it, doesn't it?

THE INDEPENDENCE DAY PARADE
Original oil on canvas 28 x 22 in (71.1 x 55.8 cm), 1985
Offset lithograph 24 x 19 in (60.9 x 48.2 cm), 1987

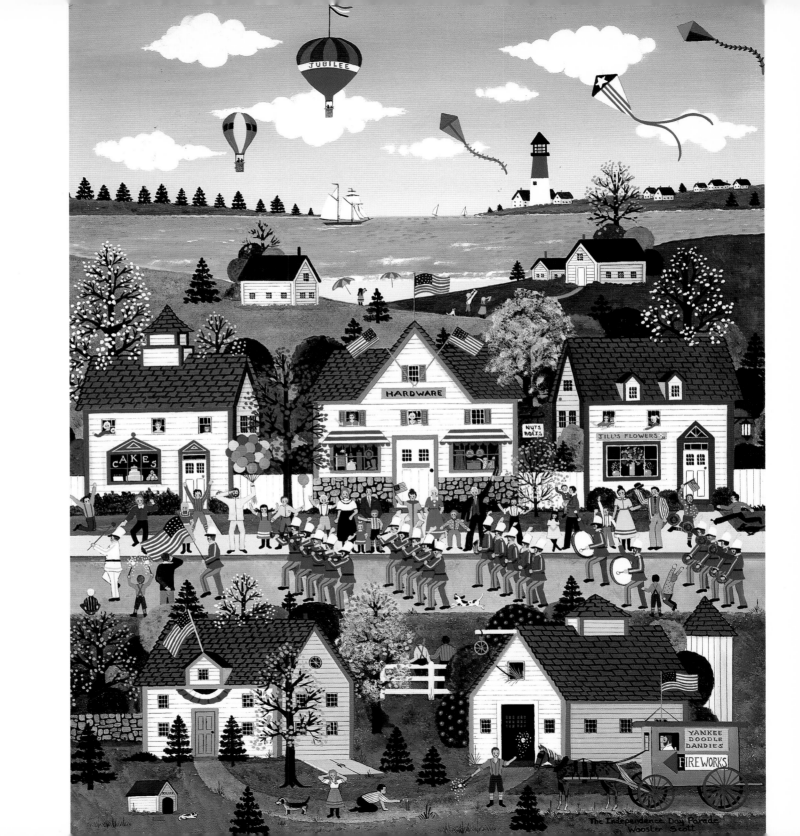

A Major in the Minors

Baseball is as much a part of understanding America as any of the nation's institutions, a sport that is at once a team enterprise and yet uniquely individual, reflecting the national motto *E Pluribus Unum*. Baseball, the country's oldest and most beloved pastime, surpasses all other games and sports as a favorite of artists.

Scott has painted children's baseball games, sandlot contests, bush leagues, Little League and the major leagues. This colorful canvas reflects opening day of the Class A Boise Hawks, the bleachers are full and hopes run high for a pennant, a scene repeated in scores of cities across the land each spring.

A MAJOR IN THE MINORS
Original oil on canvas 24 x 30 in (60.9 x 76.2 cm), 1989
From the collection of Mr. and Mrs. William Pereira
Offset Lithograph 17⅜ x 22 in (44.1 x 55.8 cm), 1989

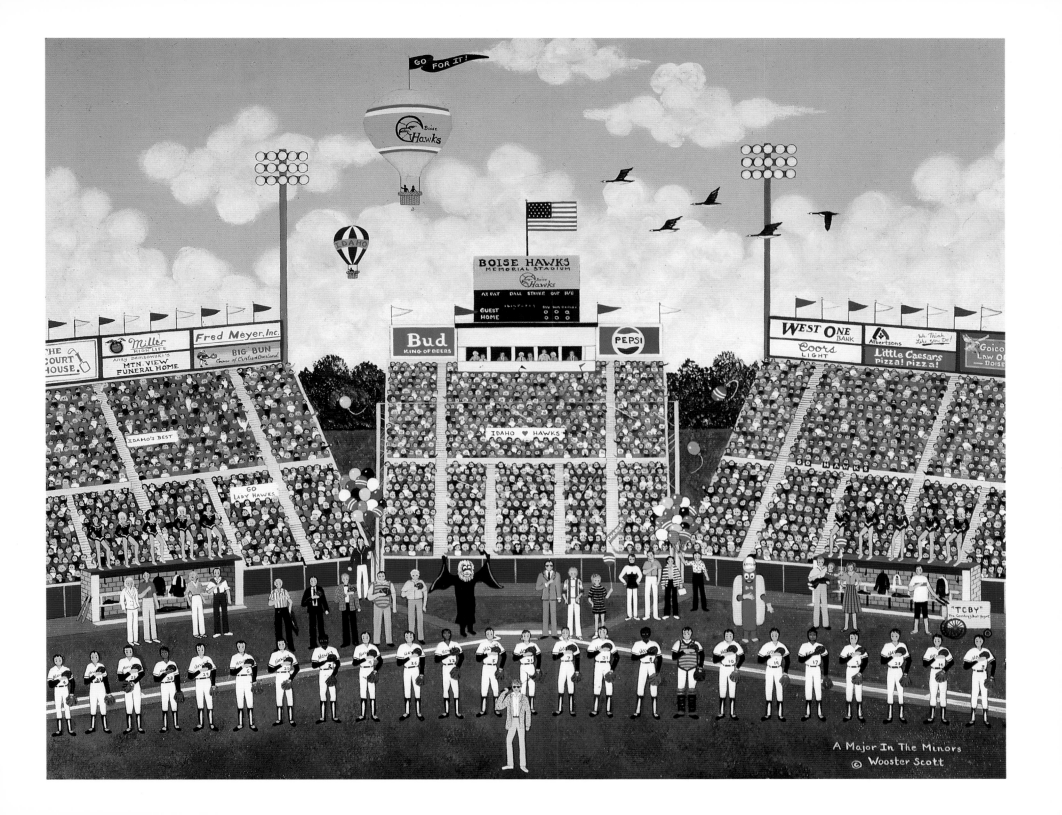

Country Living

If you hoped to see all the delightful elements of country life in a single painting, Jane Wooster Scott has fulfilled that fantasy with a profusion of blossoming trees, scampering children, placid lifestock, pecking hens and waddling geese.

There was not an exact landscape for *Country Living*, but the artist has seen a hundred similar scenes traveling through sections of Pennsylvania, agricultural communities in Vermont, in areas of New Hampshire, Massachusetts and upstate New York.

Of course, there are barns and houses, windmills and meadows like these in every state. Scott had the good sense to combine them in poetic proximity, creating a landscape for our dreams. We know it would be a lovely place to visit, perhaps to call home. Even the scarecrow looks happy.

COUNTRY LIVING
Original oil on canvas 16 x 20 in (40.6 x 50.8 cm), 1983
From the collection of Victoria Principal

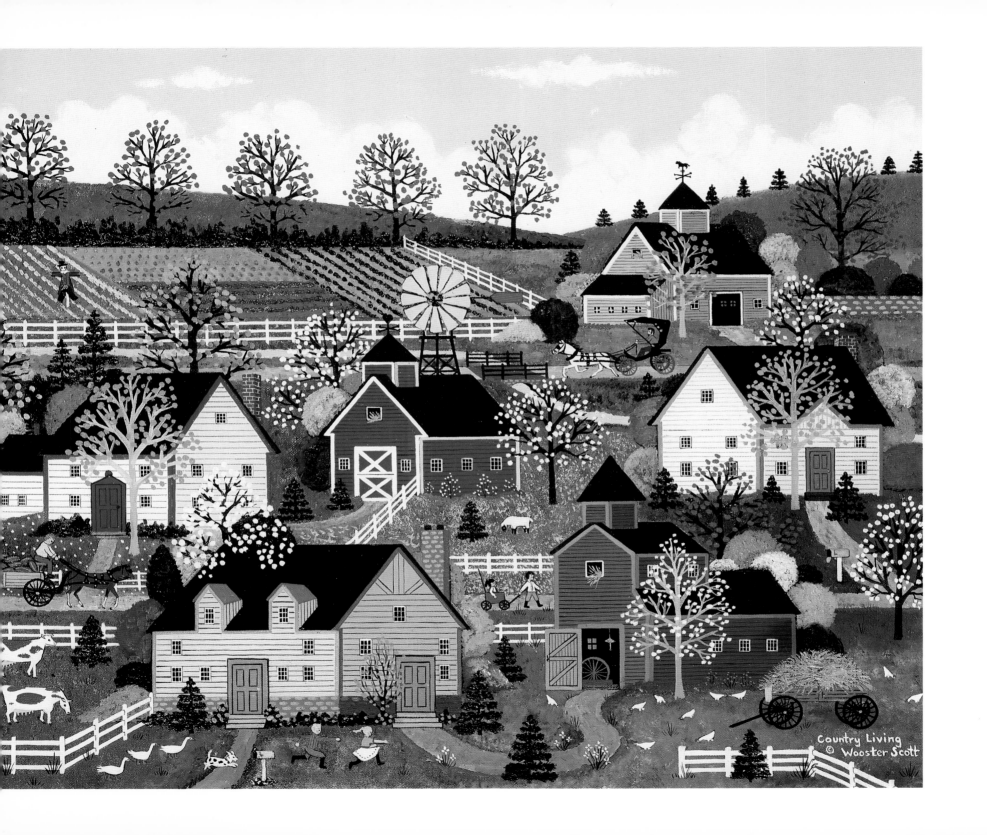

Country Living
© Wooster Scott

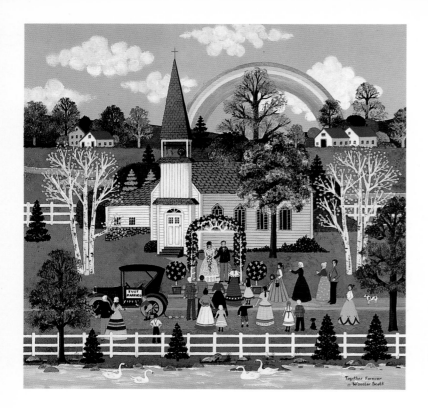

TOGETHER FOREVER
Original oil on canvas 24 x 24 in (60.9 x 60.9 cm), 1990
Silkscreen serigraph 14 x 14 in (35.5 x 35.5 cm), 1991

The Four Seasons Suite

Autumn is a different season from the others.

Winter is cold, bleak and the earth sleeps.

Spring betokens rebirth and awakening.

Summer is the seasonal star, life's celebration.

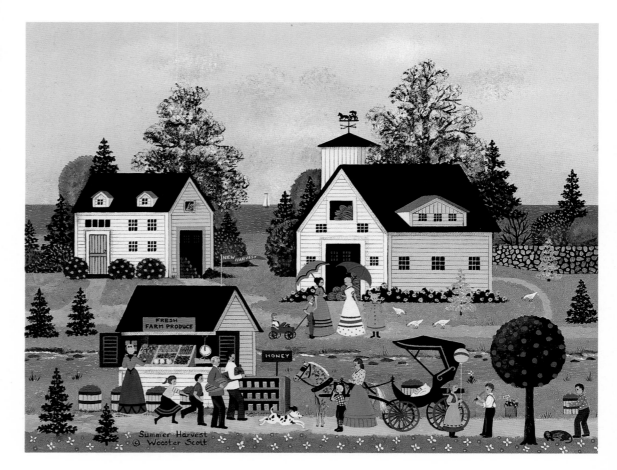

SUMMER HARVEST
Original oil on canvas 16 x 20 in (40.6 x 50.8 cm), 1990
Silkscreen Serigraph 11⅓ x 14 in (28.5 x 35.5 cm), 1991

But autumn is different.

It is transitional and about change.

A time to bid farewell to summer's light.

A season to gird for winter's dark.

We mourn the passing of long sunny days.

We dread old winter shuffling into view.

But when autumn's dazzling colors blaze

We see the glass half full, not half empty.

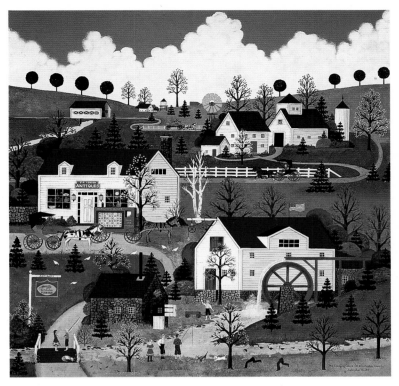

THE CHANGING COLORS OF WINCHESTER COUNTY
Original oil on canvas 30 x 30 in (76.2 x 76.2 cm), 1985
From the collection of Karen Cameron
Silkscreen serigraph 14 x 14 in (35.5 x 35.5 cm), 1991

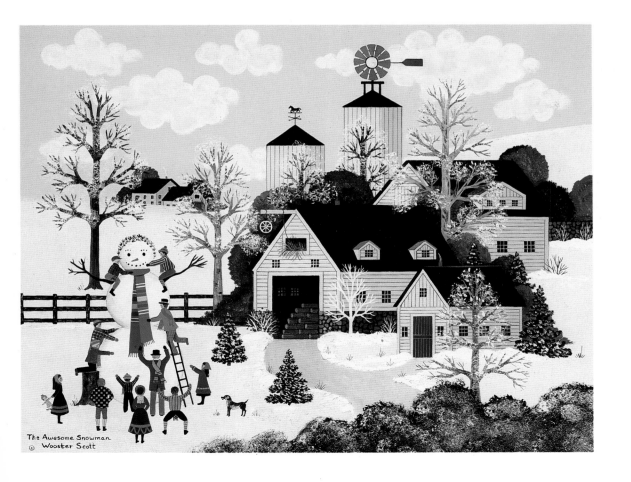

THE AWESOME SNOWMAN
Original oil on canvas 20 x 24 in (50.8 x 60.9 cm), 1990
Silkscreen serigraph 11⅓ x 14 in (28.4 x 35.5 cm), 1991

The First Service Station in Deerfield

We were downright proud when they built the station, except for Dan Marshall, the blacksmith. The pumps and garage gleamed with new paint. And there was the vagrant aroma of gasoline. We thought we were keeping up with the times.

Oh, we'd seen service stations before, but clear down to Westfield or over to Richmond. This one was ours and it got some roads paved, too.

It wasn't long before the water trough became firewood. The harness shop closed. Carriages, shays, surreys and wagons disappeared. The rich, natural aroma of manure evaporated. So did the sweet breath of plowed fields, wild flowers and the scent of blooming orchards. They were drowned by acrid vapors from gas and oil, clouds of foul smoke from internal combustion engines.

Now a freeway runs a mile west of Deerfield. Nobody comes through here much anymore. The filling station burned down twenty years ago.

And to think we called it progress.

THE FIRST SERVICE STATION IN DEERFIELD
Original oil on canvas 24 x 30 in (60.9 x 76.2 cm), 1982
From the collection of Sylvester Stallone
Offset lithograph 14⅜ x 18 in (36.5 x 45.7 cm), 1990

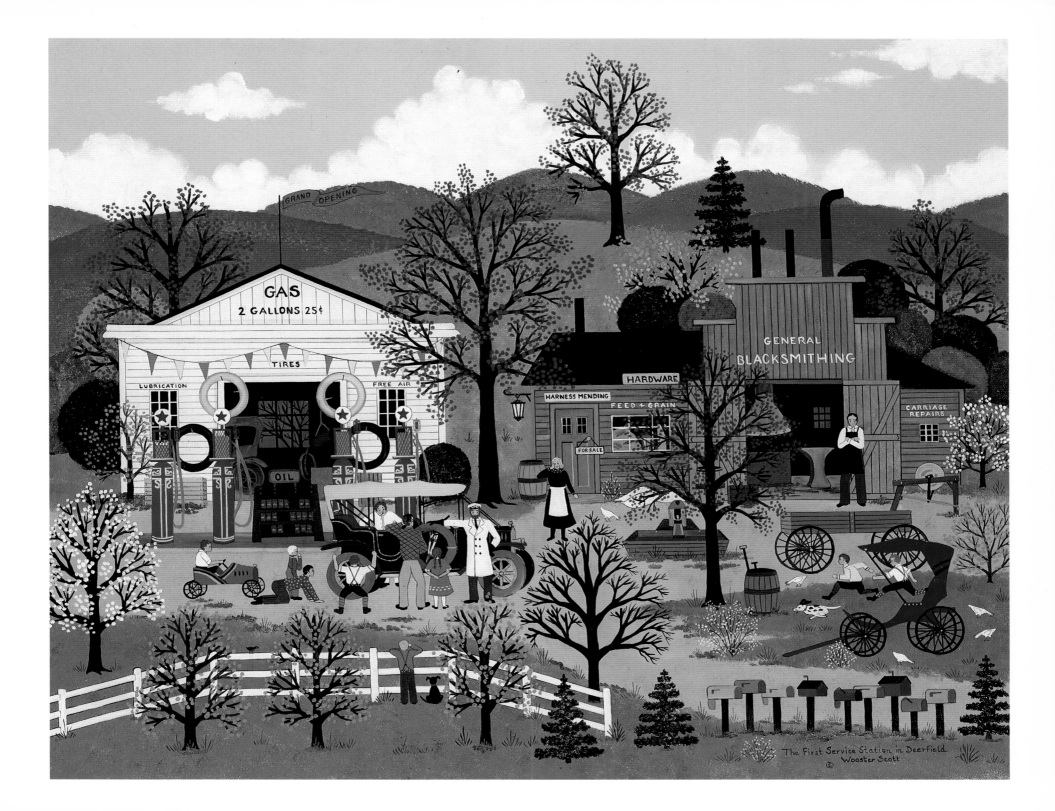

The First Service Station in Deerfield
Wooster Scott

Winter Pastoral

Peace and quiet descend on man and beast, as befits the season
when earth rests and man sets aside his labor.

WINTER PASTORAL
Original oil on canvas 24 x 24 in (60.9 x 60.9 cm), 1993

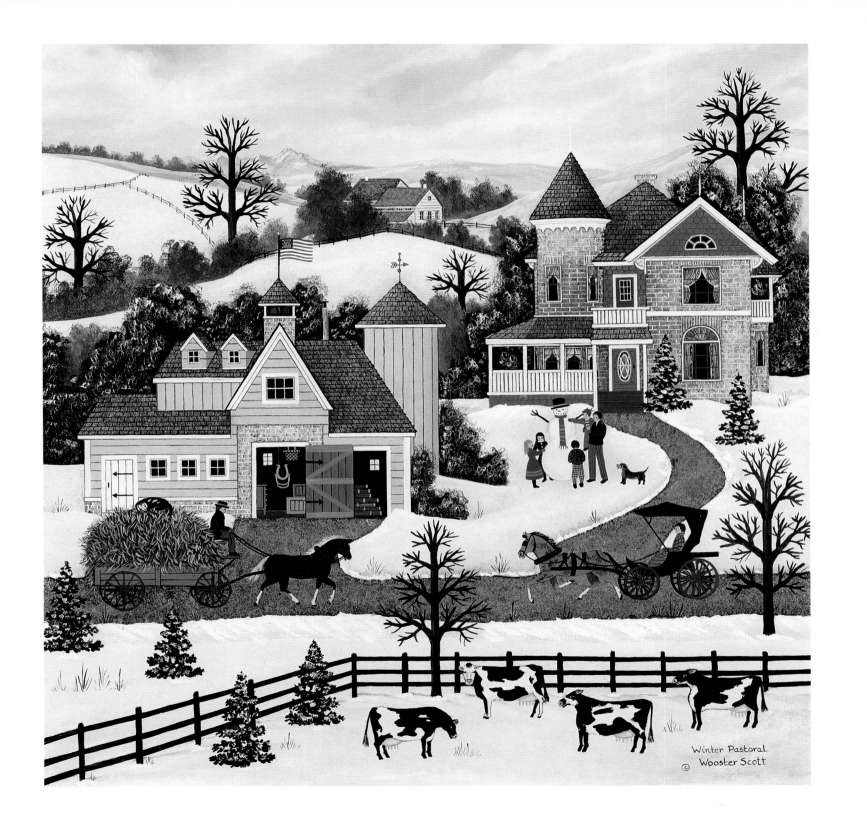

Winter Pastoral
© Wooster Scott

Springtime in Central Park

The annual miracle of vernal renewal is nowhere more welcome than in the world's great cities where gray days of winter prevail from November to April.

City dwellers, alienated from Earth's ancient cycle, become supplicants in their beloved parks when springtime bursts forth in a celebratory psalm of rebirth, of greening, sunshine and the gleeful cries of children welcoming yet another new beginning in the grand design.

SPRINGTIME IN CENTRAL PARK
Original oil on canvas 28 x 22 in (71.1 x 55.8 cm), 1982
From the collection of Howard Berkowitz

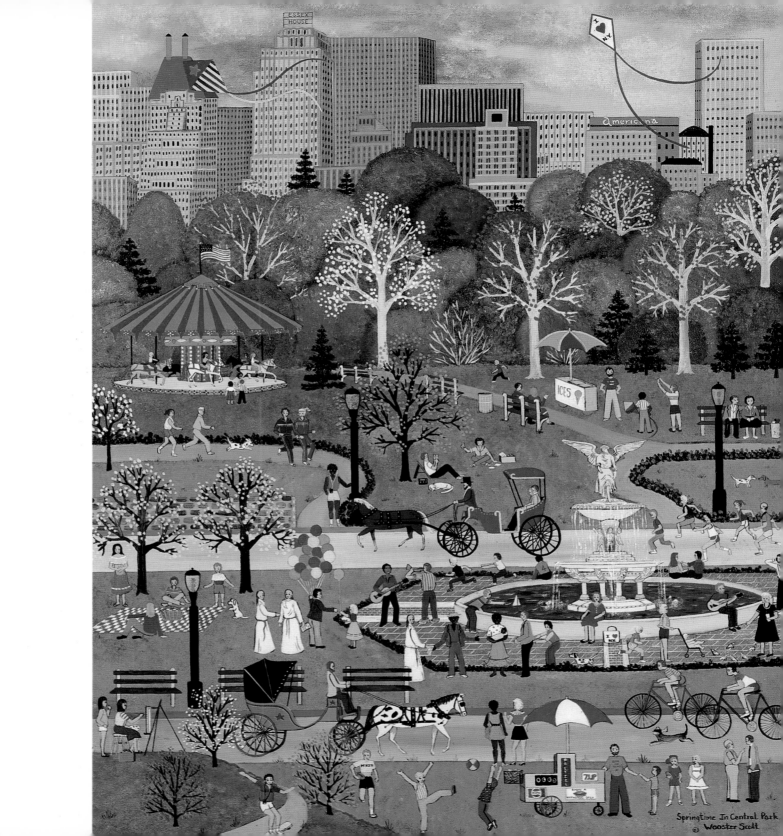

Springtime In Central Park
Wooster Scott

Yesteryear in Blue Ridge Summit

Tranquility's color is blue,

A most inspiring hue.

If you study this scene,

You will see it's not green.

YESTERYEAR IN BLUE RIDGE SUMMIT
Original oil on canvas 24 x 30 in (60.9 x 76.2 cm), 1991
From the collection of William Muir
Silkscreen serigraph 24 x 30 in (60.9 x 76.2 cm), 1991

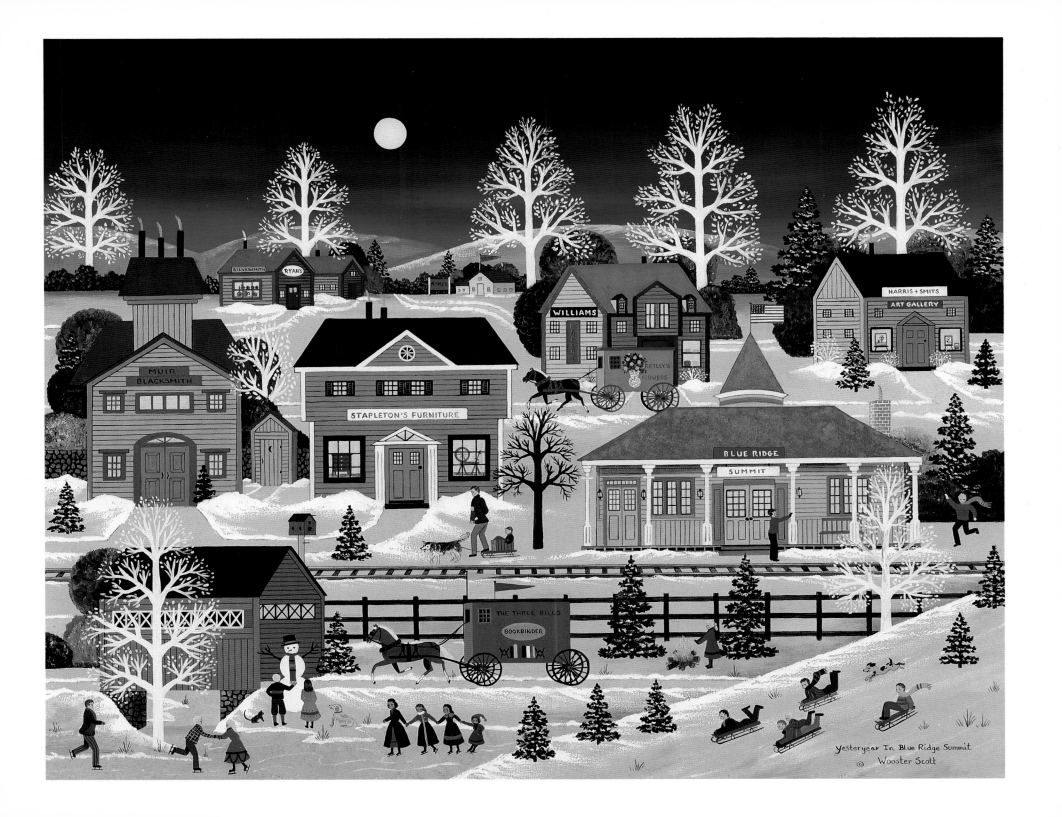

Yesteryear In Blue Ridge Summit
© Wooster Scott

Kentucky

This painting speaks to former Governor John Y. Brown of Kentucky whose public milestones are represented here, commissioned by his wife, former Miss America Phyllis George, when he was chief executive of the Blue Grass State.

Governor Brown's home, the state capital building, the governor's mansion and business enterprises are testimonials to his accomplishments before, during and after his term of office.

KENTUCKY
Original oil on canvas 40 x 30 in (101.6 x 76.2 cm), 1978
From the collection of Governor and Mrs. John Y. Brown (Phyllis George)

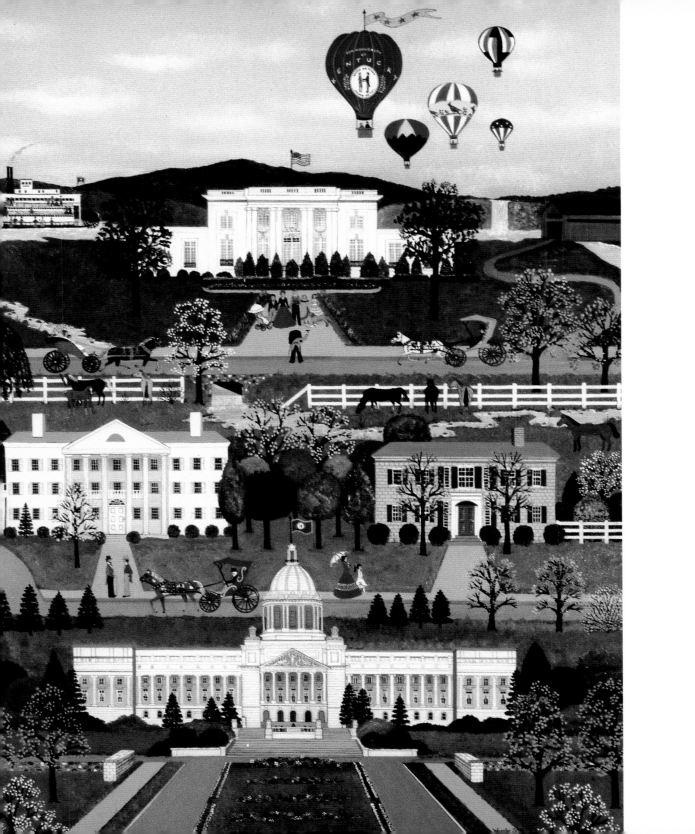

Hanging Out at Miller's Pond

Parents in this neck of the woods knew where to find their kids when chores were done and school was out.

Youngsters swam in that little body of water in summertime. Occasionally they caught a perch or two. In wintertime they skated and skylarked on its ice. You could hear 'em over half the township.

I suppose kids weren't any better or worse than today. There were no drugs, except sulfur and molasses for spring tonic. No tailor-made cigarettes, but they smoked corn silk out behind the barn. They drank no liquor. McComb county was dry and corn squeezings hard to come by. Spray cans weren't invented. No tomfoolery in the back of automobiles because there weren't no such contraptions. Of course there were tussles in haylofts now and again, teenagers being what they are.

If kids were less wild, it wasn't out of virtue. Truth is, Miller's Pond was a hangout because there was no place else to go and nothing much else to do.

HANGING OUT AT MILLER'S POND
Original oil on canvas 40 x 30 in (101.6 x 76.2 cm), 1988
Silkscreen serigraph 25 x 34½ in (63.5 x 87.6 cm), 1988

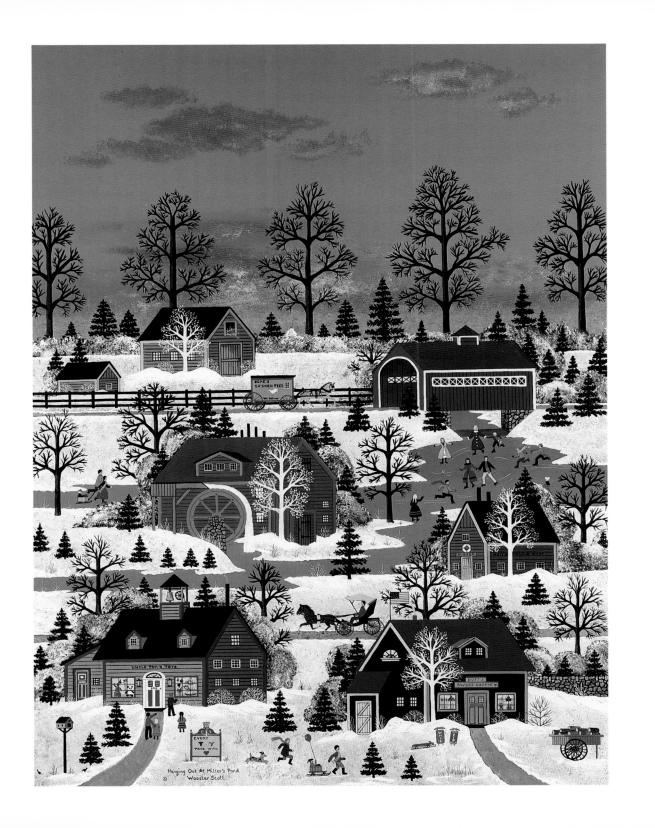

Hanging Out At Miller's Pond
Wooster Scott

Storybook Summer

Lassitude falls over the land in mid-summer when it's hot and the air is still, when cicadas are overcome by ennui. This is a time to laze, to contemplate the meaning of life, to daydream and drink lemonade.

Jane Wooster Scott perfectly embodies the spirit of this muzzy day in the sun. Next winter, 'midst blowing snow and frozen landscape, this mid-summer break will be savored and fondly remembered.

STORYBOOK SUMMER
Original oil on canvas 16 x 20 in (40.6 x 50.8 cm), 1991
From the collection of Dr. Craig Bass

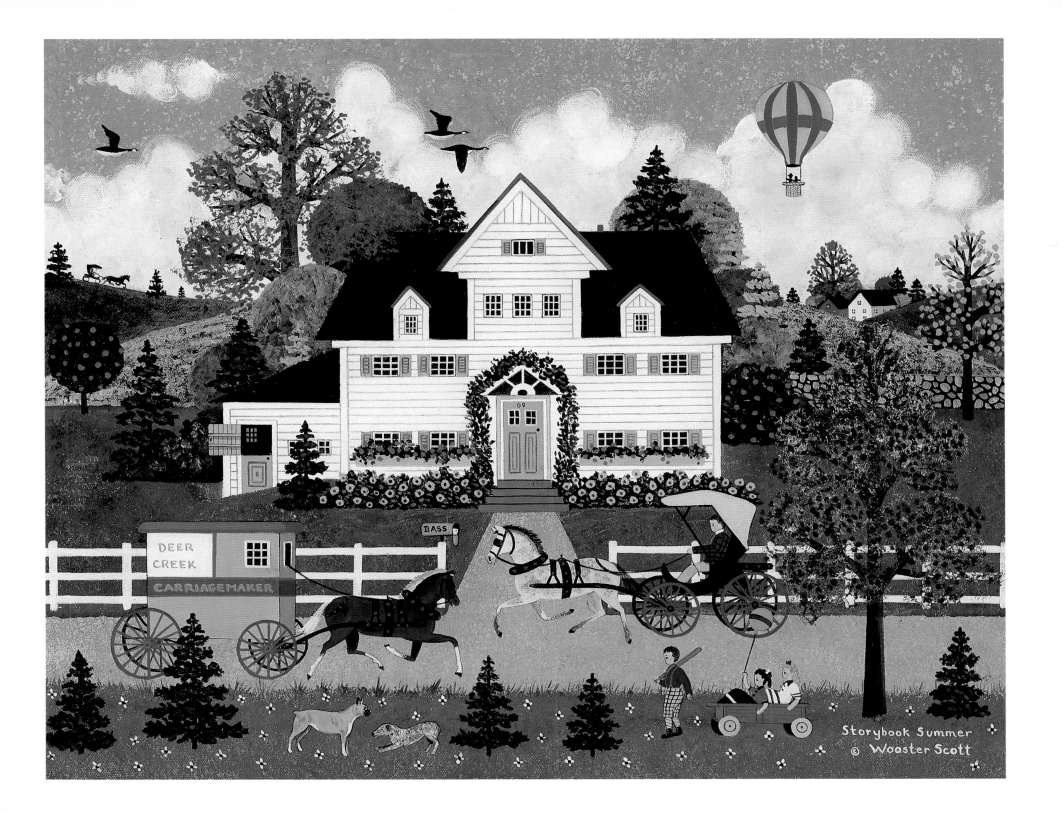

Storybook Summer
© Wooster Scott

The Artist at Her Easel

Imitation is the sincerest form of flattery.

THE ARTIST AT HER EASEL
Original oil on canvas 20 x 24 in (50.8 x 60.9 cm), 1988

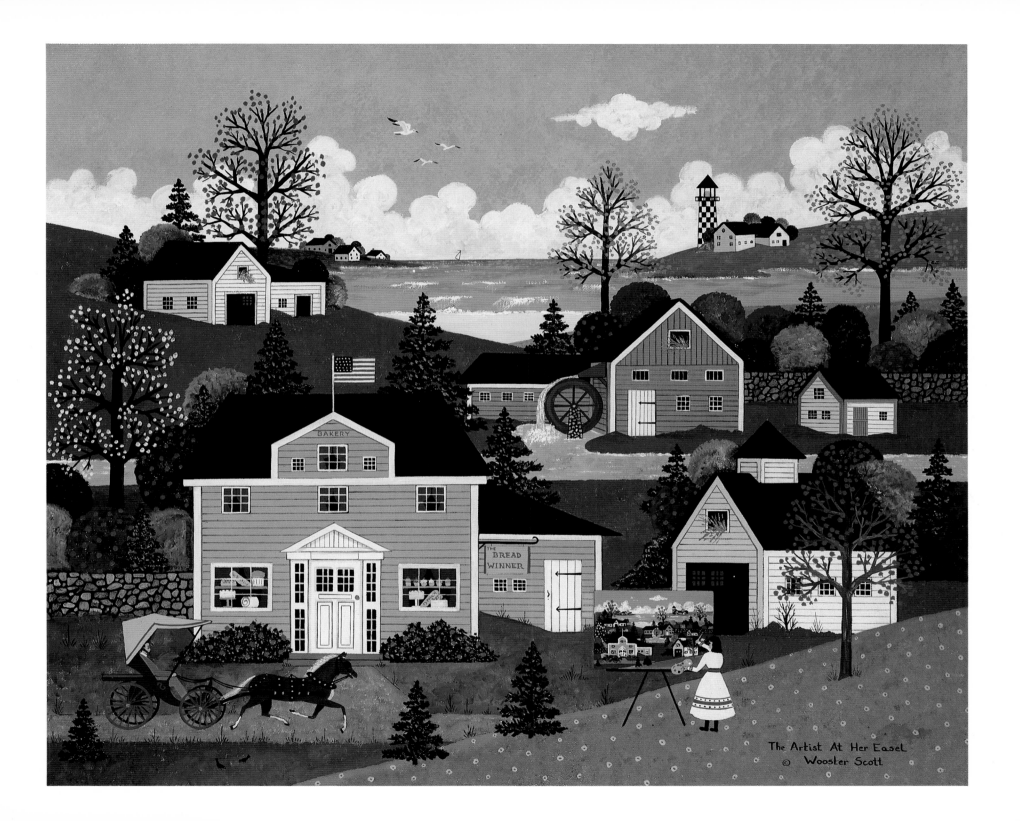

BAKERY

THE
BREAD
WINNER

The Artist At Her Easel
© Wooster Scott

Auld Lang Syne at the Golden Nugget Inn

By 1907 the Wild West had been considerably tamed, except perhaps in Nevada, areas of which remain reasonably wild and woolly today, thanks in part to the universal tradition of welcoming the New Year.

Teddy Roosevelt was President, the country was at peace and Old Glory boasted but 45 stars. Oklahoma would become a state that year, but Arizona and New Mexico were only territories.

So raise a toast of farewell to 1906 and a rousing welcome to '07.

To innocent times and the devil take the hindmost.

AULD LANG SYNE AT THE GOLDEN NUGGET INN
Original oil on canvas 20 x 24 in (50.8 x 60.9 cm), 1984
From the collection of Mr. and Mrs. Steve Wynn

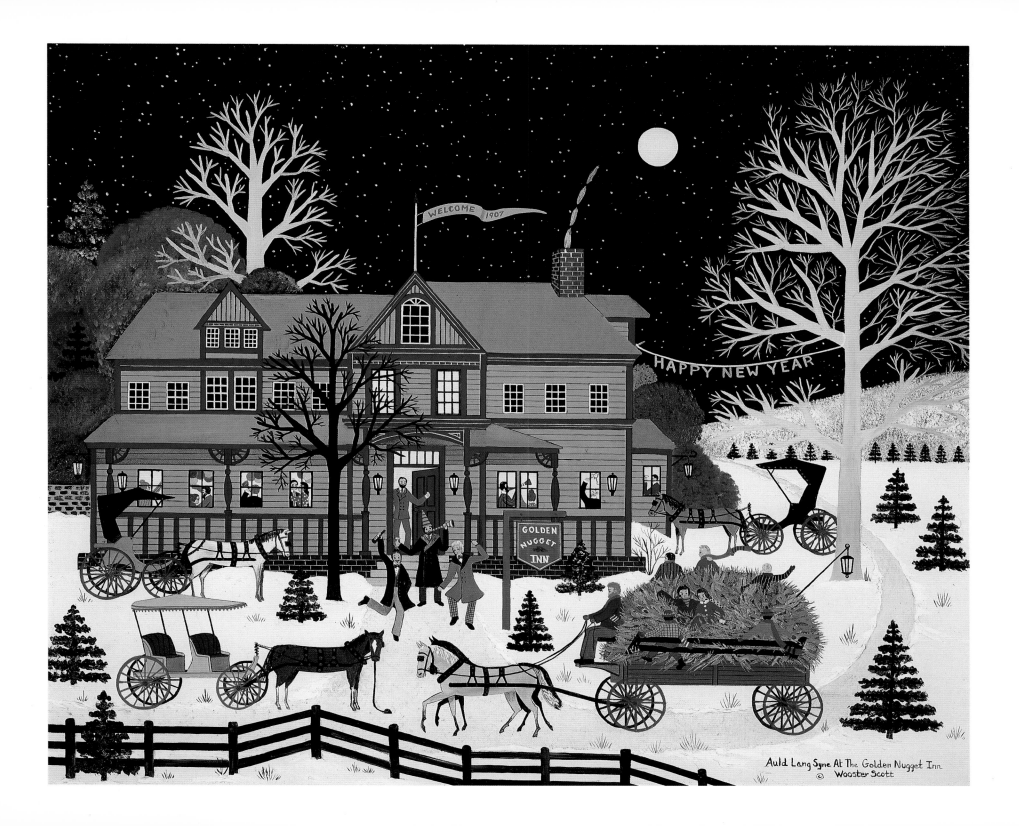

Auld Lang Syne At The Golden Nugget Inn
© Wooster Scott

Courting the Farmer's Daughter

Folks been hootin' and hollerin' from time immemorial over stories about farmers' daughters. Well, they aren't so doggone funny if you're the farmer.

I don't like the cut of this city slicker with his fancy horseless carriage courting my Clementine. He wouldn't be so all-fired uppity if he knew I was keeping an eye on him. And that's not all. What he doesn't know is the red flannels flapping out back belong to Clementine.

Now how's that for a farmer's daughter joke, neighbor?

COURTING THE FARMER'S DAUGHTER
Original oil on canvas 20 x 24 in (50.8 x 60.9 cm), 1982

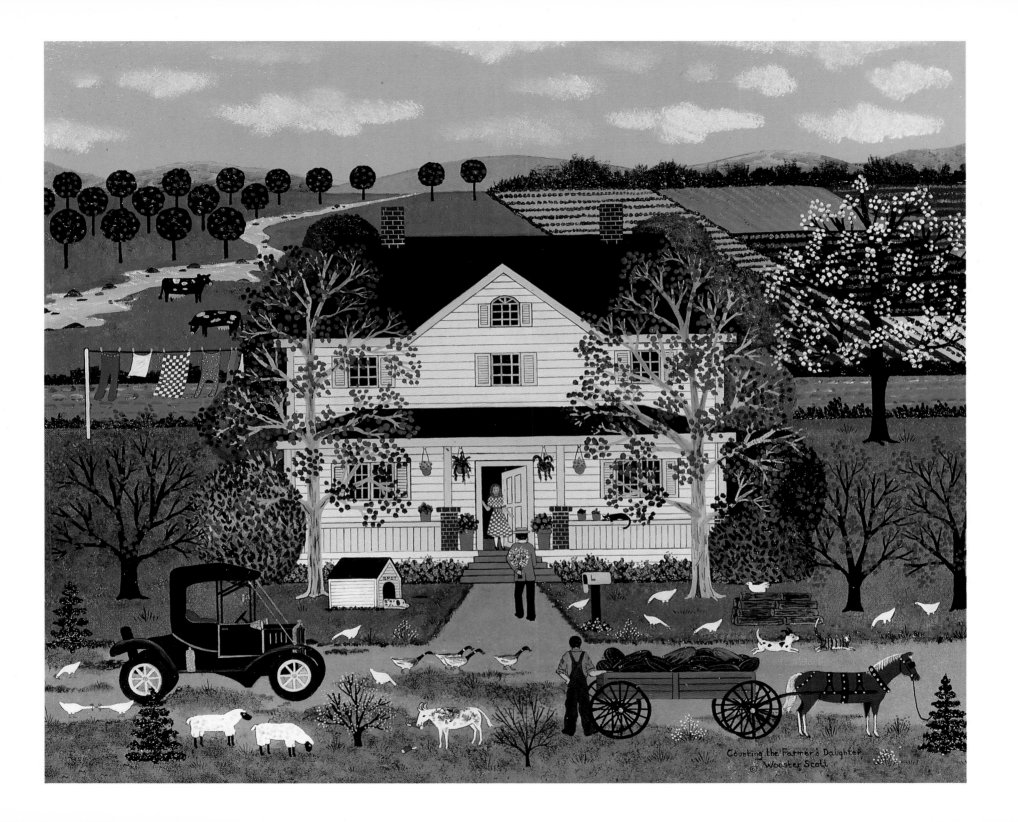

Courting the Farmer's Daughter
© Wooster Scott

Derby Day in Dayton

Soapbox Derbys were a big deal when kids built their own racers to coast down sloping streets in neighborhoods across the country. Mostly, the racers were made from discarded tricycle wheels, scrap lumber, soap boxes and peach crates. More than half the fun was building the racers.

Then parents got into the act, organizing state competitions and a national Soap Box Derby Association. Adults ran elimination events, standardized coasters, helped children to build and "improve" the little motor-less cars. Worse, cheating cropped up, and accusations, and finally a scandal.

Soapbox Derby is no more, killed by the competitive frenzy of parents. Affluence and TV didn't help either. Instead of tinkering, building and taking pride in creating fun, kids park themselves in front of TV sets and drive factory-made motorized go-carts. Sometimes they join Little League and play baseball supervised by parents. Some fun.

Why don't adults leave kids' stuff to the kids, hey?

DERBY DAY IN DAYTON
Original oil on canvas 24 x 24 in (60.9 x 60.9 cm), 1991

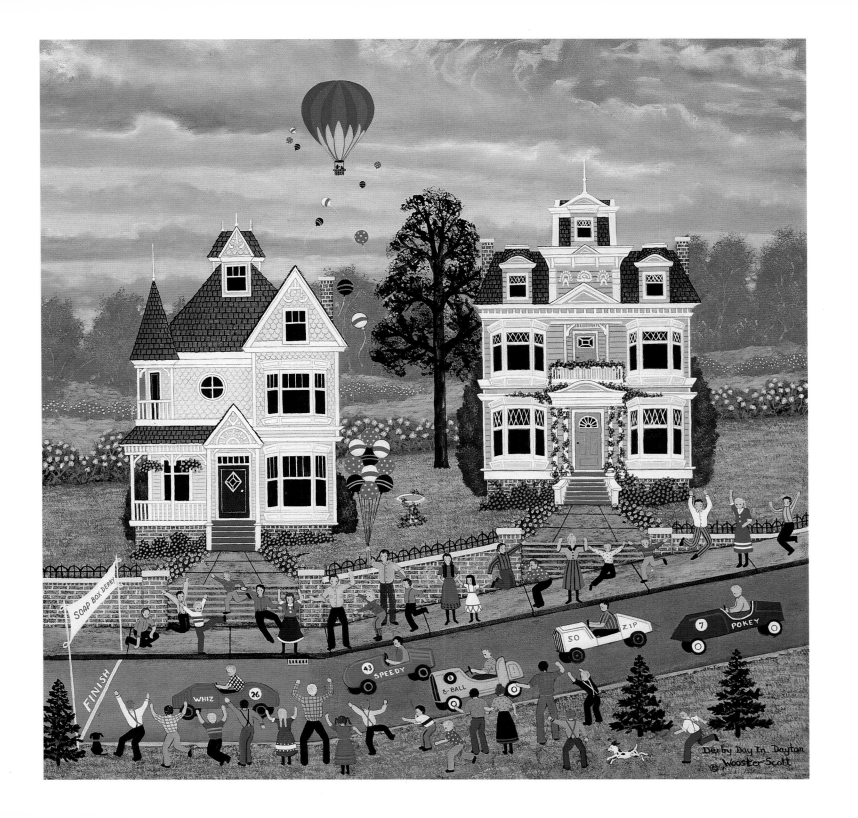

Funning

If you were a kid, like these on the frozen pond, you'd know immediately why the painting is titled *Funning*.

Here's a clue: count the number of grown-ups in the scene.

One! Only one!

(Top Left)
FUNNING
Original oil on canvas 8 x 10 in (20.3 x 25.4 cm), 1985
From the collection of Marlon Brando

The Unveiling of Major Culpepper

It was a big day in Alabama when they undraped Major Beauregard Culpepper's statue in Courthouse Square. But it takes some explaining.

When that brave Confederate officer returned home after the battle of Vicksburg he wasn't quite the hero we'd been led to believe. Seems the major — he always called himself *colonel* after mustering out — was captured by Yankees when they caught him hugging a northern hussy at a soiree up Tennessee way or one of them other border states.

Still, Beauregard was the closest thing we had to a hero in this county, even though he did spend the war in a Yankee lockup.

Major Culpepper was a cavalry officer, so his statue was going to have him astride his faithful charger, *Gabriel.* There wasn't enough money for Beau *and* his horse. And folks wouldn't hear of having a statue of just Gabriel, who was a hero in his own right. Gabriel kicked the bejabbers out of a blue-nosed U.S. mule down around the battle of Chickamauga. But that's another story.

(Bottom Right)
THE UNVEILING OF MAJOR CULPEPPER
Original oil on canvas 20 x 24 in (50.8 x 60.9 cm), 1984
From the collection of Ron Sunderland
Offset lithograph 11¼ x 13½ in (28.5 x 34.2 cm), 1991

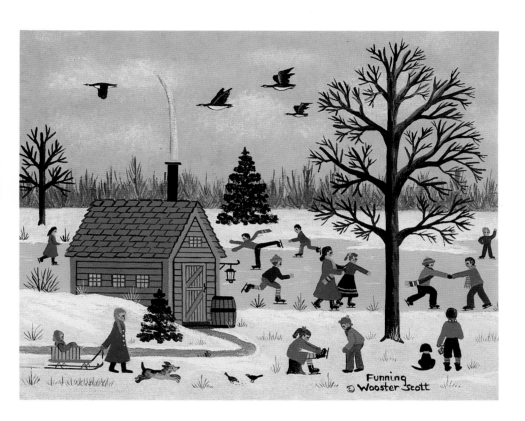

Funning
© Wooster Scott

The Unveiling Of Major Culpepper
© Wooster Scott

The Baseball Game

It's the top of the ninth, a seven-to-seven tie and the bases are loaded with antler-less Elks.

We'll never know if the slugger at the plate hits a home run or, like Casey, strikes out. It doesn't matter. Baseball is a state of mind, a national pastime that delights our hearts. The game is part of the glue that holds the nation together.

Baseball and apple pie.

THE BASEBALL GAME
Original oil on canvas 20 x 24 in (50.8 x 60.9 cm), 1981
From the collection of Mr. and Mrs. Robert Ruggles

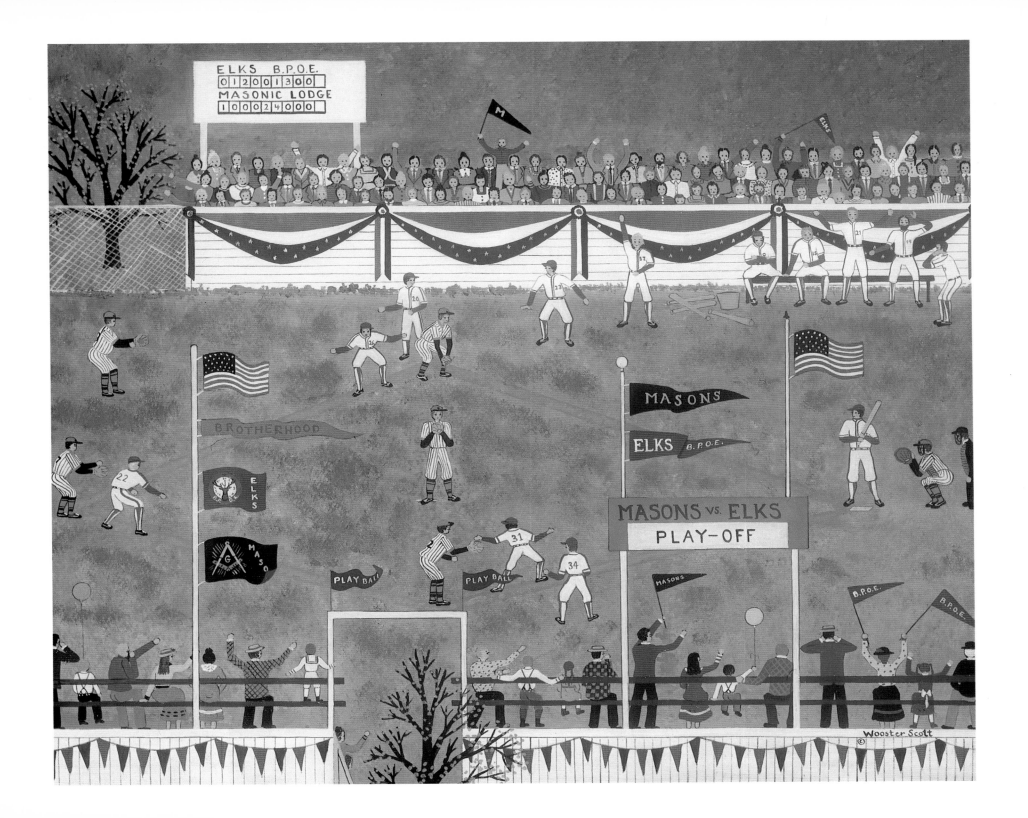

Mining Earth's Bounty

The industrial revolution did little to beautify earth's natural landscape. There are precious few examples, for instance, of esthetic factories and machinery.

Yet here we find man-made works of art in the workaday world of loading gondola freight cars from the mine entrance of a soaring colliery.

The gracefully rising architecture of Cinderella Hollow was a blueprint for many a modern condominium complex and the decorative steam engines pulling the colorful coal cars challenge nature for sheer eye-appealing pleasures.

MINING EARTH'S BOUNTY
Original oil on canvas 20 x 24 in (50.8 x 60.9 cm), 1992
From the collection of Mr. and Mrs. Charles McNamee

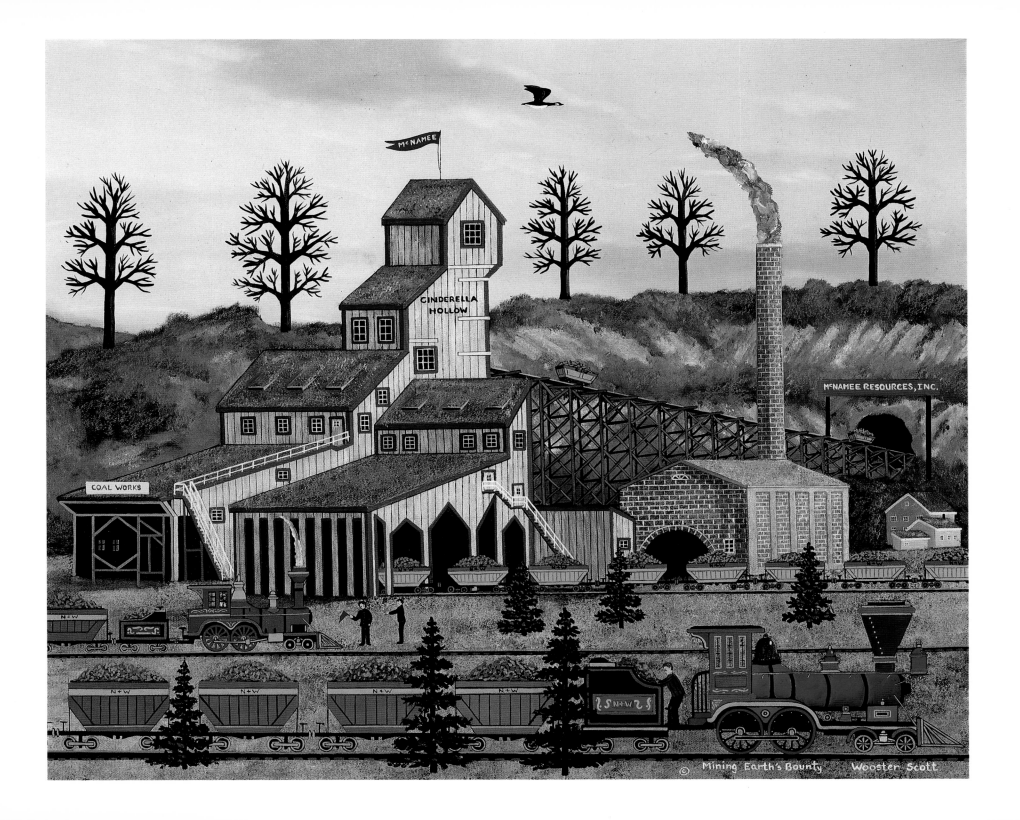

Mining Earth's Bounty Wooster Scott

The Holiday Suite

Jane Wooster Scott's Holiday Suite accurately depicts mid-winter and mid-summer revelers at an identical village high in the Rocky Mountains near her home.

With *Pond At The Inn* and *A Song For The Season* she steals two moments in time from one of the country's most popular resorts, Sun Valley, Idaho.

Some vacationers prefer the challenge of a winter holiday, crystal clear nights, brilliant snow and gleaming ice. Others choose a balmy summertime hiatus with nature aflower in sunburst colors.

As a resident of the community, the artist enjoys the best of both holiday seasons, and the months in between as well.

(Top Left)
POND AT THE INN
Original oil on canvas 22 x 28 in (55.8 x 71.1 cm), 1990
From the collection of Mr. and Mrs. Marriner Eccles
Offset lithograph 17½ x 22¼ in (44.4 x 56.5 cm), 1991

(Bottom Right)
A SONG FOR THE SEASON
Original oil on canvas 20 x 24 in (50.8 x 60.9 cm), 1991
Offset lithograph 17½ x 22¼ in (44.4 x 56.5 cm), 1991

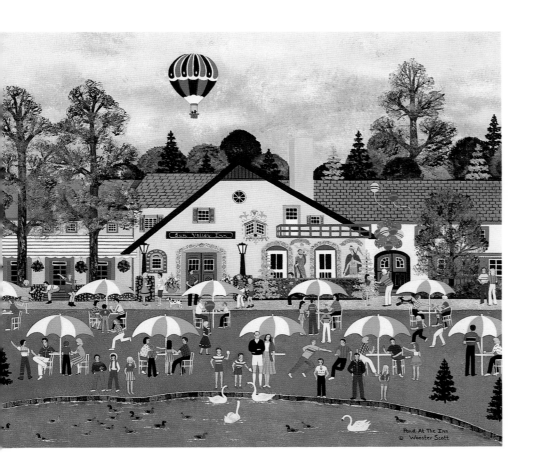

Pond At The Inn
© Wooster Scott

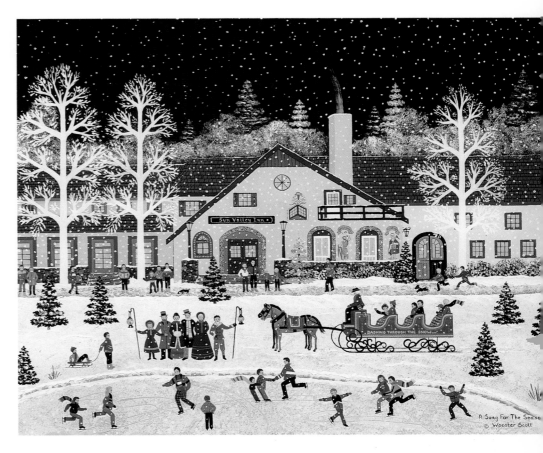

A Song For The Season
© Wooster Scott

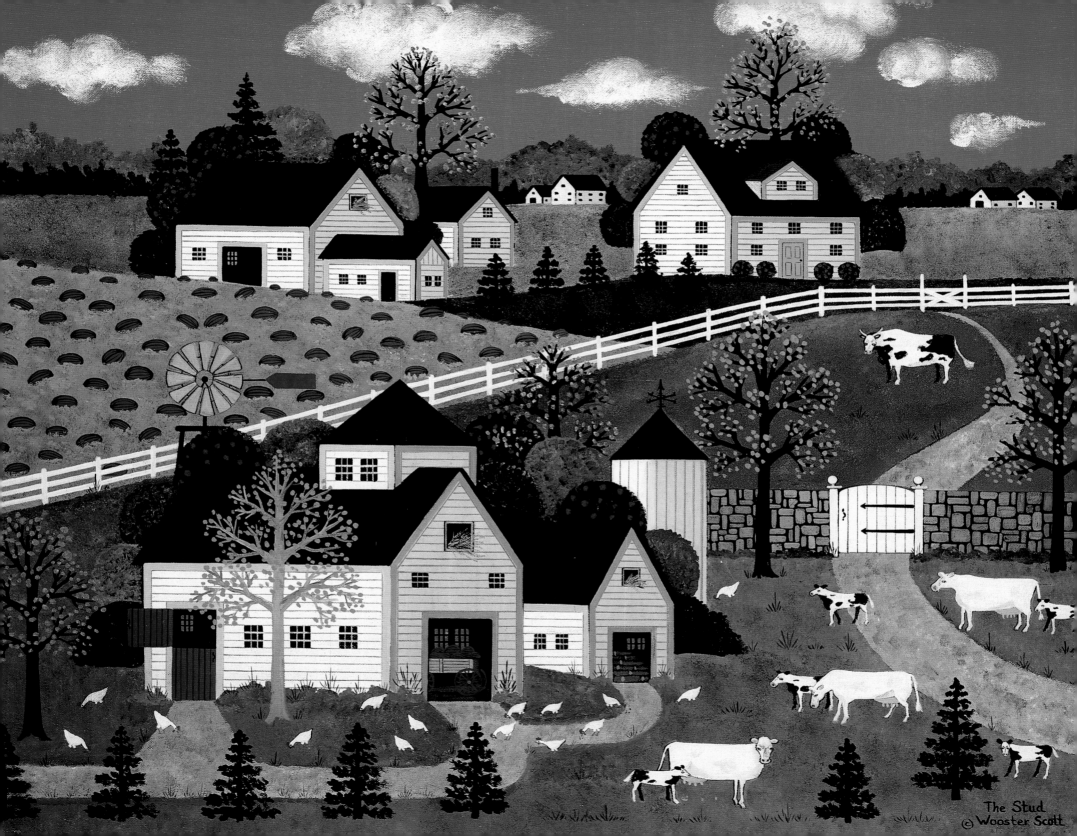

The Stud
© Wooster Scott

The Stud

If ever a critter took pride in his work, it's the large dude in the segregated field. He certainly gives the appearance of being a family man, but apparently he's been turned out to pasture before his time. Don't be surprised if the old campaigner takes up wall-jumping before the year is over.

THE STUD
Original oil on canvas 20 x 24 in (50.8 x 60.9 cm), 1985
From the collection of Mr. and Mrs. Porter Washington

White on White

The mystical elements of snow rarely cease to fill the human soul with wonder.

There is an innocence to snow that hints at the beginning of the universe when all was fresh and new and untouched as ordained by the natural order of providence.

Here the artist combines white homes with new-fallen snow, no two flakes of which are the same. The crystal freshness of this canvas invites you to hang it where you like to sit and contemplate the imponderables of life.

WHITE ON WHITE
Original oil on canvas 16 x 20 in (40.6 x 50.8 cm), 1985

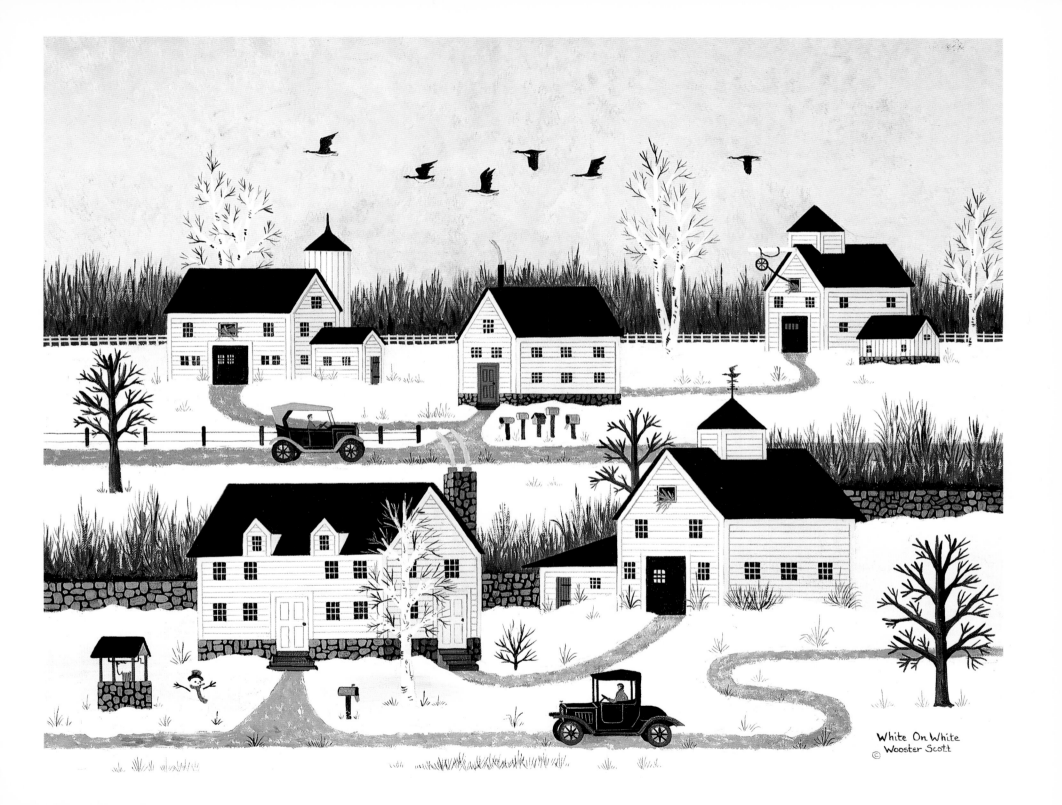

White On White
© Wooster Scott

Wild Swans of Chesapeake

Soar upward! Soar high! Soar on, you wild beauties of the endless blue. Wing your way heavenward where you doubtless belong like the angels you so resemble.

You thrill the earth-bound spirits of we poor mortals, who are able only to stare upward at your graceful flight and wish with all our hearts we might join your wondrous migration.

WILD SWANS OF CHESAPEAKE
Original oil on canvas 20 x 24 in (50.8 x 60.9 cm), 1988
From the collection of Mr. and Mrs. Mahammed Mortazavi
Offset lithograph 18 x 21½ in (45.7 x 54.6 cm), 1988

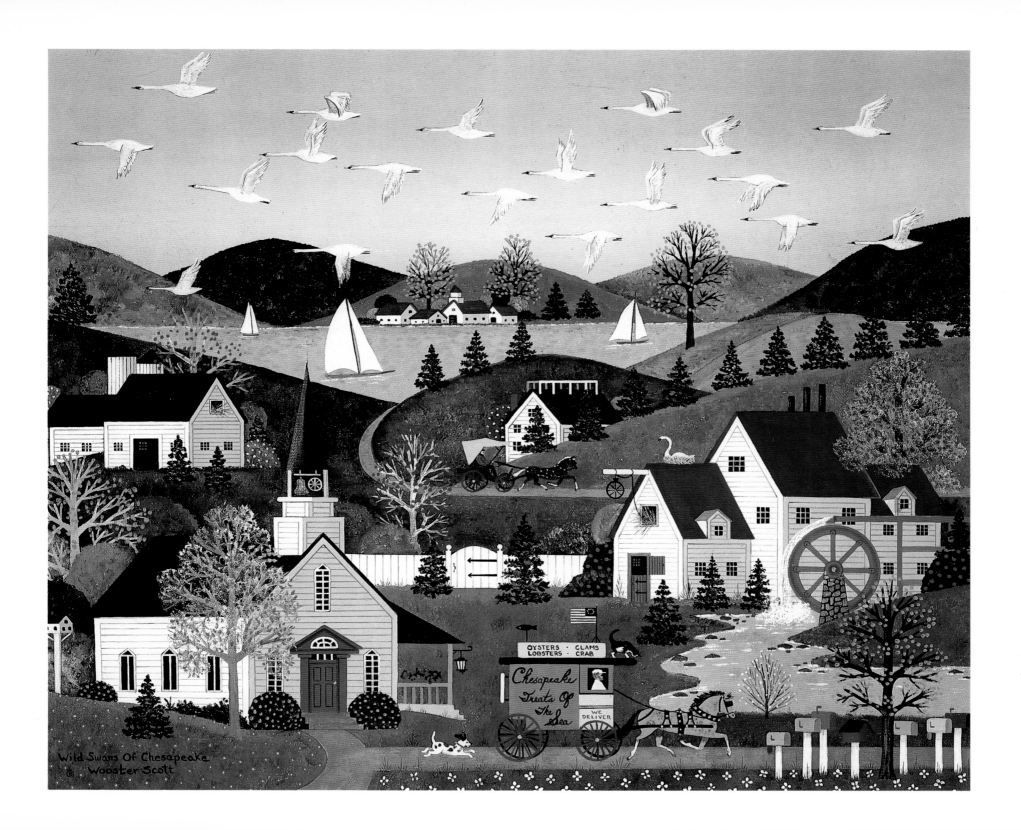

Wild Swans Of Chesapeake
© Wooster Scott

OYSTERS · CLAMS
LOBSTERS · CRAB

Chesapeake
Treats Of
The Sea

WE
DELIVER

Bears! Bears! Bears!

Toys and dolls come and go, but Teddy is always with us. Well at least since President Teddy Roosevelt took up with grizzly bears out west in the early years of the twentieth century. Since 1904 or thereabouts the fuzzy bruin has been childhood's favorite bedtime companion.

Teddy is a snuggler and comforting pal, protector against things that go bump in the night. He's confidante, playmate, ally and fall guy.

Most of us have a tattered old Teddy tucked away in a corner somewhere, tugging at childhood memories, still available for a comforting confidence or two.

The artist has painted a Valhalla for these beloved stuffed creatures, a splendid Victorian manse inhabited only by Teddy Bears and the children who love them.

BEARS! BEARS! BEARS!
Original oil on canvas 16 x 20 in (40.6 x 50.8 cm), 1992
From the collection of Michelle Kazanjian
Offset Lithograph 10¾ x 13 in (27.3 x 33.0 cm), 1993

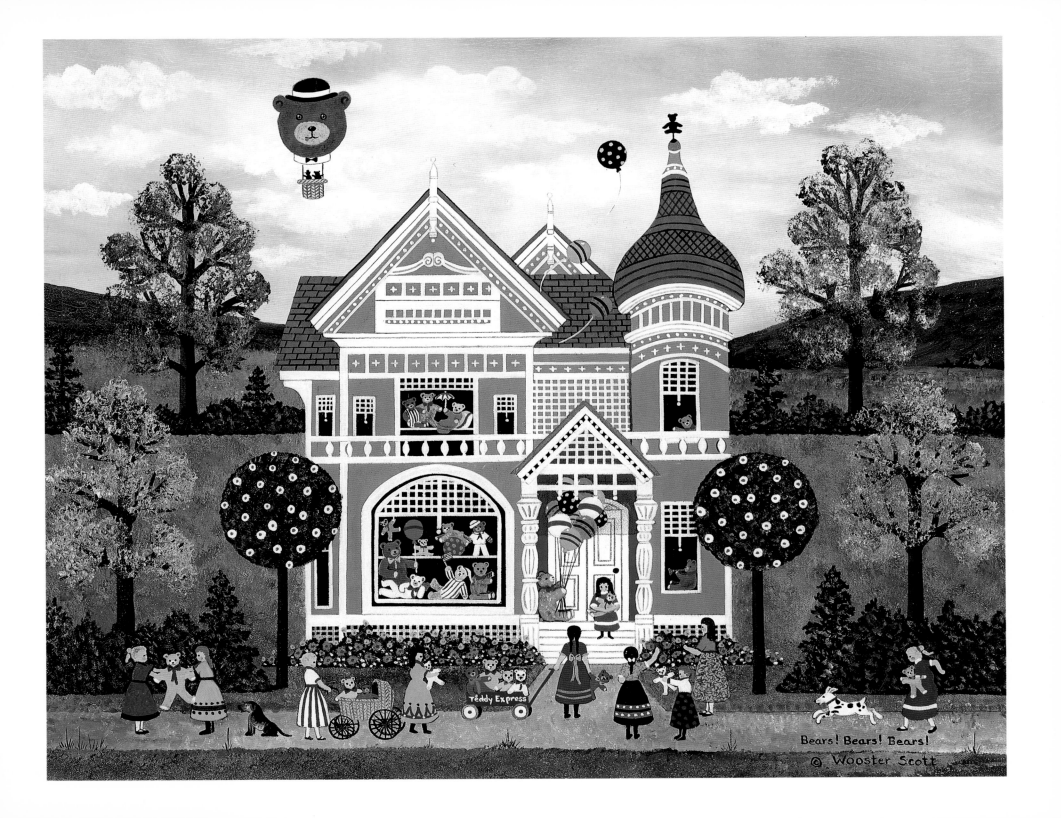

Bears! Bears! Bears!

© Wooster Scott

Once Upon a Time...

This painting—then and now—is as American as the names of folk here in Foleytown.

There are Sheahan and Rosenberg, Dawson and Balak, McGreevy and Rostenkowski, Hartigan and Stevens, Hardin and O'Connor building a life and community together.

If they keep it up, caring for each other, working together, playing and building together, then maybe no one will ever see it written, *Once upon a time there was a noble experiment called America.*

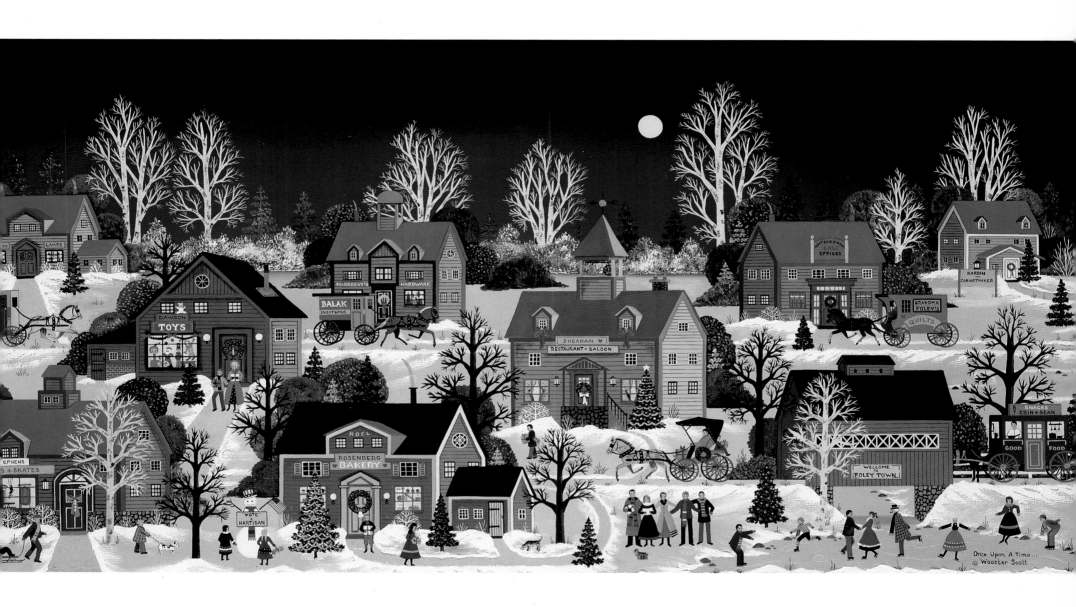

The Return of the Hostages

This moment in American history is significant for many reasons; a restoration of the nation's pride, the freeing of innocent citizens from imprisonment by Iran, and the consequences of a national election ending in the defeat of President Jimmy Carter.

The painting was commissioned by John Mack Carter, Editor in Chief of *Good Housekeeping* magazine, for its 1981 special Fourth of July edition.

(Left)
THE RETURN OF THE HOSTAGES
Original oil on canvas 18 x 14 in (45.7 x 35.5 cm), 1981
From the collection of Elsie Floriani

The Peddler

When the nearest crossroad is twenty miles away and the closest village is a two-day wagon ride, few visitors are as welcome as the itinerant peddler wending his way to your door.

This hardy entrepreneur is more than a source of hardware and dry goods and trinkets. He also is a prime source of news about Abigail Slade over on the next spread. Did she have her baby yet, and has her husband, Enos, recovered from the ague?

The peddler will have all the answers and a bolt of flower-designed calico you ordered from last planting time.

Like a tonic, the peddler's visits always did a body good.

(Right)
THE PEDDLER
Original oil on canvas 18 x 24 in (45.7 x 60.9 cm), 1976
From the collection of Nancy Sinatra

The Return Of The Hostages
© Wooster Scott

The Peddler
© Wooster Scott

Sandlot Slugfest

This is where it all began for Babe Ruth, Ty Cobb and other early Hall of Famers. Kids with a ball and bat learned to play baseball without having seen a professional game. The great national pastime must be in the genes. It's as good an explanation as any.

SANDLOT SLUGFEST
Original oil on canvas 20 x 24 in (50.8 x 60.9 cm), 1992
From the collection of Mr. and Mrs. Raymond Hoover

CUSHING GREENE

HOOVER

BALLOONS
PARTY FAVORS

Sandlot Slugfest
© Wooster Scott

Feminine Curiosity

Feminine surveillance at the old swimming hole.

FEMININE CURIOSITY
Original oil on canvas 24 x 24 in (60.9 x 60.9 cm), 1993

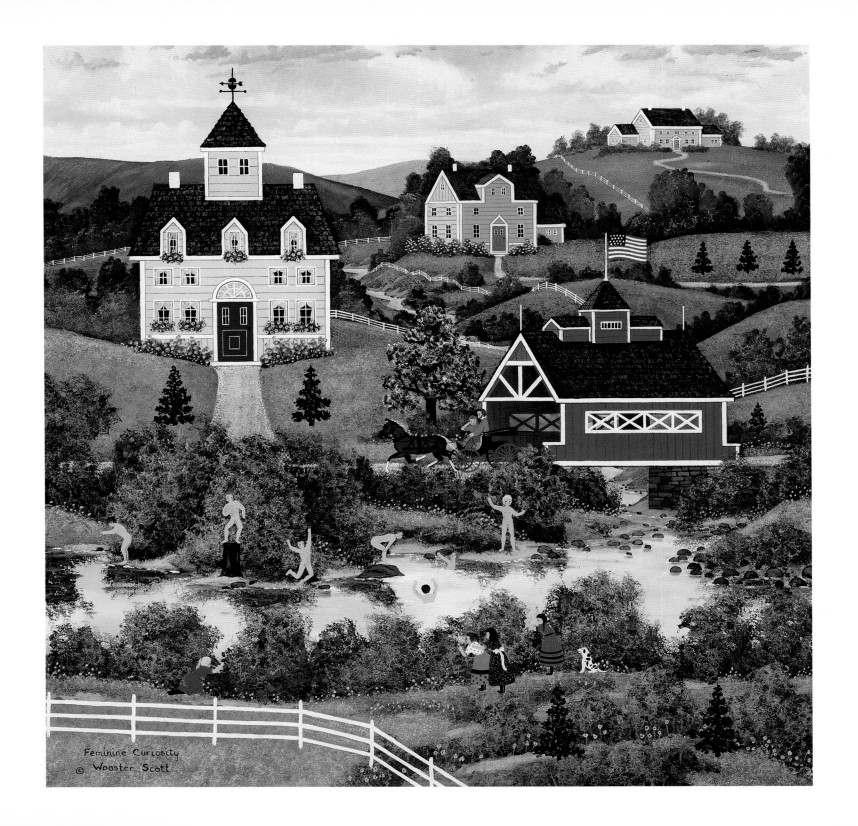

Feminine Curiosity
© Wooster Scott

Waiting for the Sea Shore Special

Getting there was half the fun all right, especially when boarding the Sea Shore Special for a scenic ride to tangy salt air, soft white beaches and refreshingly cold combers.

The nice thing about such excursions was the return trip to Haverford, a most pleasant place to come home to.

WAITING FOR THE SEA SHORE SPECIAL
Original oil on canvas 20 x 24 in (50.8 x 60.9 cm), 1981
From the collection of Mr. and Mrs. Thomas McClain

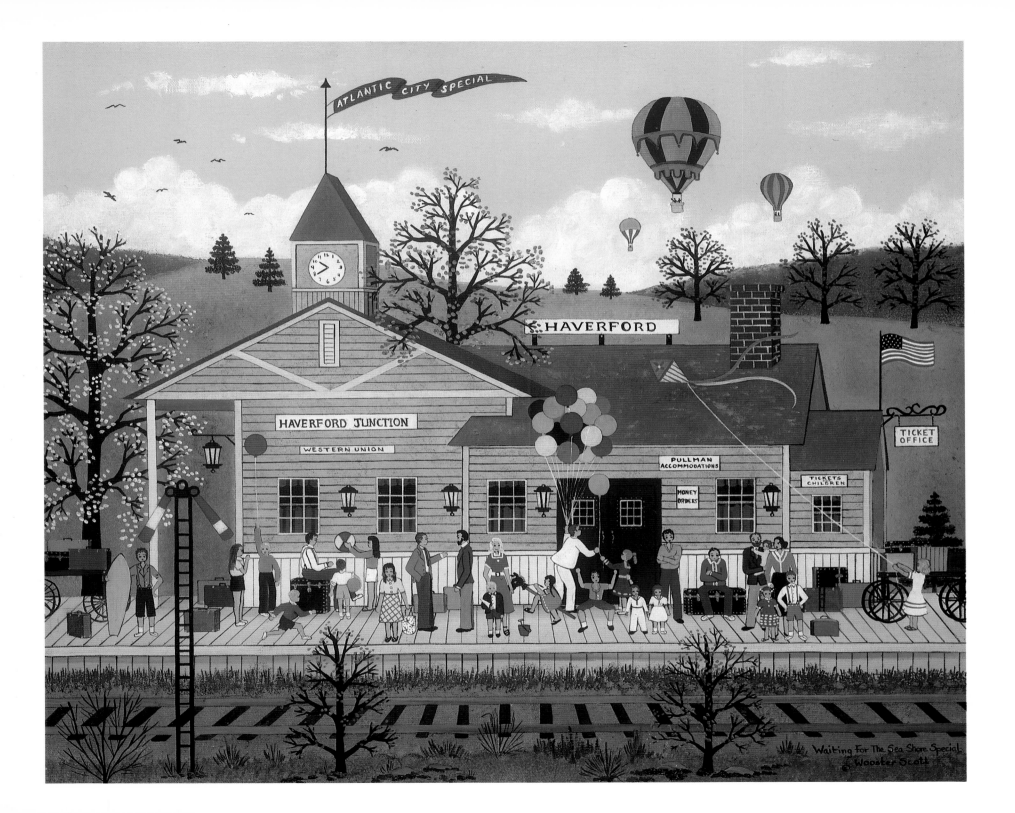

Waiting For The Sea Shore Special
© Wooster Scott

It's Barney Oldfield Hitting 131 mph!

No matter how fast other men may drive automobiles, Barney Oldfield will always be the standard by which race car drivers are measured. There are men and women whose dedication and determination set them apart from mere mortals. Golf's Bobby Jones, tennis' Bill Tilden, the Olympics' Jim Thorpe, aircrafts' Charles Lindbergh, track & field's Babe Didrikson Zaharias.

Oldfield was the first human being to travel on land at speeds in excess of 100 miles per hour. And if all the people who claimed to have been at Sheepshead Bay Race Track on this day had truly been present, the state of Alaska would not have been big enough to hold them all.

IT'S BARNEY OLDFIELD HITTING 131 MPH!
Original oil on canvas 22 x 28 in (55.8 x 71.1 cm), 1982
From the collection of Mr. and Mrs. Robert Petersen

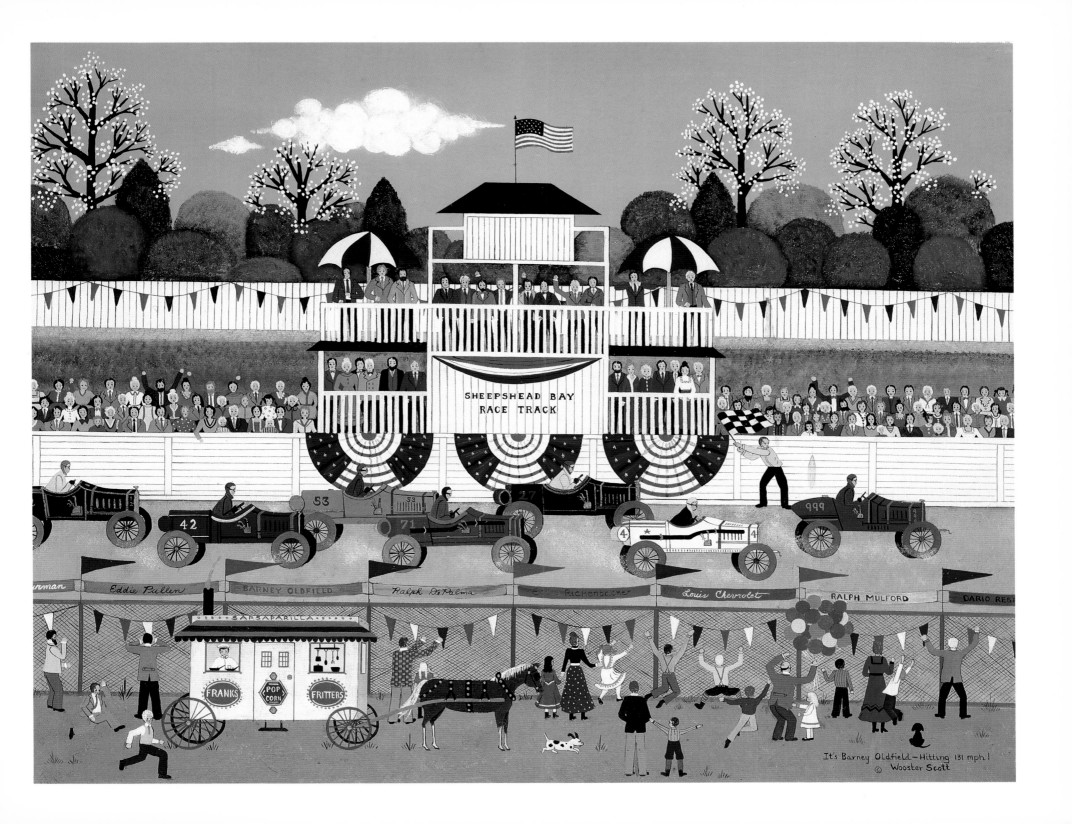

SHEEPSHEAD BAY
RACE TRACK

FRANKS POP CORN FRITTERS

SARSAPARILLA

Eddie Pullen BARNEY OLDFIELD Ralph DePalma Eddie Rickenbacker Louis Chevrolet RALPH MULFORD DARIO RES

It's Barney Oldfield—Hitting 131 mph!
© Wooster Scott

First Day of School

The first snip of apron strings is wrenching for mother and child alike. A time for tykes to make new friends, stand on one's own two feet, to face the world without mother or father at one's side. A very big day indeed.

At Cedar Glen School a first grader or two shed tears. Seasoned veterans in the second and third grade dash about greeting classmates after the long summer vacation.

It's a scene played out each Indian Summer in uncounted villages, towns and cities the length and breadth of the country.

No one forgets the first day of school. Not really.

Remember yours?

FIRST DAY OF SCHOOL
Original oil on canvas 20 x 24 in (50.8 x 60.9 cm), 1992
From the collection of Rusty Staub

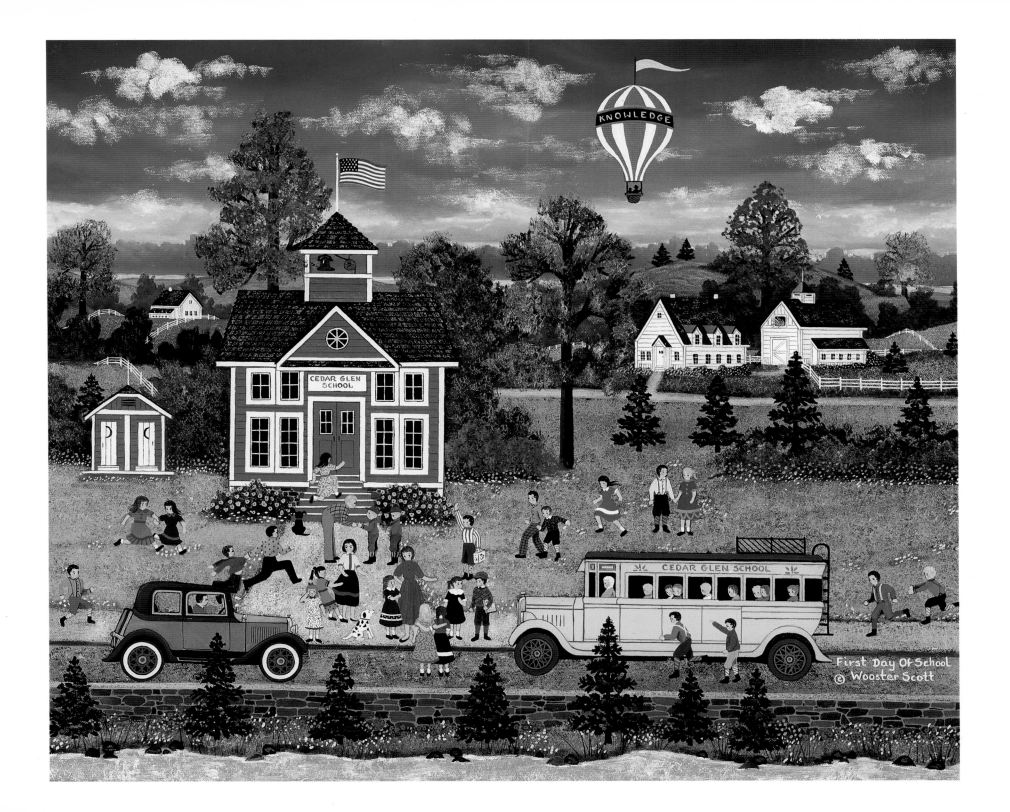

First Day Of School
© Wooster Scott

Quigley's Quality Quilts

Quilts are fascinating creations because no two are alike and each one is fashioned by loving hands.

You just get the feeling that some of Mrs. Quigley's loving care has rubbed off on her artistry, and if you take a quilt home you will be the beneficiary of her bounty.

You know, the same might be said for Jane Wooster Scott's remarkable paintings.

QUIGLEY'S QUALITY QUILTS
Original oil on canvas 24 x 30 in (60.9 x 76.2 cm), 1993

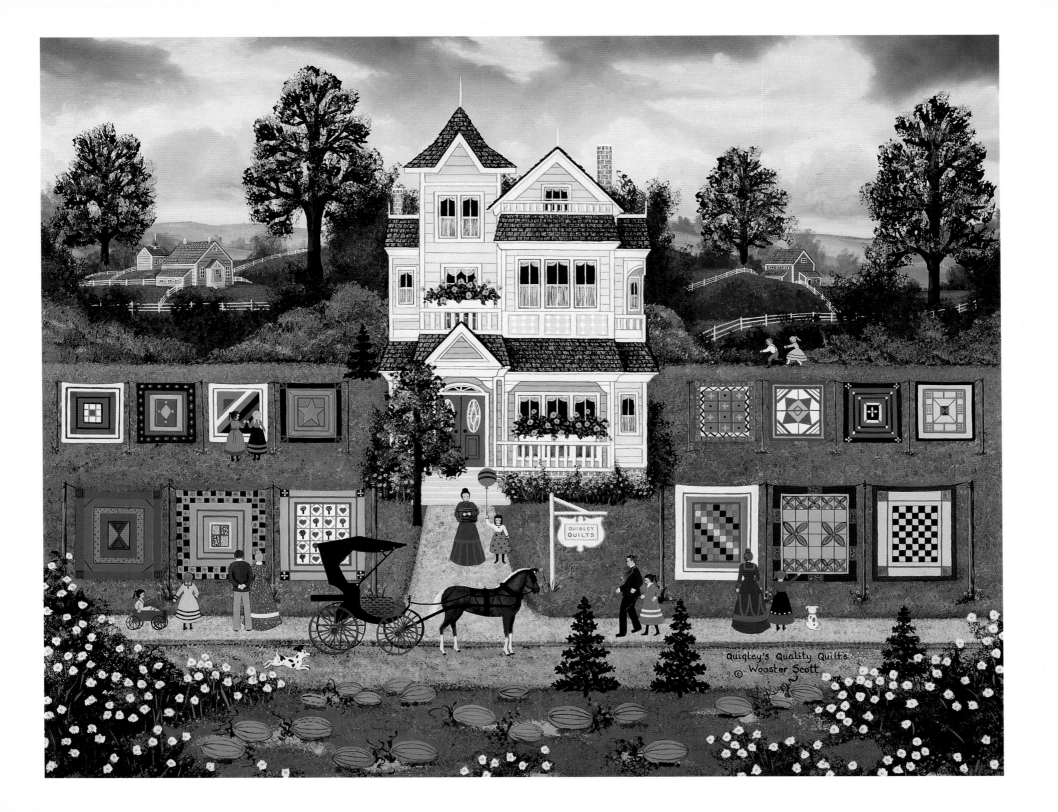

Quigley's Quality Quilts
© Wooster Scott

The Easter Egg Hunt at the Country Club

How many duffers shanked their golf balls into the rough on Easter Sunday only to come upon a gaily painted Easter egg nestled where they thought their shots had landed?

For that matter, how many kids picked up plain white orbs and complained to their parents that the Easter Bunny had neglected to color their eggs?

THE EASTER EGG HUNT AT THE COUNTRY CLUB
Original oil on canvas 22 x 28 in (55.8 x 71.1 cm), 1978
From the collection of Mr. and Mrs. Charles Bucks

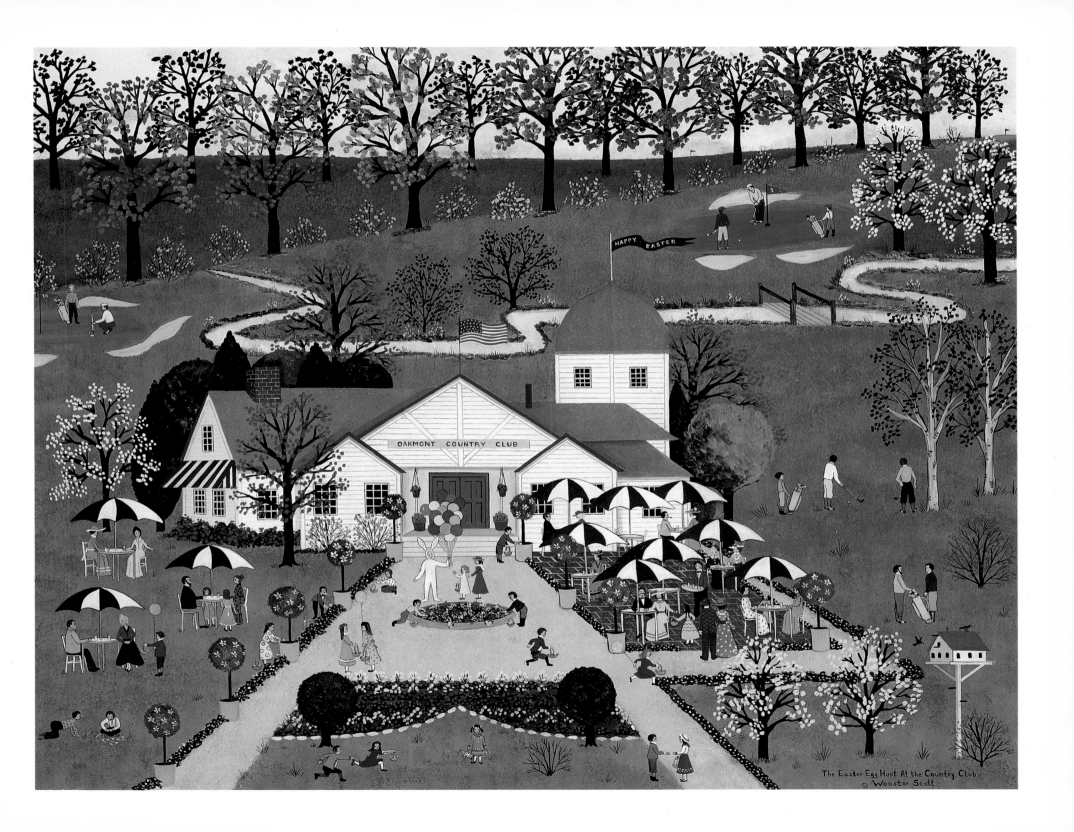

The Easter Egg Hunt At the Country Club
© Wooster Scott

Red Roofs

Ever wonder why farmers painted their homes and barns with red roofs? There must have been a reason. But nobody seems to have the answer.

Maybe it was out of a sense of beauty, knowing some day artists would come along and do exactly what Jane Wooster Scott has done for us here.

Fall Colors

Like most beautiful things, fall is perishable.

These brilliant hues start with the first frost and begin to perish with the first major rain and wind storm of the season.

Happily, Jane Wooster Scott was visiting Rhode Island at exactly the right moment. She did fudge a little, however. Artistic license permitted her to magically clear the roads and lanes of fallen leaves. But maybe the smoke pluming from all the chimneys accounts for all the missing foliage on the ground.

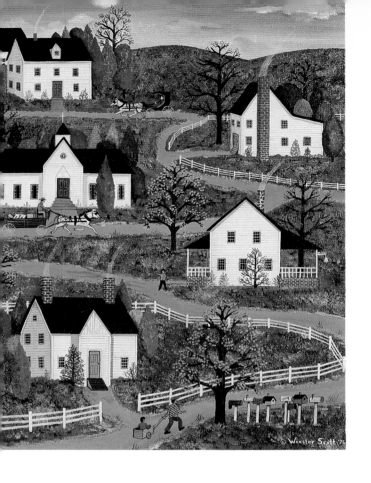

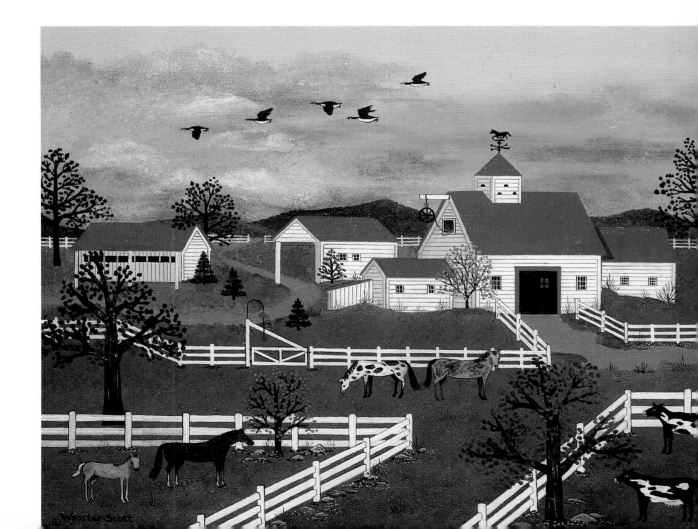

Carnival Time in Willow Bend

Lord a'mighty what to do first? Ride the Ferris Wheel? Throw baseballs? Taste the cotton candy? Buy a balloon? Watch the elephant do his tricks? Try the rollercoaster? And what a lovely carousel!

Willow Bend wasn't big enough for a full-grown circus, but once a year the carnival enlivened our village and we all became children for a day. Now we have TV and everyone, even kids, are grown-ups. We miss the carnival.

CARNIVAL TIME IN WILLOW BEND
Original oil on canvas 30 x 24 in (76.2 x 60.9 cm), 1987
From the collection of Gregory Erwin
Silkscreen serigraph 30 x 24 in (76.2 x 60.9 cm), 1987

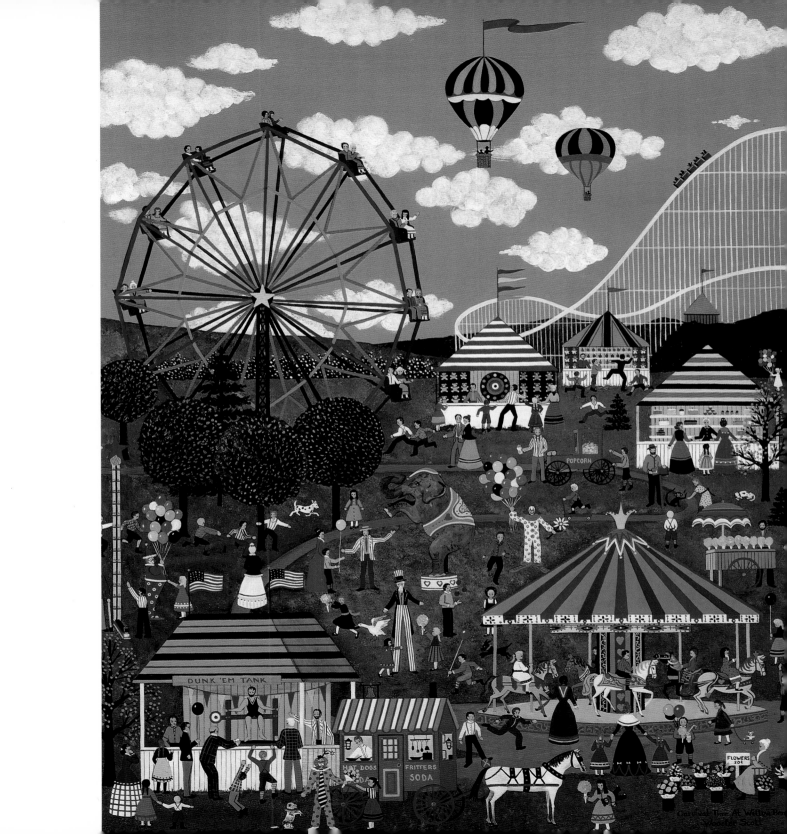

The Christening

Maybe christenings are everyone's favorite ritual.

In very large families they become quite habitual.

We celebrate Mothers Day and Fathers Day too,

But this day, little baby, is especially for you!

THE CHRISTENING
Original oil on canvas 40 x 30 in (101.6 x 76.2 cm), 1985
From the collection of George Gilmore
Offset lithograph 28 x 20 in (71.1 x 50.8 cm), 1987

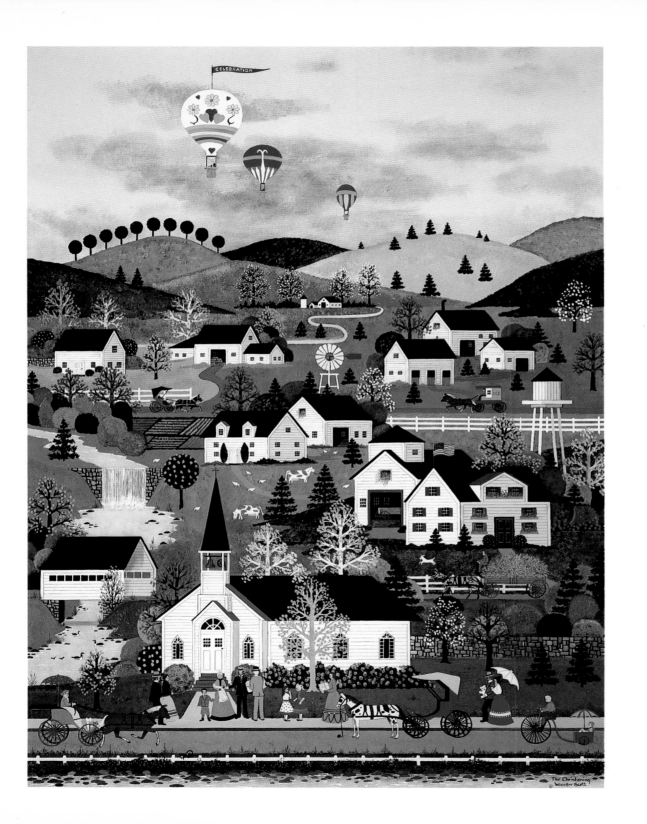

Oasis in the Urban Jungle

The wildest animals inhabit the glass and concrete towers in the dangerous, distant jungle. The foreground finds nature's gentle creatures, grateful the barriers that keep most of the human zoo from their green oasis.

OASIS IN THE URBAN JUNGLE
Original oil on canvas 30 x 30 in (76.2 x 76.2 cm), 1991

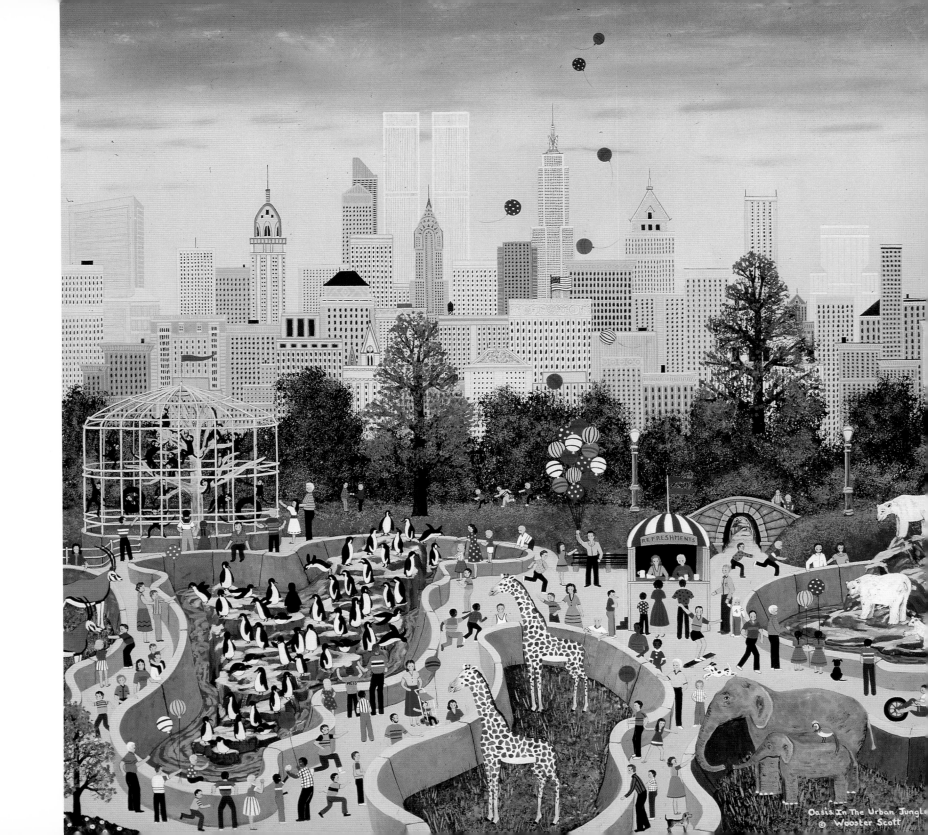

Oasis In The Urban Jungle
© Wooster Scott

Halloween

Halloween is an opportunity for little folk to put on masks, stay up late and pretend to scare the adult world, which has been frightening them most of their young lives. The treats are just the icing on the cake.

HALLOWEEN
Original oil on canvas 14 x 18 in (35.5 x 45.7 cm), 1976
From the collection of Ed Gregory Hookstratten

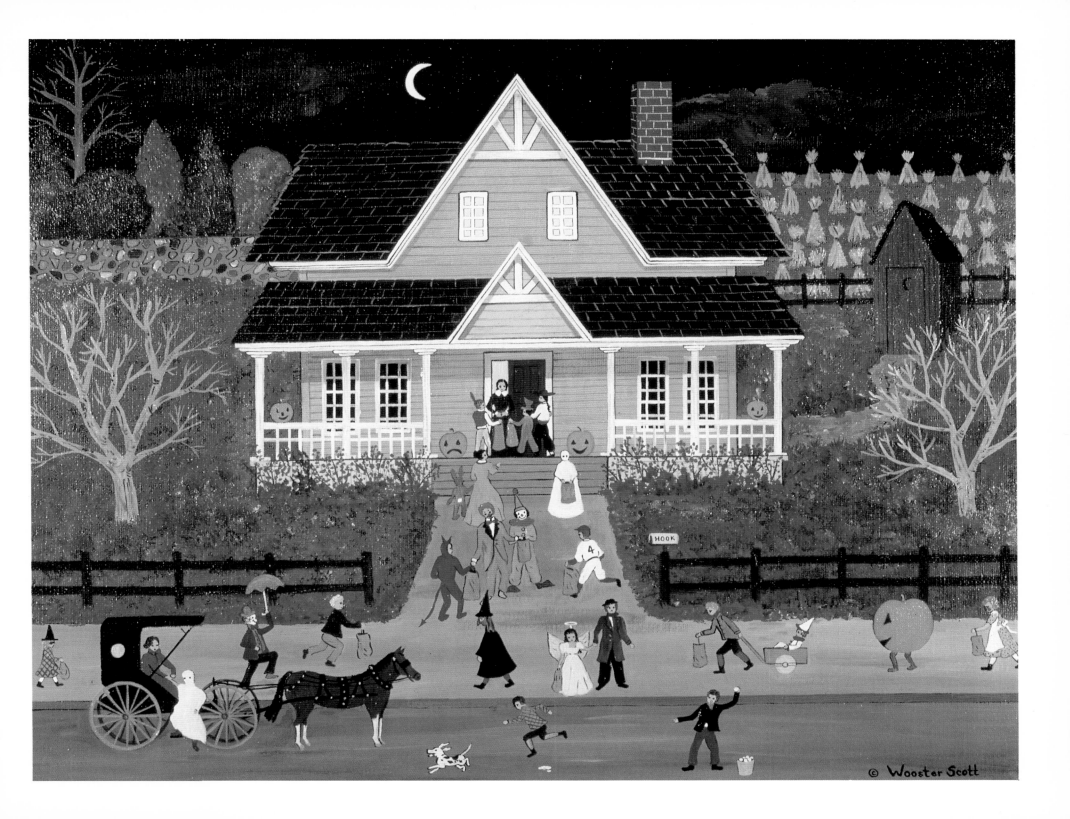

© Wooster Scott

Mother's Day Celebration

Motherhood creates a common bond among all females in the galaxy.

Not just among humans, but all species. Watch a woman's reaction to a baby anything: puppies, foals, kittens, calfs, lambs, even ugly little shoats and nestlings of every variety. See the soft, nurturing warmth in mothers' eyes and listen to their cooing reassurance to the newborn and the young, bidding them welcome to a sometimes hostile environment.

Only a single day a year is formally set aside to honor mothers. In truth, each and every day hosannas should be raised in appreciation for their loving presence in the scheme of things.

MOTHER'S DAY CELEBRATION
Original oil on canvas 24 x 24 in (60.9 x 60.9 cm), 1993

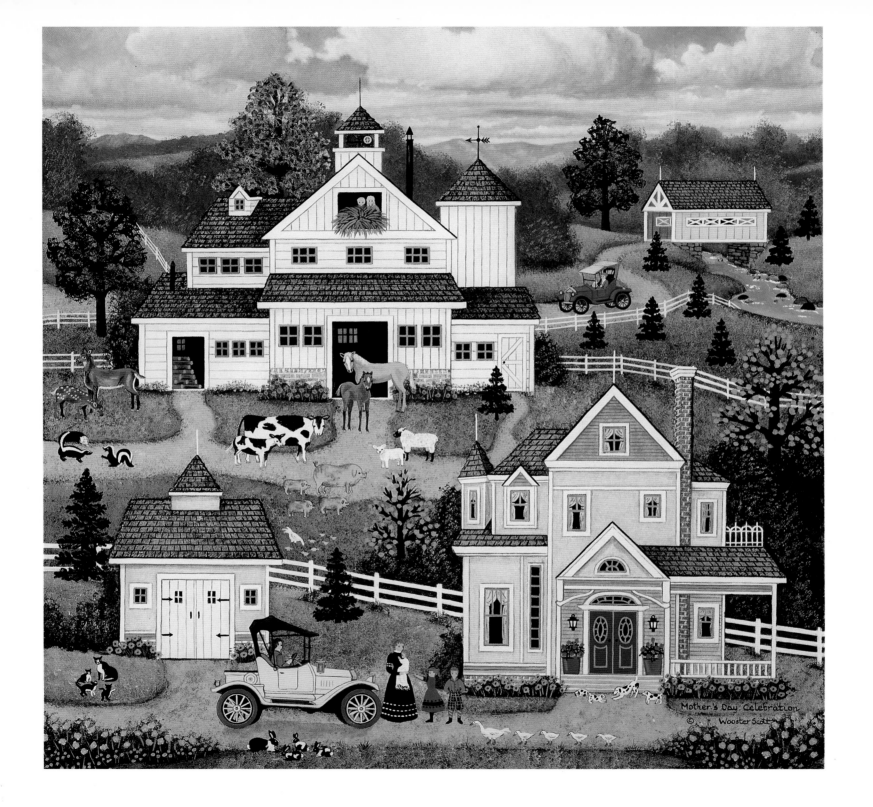

Mother's Day Celebration
© Wooster Scott

Collector's Pride

Most people think Maybelle Bodine painted this picture of her new house out of pure pride when she moved here to Schenectady from down South with her husband, Buford. Turns out pride had nothing to do with it. Buford let the cat out of the bag yesterday. He was down to Soggins' Tavern enjoying a sarsaparilla, so you know he's not a drinking man. Anyhow, Buford swears that's a painting of the house they used to live in down in Natchez. Can you believe that!

COLLECTOR'S PRIDE
Original oil on canvas 20 x 16 in (50.8 x 40.6 cm), 1985
From the collection of Mrs. Freeman Gosden
Offset lithograph 20 x 16 in (50.8 x 40.6 cm), 1987

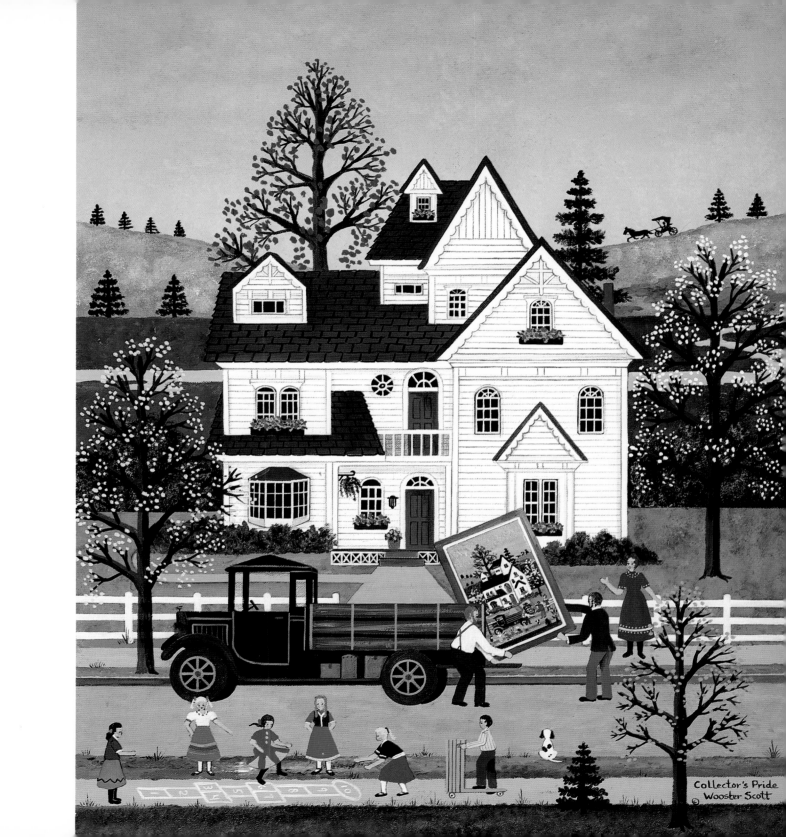

Collector's Pride
Wooster Scott

Mounting Up in Virginia

Tally ho, tantivvy, yoicks and away,

To the hounds we do ride on this splendid day.

Fair warning, friend fox, the chase is begun,

For you 'tis a lark, for us it's great fun.

MOUNTING UP IN VIRGINIA
Original oil on canvas 24 x 24 in (60.9 x 60.9 cm), 1991

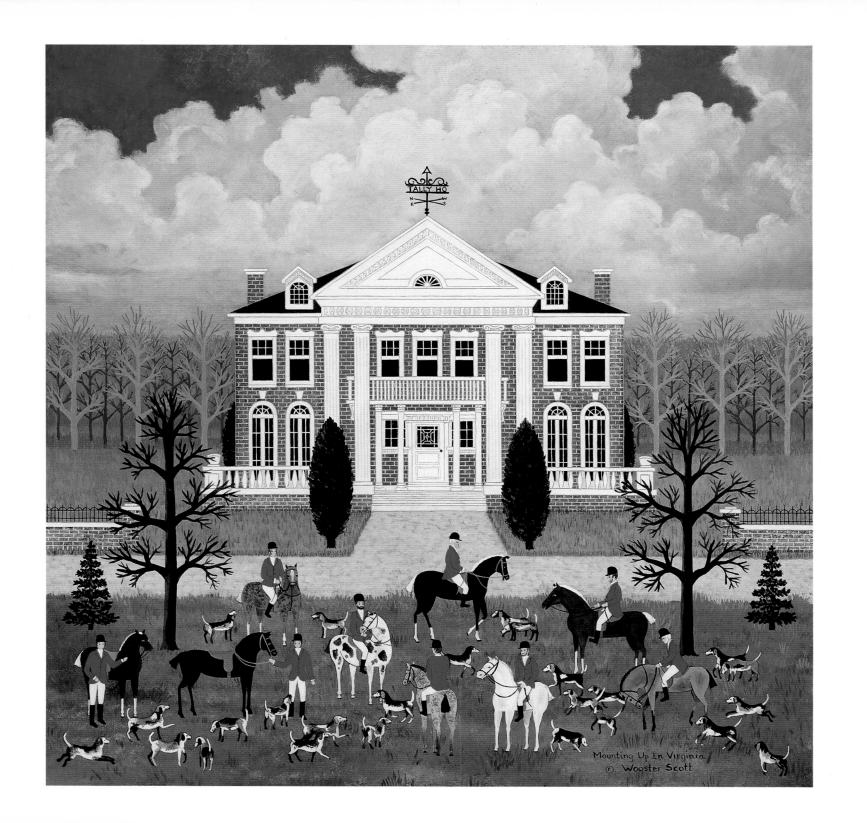

Mounting Up In Virginia
© Wooster Scott

Cross Country in Central Park

It's not Sun Valley, Aspen or Stowe, but Central Park provides snow and a towering scenic backdrop for these dedicated cross-country skiers.

CROSS COUNTRY IN CENTRAL PARK
Original oil on canvas 24 x 20 in (60.9 x 50.8 cm), 1985
From the collection of Mr. & Mrs. Joseph Di Martino
Offset lithograph 24 x 20 in (60.9 x 50.8 cm), 1985

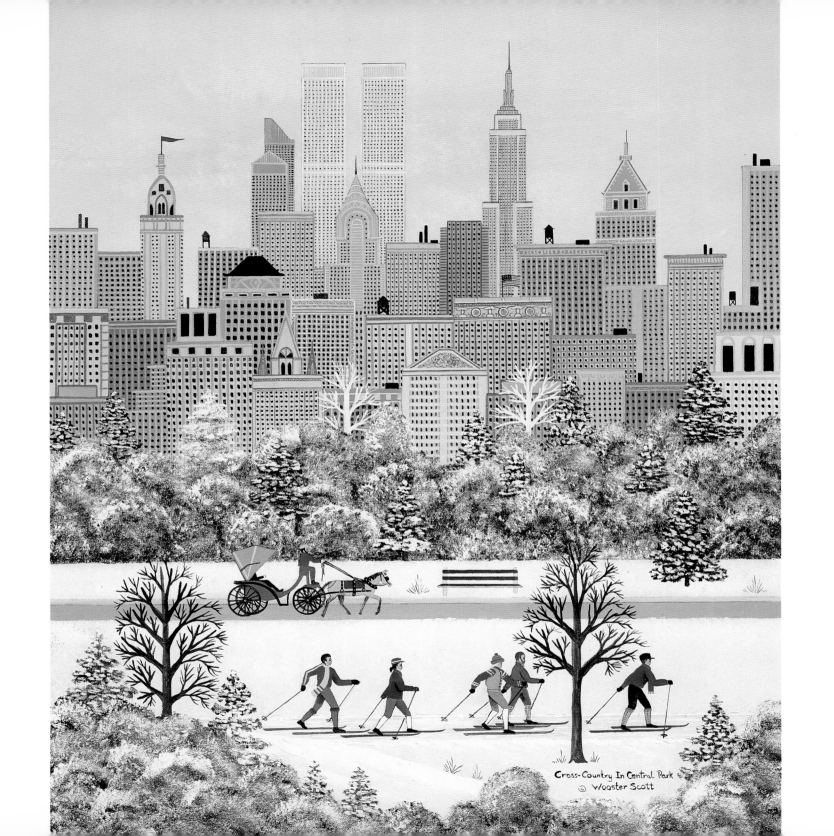

Cross-Country In Central Park
© Wooster Scott

Doggie Deliverance

You never heard such a foofaraw as the time Toby McGonagle liberated that pack of noisy pooches from the dog catcher's dray. Right in front of the pound, too, by gum.

There were big dogs, little dogs, spotted dogs, handsome hounds and ugly feists, pedigreed pups and mangy mutts. There were pointers and setters and breeds that don't exist running lickity-split down Elm Street. It was a sight to behold and all because Homer Higgins, the dog catcher, got his head on backwards over that pretty blonde with the red and blue parasol.

The aldermen should never have passed a law making local canines wear collars and licenses. Hell fire, some of those animals were *town dogs*, good old boys who hung around Zeke's General Store looking for handouts. They didn't belong to anybody.

Toby's pa tanned his hide, you can be sure of that. But the story has a happy ending. Toby grew up to be dog catcher himself. He's still picking up strays, buying 'em licenses and turning them loose.

Toby always did like dogs.

DOGGIE DELIVERANCE
Original oil on canvas 30 x 24 in (76.2 x 60.9 cm), 1992
From the collection of Stuart Patrick

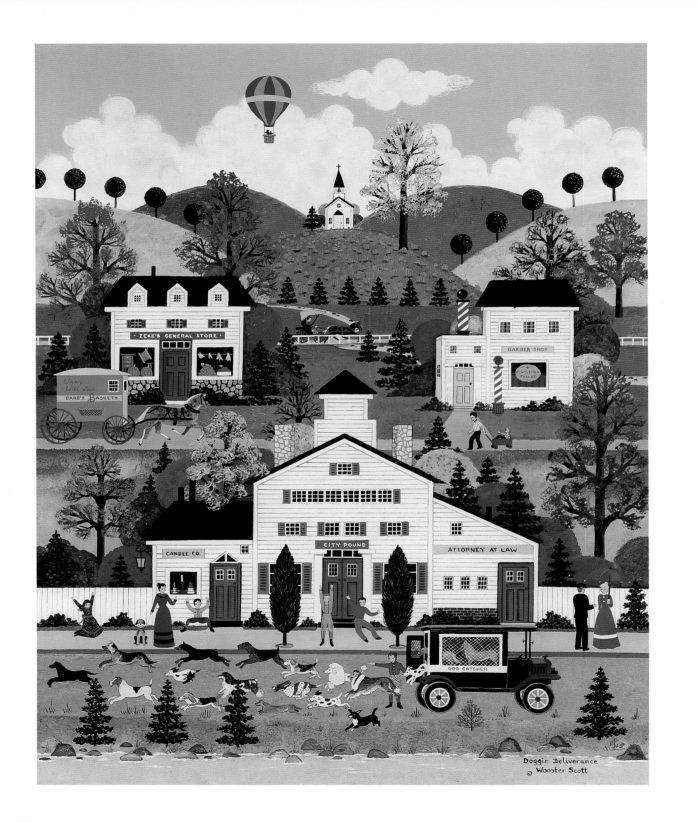

Doggie Deliverance
© Wooster Scott

The Chicken Farm

I've never seen so many chickens before.

I'd be quite content if I never saw more.

A Duck

You can't leave anything lying around Jane Wooster Scott's studio.

Not even a wooden duck.

Look what she did to this one!

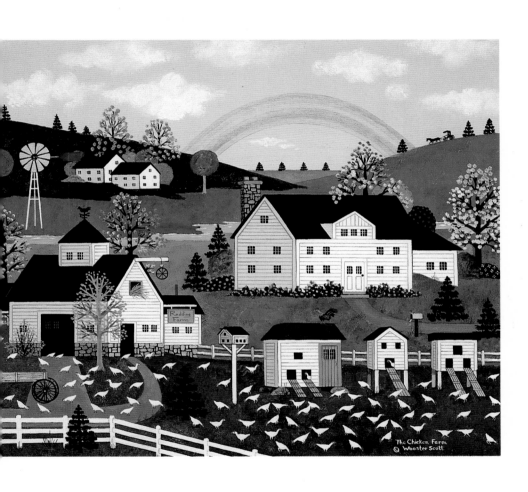

Alpine Constitutional
A Jaunty Mountain Ride

That's old Bald Mountain in Sun Valley, Idaho, providing seasonal backdrops for two of the artist's paintings — cross-country skiers gliding over the snow, and a pair of horseback riders on a summer afternoon.

The equestrians make this an especially endearing painting to Jane Wooster Scott. They depict her daughter Ashley, and son Vernon Scott IV in their favorite mountain retreat.

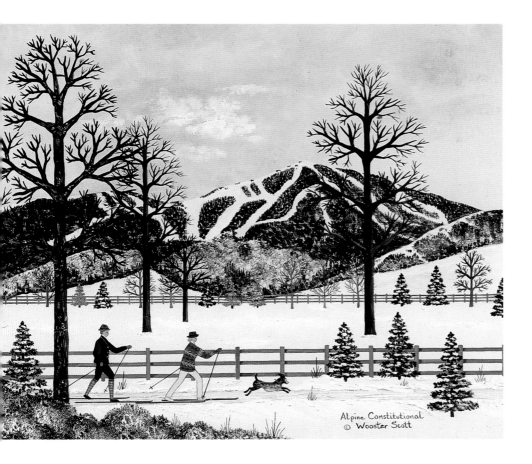

Alpine Constitutional
© Wooster Scott

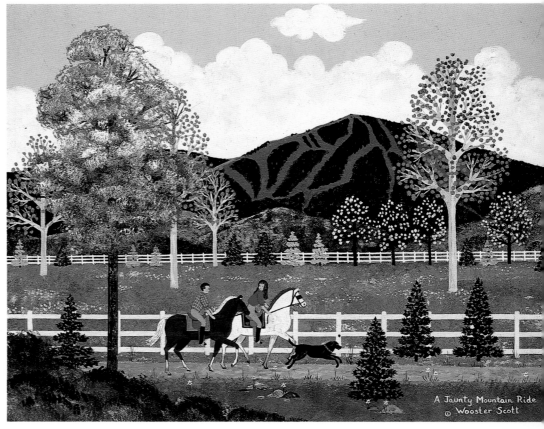

A Jaunty Mountain Ride
© Wooster Scott

Wilber is Impersonating Santa Again!

Once a year Wilber Secombe has a good time. The other 364 days he suffers deep melancholy, victim of his lifelong occupation as county truant officer, nabbing small miscreants playing hooky from school. Every Christmas Eve Wilber shakes the mothballs from his Kris Kringle suit and rides out to visit the homes of young scalawags he's collared during the year.

Wilber has his reasons. He holds the county record for skipping school during his third year in the sixth grade.

WILBER IS IMPERSONATING SANTA AGAIN!
Original oil on canvas 16 x 20 in (40.6 x 50.8 cm), 1989
From the collection of Cynthia Klapper
Offset lithograph 11 x 13¾ in (27.9 x 34.9 cm), 1992

Wilber Is Impersonating Santa Again!
© Wooster Scott

The Trolley Car At Crippen Creek
Wooster Scott

Jane Wooster Scott

BIOGRAPHY

"The leading exponent of American primitive painting....Her own distinctive style, recreating in bright uninhibited colors, an older, simpler world....Collectors of her work include art connoisseurs and celebrities."
GOOD HOUSEKEEPING MAGAZINE

JANE WOOSTER SCOTT, among the world's foremost painters of American folk art, has won international acclaim with her colorful works reaching increasing numbers of admirers and collectors in Europe, Africa and Asia.

SCOTT, who signs her canvases <u>Wooster Scott</u>, has expanded her horizons to Japan, Africa and Europe with exhibitions of her original oil paintings and brilliant serigraphs. Her popularity has spread to such nations as Portugal and Australia through permanent displays in American embassies as representational of American traditions. For a time, one of the artist's paintings graced the walls of the White House. She has had major shows in New York, Los Angeles, Boston, Atlanta and other cities across the United States.

Her paintings echo in the hearts and minds of all cultures as she depicts in a very human way America's celebrations of life, traditions and values. She catches moments in time in small towns, great cities, at festivals, sports, politics and in family relationships—the panoply of a young country at the turn of the century. She commits these images beautifully and unforgettably to canvas. Her soaring imagination, twice-told tales, exhaustive research and trips to antique locales enable her to make the American Dream spring to life through daring brush and vivid palette.

The artist, who makes her home in Sun Valley, Idaho, high in the Sawtooth range of the Rocky Mountains, was commissioned to visit Kenya and Tanzania to paint a stunning African scene for the California Special Olympics. Her recent travels have included many tours of Japan, where she showed her works in seven of that nation's largest cities. These whirlwind tours are so popular with the Japanese, a people she admires for their ancient traditions, that, incredibly, all her paintings and serigraphs immediately sold. The future holds more trips to Japan to display her works.

Scott never was educated in any disciplines of formal painting techniques. It was not until after she became an adult that she decided to experiment with oils on canvas to decorate her home. Pleased with her first attempts, she created more and more works of art until friends asked to buy them. Instead, Scott chose to exhibit her paintings at a show on La Cienega Boulevard's famed "gallery row" in Los Angeles. On the first night, the gallery sold out her entire collection.

While her paintings have become increasingly sophisticated in her own instinctive techniques, the subjects, locations and activities retain their purely American folk art flavor. Scott says, "I paint the way I do and choose my subjects out of a deep love for my country's heritage. The era I choose most often is just before or just following the birth of the Twentieth Century. That period seems to me to have

been a perfect time to live – no wars, no pollution, no crime waves. I believe people were more honorable then. The pace was slower. More time was given to the appreciation of life's small pleasures and the simple beauty of nature. Family units were stronger, more loving and binding. People took greater joy in living. I try to capture that essence in my work."

The artist says it is increasingly difficult to find the United States as she imagines it was a century ago. The barns and stables, cottages and silos, Victorian store fronts, carriages and town halls, water pumps and windmills, covered bridges and one-room school houses are disappearing from the American landscape. Scott hopes in her travels to discover remaining relics of that era and bring them to her paintings, allowing future generations to better appreciate their heritage.

"I travel to New England and southward along the Atlantic Coast, scouring the back roads and country lanes searching for the past," she says, smiling. "But even as a child I saw few enough of the remnants of that time in history."

Scott was born and reared in Pennslyvania on the edge of rural America. She attended a Quaker School near Philadelphia. Scott often includes figures in her paintings of a little girl with long dark hair, depictions of her daughter Ashley as a child, and her son Vernon IV as an active, mischievous lad. The ubiquitous white dog with the floppy ears looks a great deal like Mitzi, her favorite childhood pet.

Collectors List of Original Paintings

Steve Ackerman
Merv Adelson
William Ahmanson
Marty Allen
Jerome Anderson
Samuel Arkoff
Edward Asner
Don Atkinson
Craig Bass
Armen Bagdasarian
Joseph Barbera
Juanita Bartlett
Jim Benson
Howard Berkowitz
Glen Best
James Blake
John Blakely
George Bloom
Ernest Borgnine
Richard D. Bower
Marlon Brando
Charles Bronson
Governor John Y. Brown
Scott Brown
Charles Bucks
Carol Burnett
John Mack Carter
Karen Cameron
Michael Cameron
Shawn Cassidy
David Cerva
Dave Clack
John Coble III
Edie Adams Condoli
Mike Connors
Robert Conrad
Nancy Conway
Warren Cowan
Arthur Crames
Richard Crenna
Harry Davison
Hanley Dawson
Susan Dey
Joseph DiMartino
Marriner Eccles
Howard Ecker

Ralph Edwards
Greg Erwin
Jamie Farr
Farrah Fawcett
Thomas Ferris
Warren Finn
Mary Fiore
Elsie Floriani
Ed Flynn
Pat Foley
Shirlee Fonda
Amanda Foreman
Wallace Franson
Robert Freidman
Michael Freilich
Robert Garber
Sidney Garber
Jerry Garrett
Phyllis George
David Gerber
Jacqueline Getty
Gloria Gilfenbain
George H. Gilmore
Harry Glassman
Norman R. Glenn
Barry Goldsmith
Mrs. Freeman Gosden
David Hartman
Valerie Harper
William Hayes
Christina Healy
Stan Herman
William Hewlett
Herbert Hills
Joseph Hirschhorn
Ed Hookstratten
Earl Holding
Raymond Hoover
Herb Hutner
Harry Jones
William Justice
Alan Kane
Jack Kanegaye
Michael Kazanjian
Gene Kelly
Cynthia Klapper

Bernie Kopell
Irwin Kourland
Peter Kremer
Abbe Lane
Ambassador William Lane
Hope Lange
Joyce Larsen
Perry Leff
Michael Livingston
James Lockwood
Jerry London
Gloria Luckenbill
Richard Ludwig
Gavin MacLeod
Merritt Malloy
Douglas Manchester
Dick Martin
Olavee Martin
Morton Marvin
Thomas McClain
Ed McMahon
Charles McNamee
Jack Miller
Michael Minchin
Archie Mishkin
Paul Monash
Henri Moreault
Mahammed Mortazavi
John Moser
Charles Moss, Jr.
William Muir
William Nadeau
James Nelson
Paul Newman
Leonrad Nimoy
Larry Niven
Jim O'Hara
Joseph Ossorio
David Ostrove
Phyllis Parvin
Stuart Patrick
Dorothy Pearson
George Peppard
William Pereira
Robert E. Petersen
Barry Peterson

Lloyd Pettit
JoAnn Pflug
Arthur Pine
Victoria Principal
Ragnar Qvale
Deborah Raffin
Russ Randal
Mary Lee Reeder
Lee Rich
Kenny Rogers
Terry Ross
Gerry Rubin
Robert Ruggles
Ashley Scott
Vernon Scott IV
Sidney Sheldon
Sy Sher
Nancy Sinatra
Dale Snodgrass
Tom Snyder
Aaron Spelling
Sylvester Stallone
Jean Stapleton
Rusty Staub
Mary Munds Stewart
Gordon Stulberg
Ron Sunderland
Bo Svenson
Loretta Swit
David Taylor
Al Toffle
Granville Van Dusen
Kim Verde
Michael Viner
Julio Wahl
Porter Washington
Chris Waterman
E. G. Warmington, Jr.
Frank Wells
Jill Weyland
Andy Williams
Jonathan Winters
Joanne Woodward
Chuck Woolery
Steve Wynn

Index

Admiring The New House 98
Aeries For Canaries 78
Alpine Constitutional 296
The American Train Suite 44
Aquatic Playmates 58
Aromas Of The Gods 56
The Artist At Her Easel 232
At Attention! 54
Auld Lang Syne At The Golden Nugget Inn 234
Autumn Hayride 110
The Awesome Snowman 216
The Ballet School 160
The Baseball Game 242
Bears! Bears! Bears! 254
Before The Nine O'Clock Bell 74
Beyond The Pumpkin Patch 76
Birthday Mayhem 62
Bountiful Harvest 100
Burton's Barnstormers 64
Cape Cod Harbor 66
The Cape Milford Light 80
Carefree Days 68
Carnival Time In Willow Bend 276
Central Park Contrast 114
The Changing Colors Of Winchester County 216
The Chicken Farm 294
The Christening 278
Christmas Traffic Jam 46
The City By The Golden Gate 158
The City Suite 158
Cold Snap In Bitteroot Valley 174
Collector's Pride 286
Command Performance 84
Concert On The Lawn 174
Country Living 214
Coupled 86
Courting The Farmer's Daughter 236
Crispy Day At Butternut Junction 98
Cross Country In Central Park 290
Cubs Fever 162
Derby Day In Dayton 238
A Different Place Entirely 18
Doc's Race With The Stork 73
Dog Walking: A Nightly Ritual 158
Doggie Deliverance 292

The Dow Is Up! 88
Down Memory Lane 166
Downpour Down East 124
A Duck 294
Easter At The White House 90
The Easter Egg Hunt At The Country Club 272
Ego Trip 138
Eighth Avenue 92
Fall Colors 274
Family Frolic 152
Family Night At The Black Horse Inn 148
Feminine Curiosity 262
Feminists Beware! 94
First Day Of School 268
The First Service Station In Deerfield 218
Fitchburg Township Fair 164
The Four Seasons Suite 216
Friday Night Cotillion 170
Friendly Encounters, Giraffe Manor, Kenya 176
Funning 240
The General Store 202
Goblins On A Rampage 172
Going For The Brass Ring 16
Good Neighbors 178
The Greatest Show On Earth 200
The Gulls Of Maine 180
Halloween 282
Hanging Out At Miller's Pond 228
A Happening On Foxboro Pond 182
Happily Ever After 86
Happy Birthday Hollywood 186
Harry's Hang Out 190
Head 'Em Off At The Pass 70
The Heritage Suite 124
Heroes On Wheels 192
High Flyers At Stormy Point 64
Holiday Sleigh Ride 124
The Holiday Suite 246
Ice Cream Social 184
In The Heart Of Dixie 8
The Independence Day Parade 210
Indian Summer In Nantucket 34
It's Barney Oldfield Hitting 131 MPH! 266

A Jaunty Mountain Ride 296
Keeper Of The Light 32
Kentucky 226
A Kid's World 12
La Femme Fatale 94
A Lark In The Park 204
Larsen's Lair 198
Laying In Provisions 126
Little Girls' Delight 52
A Lonely Trek 110
Loves Me, Loves Me Not? 208
The Magic Of McCall 206
A Major In The Minors 212
Memories Past 36
Mid Winter Night's Dream 14
The Milkman's Route 124
Mining Earth's Bounty 244
Moonlight Funning 118
Moonlight Merriment 96
Mother's Day 130
Mother's Day Celebration 284
The Mother's Day Picnic 6
Mountain Majesty 24
Mounting Up In Virginia 288
Nannies On Parade 39
The Nativity 196
Neptune's Fantasy 40
A New Beginning 128
The News Room 26
Nutcracker Fantasy 136
Oasis In The Urban Jungle 280
On The Summer Wind 28
Once Upon A Time 256
Outfoxing The Gentry 134
The Party's Over 10
Peaceful Harbor 48
The Peddler 258
Pond At The Inn 246
Pride Of Pottstown 132
A Profusion Of Posies 82
Putt For The Championship 124
Queen Of The Trail 116
Quigley's Quality Quilts 270
A Really Swell Parade Down Main Street 194
Red Roofs 274
The Return Of The Hostages 258
Sandlot Slugfest 260
Seafaring Sorority Sisters 188

Seashore Shenanigans 140
Sippin' Sodas At Ridley High Hangout 146
A Song For The Season 246
Southern Serendipity 30
Spanning Grand Gorge 44
A Special Moment In Time 132
Springtime In Central Park 222
Springtime In The Cascades 154
Storybook Summer 230
The Stud 249
Summer Harvest 216
Sun Valley Magic 142
Sunday In New England 104
Swing Your Partner 106
The Taylor Connection 198
Tender Ministrations 108
A Time For Sugaring 102
Together Forever 216
Tomorrow's Champs 112
Tossing The Wedding Bouquet 60
Town Square 20
The Trolley Car At Crippen Creek 300 & 301
The 12:09—On Time Again! 120
The Unveiling Of Major Culpepper 240
Venice Beach Vibes—The 80's 22
Vintage Vanities 144
The Volunteer Fire Brigade 150
Waiting For The Sea Shore Special 264
Wet Your Whistle and Warm Your Toes 156
Whistle Stop At Ashfield Junction 44
White On White 250
A Whoop And A Holler On Independence Day 42
Wilber Is Impersonating Santa Again! 298
Wild Swans Of Chesapeake 252
Winter Pastoral 220
Winter's Eve 50
Yankee Enterprise 122
Yesteryear In Blue Ridge Summit 224